LOST BALLPARKS

Writing Credits and Acknowledgments

Dennis Evanosky and Eric J. Kos would like to thank the Society for American Baseball Research, Ken Burns and the Baseball Hall of Fame for their dedication to the preservation of baseball history. They would also like to thank historian David Stinson for his website www.deadballbaseball.com; Paul Munsey and Cory Suppes at www.ballparks.com; Eric and Wendy Pastore at www.digitalballparks.com; and Tom Schieber' for his "Researching Baseball" blog. Our hats are also off to historians Cameron Collins, Joan Thomas, Alan Stein and Doug Taylor.

The publisher would like to thank the following authors for contributing to *Lost Ballparks*.
Eric Enders (Introduction and Pittsburgh), Michael Rose, Don Rooney and Paul Crater (Atlanta), Anthony Sammarco (Boston), Paul K. Williams (Baltimore and Washington, D.C.), John Paulett, Judy Floodstrand and Kathryn Maguire (Chicago), Marcia Reiss (Brooklyn and New York), Ed Mauger, Bob Skiba (Philadelphia), William Dylan Powell (Houston and Dallas), Rob Ketcherside (Seattle), Amy B. Zimmer (Denver) and Cheri Gay (Detroit). A big thank-you to Dan Mansfield who volunteered to check through the book during his beloved Cubs first World Series triumph in 108 years.

Picture credits

The publisher wishes to thank the Baseball Hall of Fame Library, Cooperstown, NY, who provided the core of photographs for this book. Other pictures were provided by
Atlanta History Center: Pages 60, 61, 96, 97.
Bruce Torrance Collection: Page 143 (bottom left).
Core Redevelopment LLC: Page 135 (bottom).
Department of Special Collections, University of Southern California: Pages 40, (left) 41.
Detroit Public Library: Page 128.
Getty Images: Pages 5, 10, 11, 21, 24, 25 (top), 37 (bottom), 38 (main), 40, (right) 42, 44 (left), 45, 51, 54, 63 (main), 68, 71, 76, 77, 79, 80, 84, 85, 89 (bottom), 93 (top right), 93 (bottom right), 94, 104 (bottom), 106 (bottom), 114 (bottom), 115, 116, 123 (bottom), 123 (top left), 127, 130, 131, 132, 133, 138, 139 (main), 143 (bottom right).
Houston Metropolitan Research Center: Pages 72, 73, 90.
King County Archives: Page 101.
Library of Congress: Pages 4, 8, 9, 11, 12, 13, 16, 17, 18, 19, 20, 22, 23, 26, 32, 33 (bottom right), 37 (top), 46, 47, 48, 52, 53, 56, 58, 59, 70, 74, 82, 83, 91, 108, 110, 111, 118, 141, 142, 142 (top).
Pavilion Image Library/Simon Clay: Pages 87, 103 (right), 107, 113 (left), 129.
Pavilion Image Library/Karl Mondon: Pages 63 (bottom), 140 (bottom), 140 (bottom right).
PH1 Harold J. Gervien: Page 100 (left).
Seattle Municipal Archives: Page 100 (right).
Tom Noel Collection Page 113 (right).
Vance Rogers Collection: Pages 34, 69, 85, 104 (top), 114 (top), 126 (bottom), 135 (bottom left).
Wikimedia: Pages 51 (center), 64 (right), 134.

First published in the United Kingdom in 2017 by PAVILION BOOKS an imprint of the Pavilion Books Company Ltd, 43 Great Ormond Street, London, WC1N 3HZ

© Pavilion Books, 2017

ISBN: 978-1-911216-49-0
A CIP catalogue record for this book is available from the British Library.

10 9 8 7 6 5 4 3 2
Reprinted in 2017

Repro by Colourdepth, UK
Printed by Toppan Leefung Printing Ltd, China

www.pavilionbooks.com

LOST BALLPARKS

Dennis Evanosky and Eric J. Kos

PAVILION

A Short History of Ballparks

Unlike the game of baseball itself which came from the Old World to the New, there is no mysterious origin myth surrounding the first ballpark. Although various bat-and-ball games were common in New York and Boston, the first written account of "base ball" in America appeared in the *National Advocate*, a New York newspaper, in 1823. The article described a match taking place at Jones' Retreat, a grassy public area on Broadway about two blocks east of today's Washington Square Park. The first written rules for baseball—and the first formally organized club—weren't created until two decades later by the Knickerbocker Base Ball Club of New York. Alexander Cartwright, one of the club's members, lived in what was then considered upper Manhattan and what is known today as the Lower East Side. He and his companions couldn't find a proper place in Manhattan to hold their games, so they took a ferry across the Hudson to Hoboken, New Jersey. There, on a grassy lot

called the Elysian Fields, they practiced among themselves and, on June 19, 1846, held their first official game against an opponent.

While Jones' Retreat and the Elysian Fields were the locations of early baseball games, they were not ballparks. They were grassy lots used for a variety of purposes and were neither enclosed nor designated specifically for baseball. The Dickson Baseball Dictionary defines a ballpark as "an enclosed baseball field including its seating areas," and by that definition, baseball historians have always considered the Union Grounds to be the first ballpark ever built. Located in Brooklyn at the corner of Marcy Avenue and Rutledge Street, the field was actually the site of the Union Skating Pond. Since ice-skating made money only in winter, owner William Cammeyer decided to use the enclosed grounds as a baseball park during the summer.

On May 15, 1862, the Union Grounds officially

opened for baseball with admission free for the first day only. Later, when well-known local clubs such as the Eckfords, Putnams, and Constellations used the grounds for their games, Cammeyer made money by charging fans for admission. According to a recent discovery by historian Tom Shieber, the first enclosed grounds—and therefore the first ballpark—was not the Union Grounds, but actually the Excelsior Grounds in Brooklyn, located at the south end of Court Street on Gowanus Bay. The

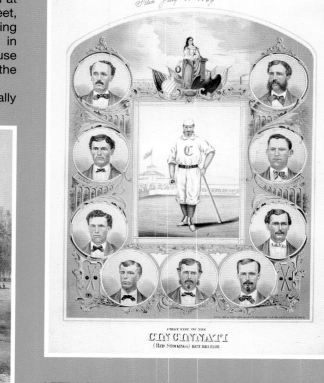

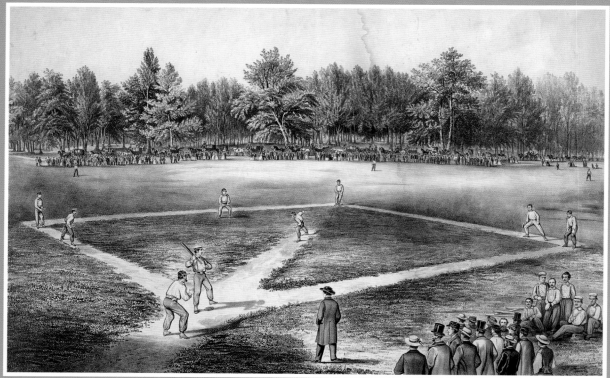

LEFT *A Currier & Ives lithograph from 1866 of early baseball being played at the Elysian Fields in Hoboken, New Jersey.*

ABOVE *A poster of the first openly professional team, the Cicinnati Red Stockings of 1869.*

OPPOSITE *Fire was the nemesis of most early ballparks, leading to their replacement with concrete and steel structures. On May 4, 1901, this fire ripped through the grandstands at League Park in St. Louis.*

Excelsior Club, a famed amateur squad featuring pitcher Jim Creighton, moved there in 1859 and apparently erected an enclosure to keep out the local riffraff who were considered "undesirables" at gentlemanly baseball games. Still, whether the Union Grounds was the first ballpark or not, it was one of the most influential.

In 1869, the Cincinnati Red Stockings became the first team to openly pay its players, and after their success, baseball as a moneymaking enterprise caught on. The first professional league, the National Association, started in 1871. Its teams played in wooden ballparks hastily erected on empty lots. Almost anyone who owned a ballpark could own a team, and by the mid-1880s the parks were becoming more lavish—for example, the luxurious wooden palaces of the Grand Pavilion in Boston, St. George Grounds in New York, and Sportsman's Park in St. Louis. Even more important than a park's characteristics was its location, and entrepreneurs scrambled to erect ballparks along the trolley and streetcar lines that sprang up in urban areas. As owners invested more money in building ballparks, they also developed greater concern for the fate of their investments. Fire had destroyed parks in Chicago in 1871, Brooklyn in 1889, and Louisville in 1892, and although ballparks burned down easily and often, new parks kept rising from the ashes of old ones. In 1894, fire destroyed ballparks in four of the nation's largest cities—Baltimore, Boston, Chicago, and Philadelphia—prompting rumors that a ballpark arsonist, perhaps someone opposed to Sunday baseball, was at work. No conspiracy was ever found, but the ballpark fires of 1894 prompted owners to focus on fire prevention and safety measures for the fans. Within two decades, almost every major league team would play in a relatively fireproof ballpark.

The first park built entirely of steel and concrete was Shibe Park, which opened on April 12, 1909, as the home field of the Philadelphia Athletics. In addition to being the most durable ballpark that had ever been built, Shibe was also bigger than most, able to hold 20,000 paying customers. Shibe's success led to the biggest building spree

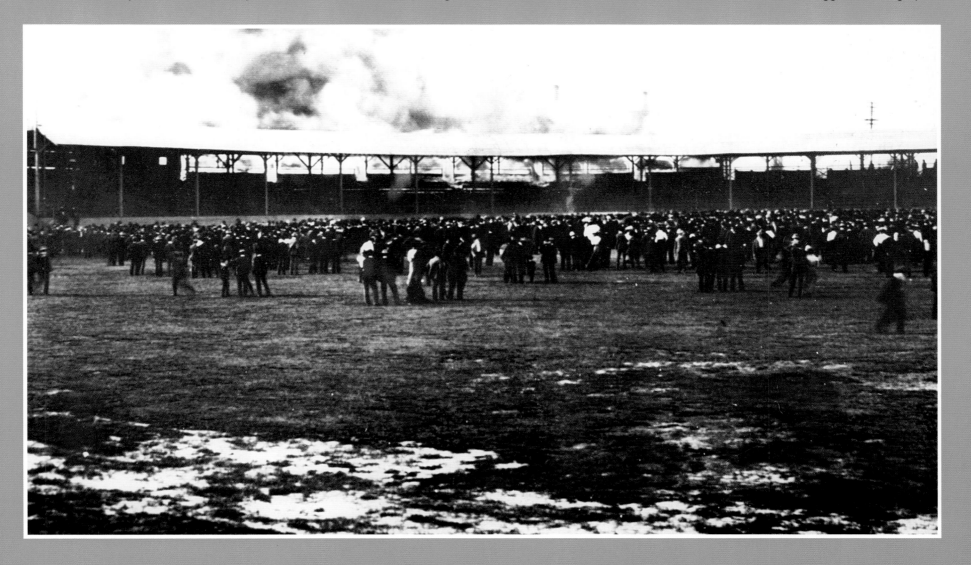

in baseball history, and within five years most of the ballparks that would become beloved by twentieth-century baseball fans had been built. Pittsburgh's Forbes Field was built in 1909; Chicago's Comiskey Park in 1910; Boston's Fenway Park and Detroit's Tiger Stadium in 1912; Brooklyn's Ebbets Field in 1913; and Chicago's Wrigley Field in 1914. By 1920 the Philadelphia Phillies were the only major league team not playing in a new steel-and-concrete park. Most of these new parks were built in relatively rural or undeveloped areas, but as America grew more urbanized throughout the 1900s, a larger population moved into the neighborhoods surrounding the ballparks. Most of the stadiums were also located along major routes of public transportation, making it easy for anyone to get to the ball game.

The parks built in the period between 1909 and 1914 were so durable and successful that most of them lasted more than 50 years, and two—Fenway Park and Wrigley Field—are still being used today. The first franchise to abandon its classic ballpark was the Boston Braves, who departed Braves Field for Milwaukee in 1953. A more lasting impact was made by the Brooklyn Dodgers, who shook the foundations of baseball economics by moving to Los Angeles in 1958. Team owner Walter O'Malley played the cities of Brooklyn and Los Angeles against each other, effectively selling himself to the highest bidder. The winner was Los Angeles, which won over O'Malley with 300 acres of free land near downtown Los Angeles, special tax breaks, and promises of road improvements in the stadium area. Although Dodger Stadium was technically

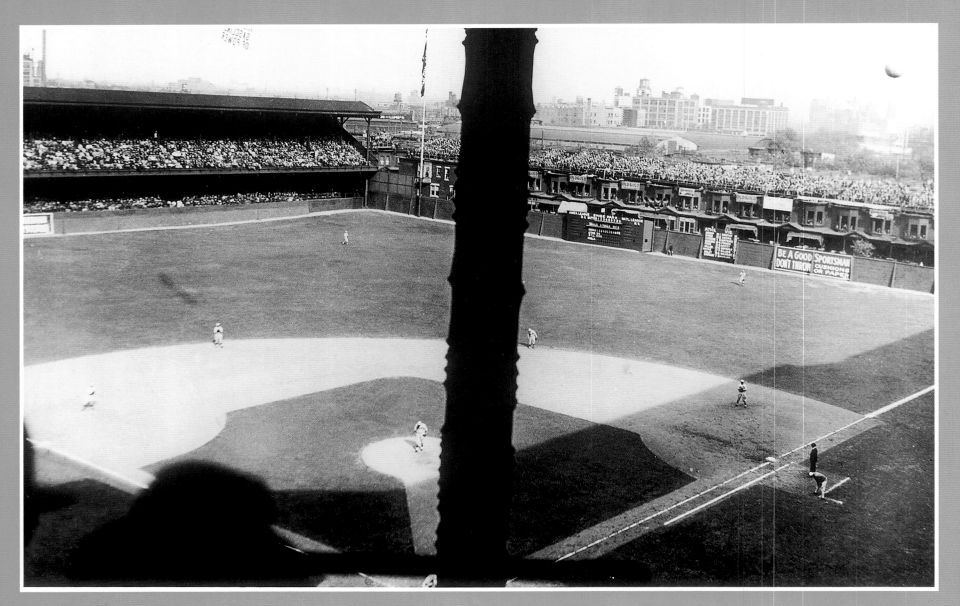

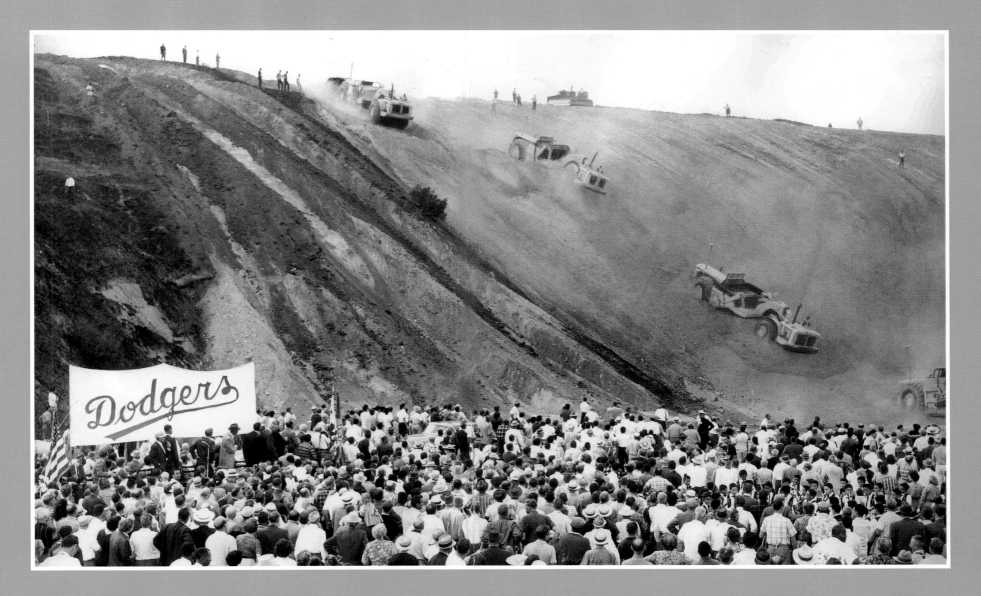

constructed with private funds, it was actually the first in a long line of ballparks built at the taxpayers' expense, enabling owners to reap greater profits. Ever since O'Malley's shrewd move, major league teams have been using the threat of relocation to entice the construction of publicly funded ballparks.

Only three years after Dodger Stadium, another ballpark opened that was just as influential, but out of this world. The Houston Astros introduced the world to futuristic indoor baseball in 1965, and when it was found that grass wouldn't grow in the Astrodome, they introduced another innovation— artificial turf, otherwise known as AstroTurf. AstroTurf was cheaper and easier to maintain than real grass, and the concept caught on quickly with other teams. Over the next decade a series of large, antiseptic, and largely indistinguishable stadiums opened in cities such as St. Louis, Cincinnati, Pittsburgh, and Atlanta. The new parks—known collectively to baseball fans as "cookie-cutters"— greatly affected the style of play during the 1970s and 1980s, particularly in the National League. Teams such as the St. Louis Cardinals and Cincinnati Reds tailored their rosters to the speedy, wide-open style of play that artificial turf encouraged. By 1989, when the SkyDome opened in Toronto, ten of the 26 major league teams played their games on artificial turf.

The SkyDome, with its lavish restaurants and luxury suites, turned out to be the harbinger of a

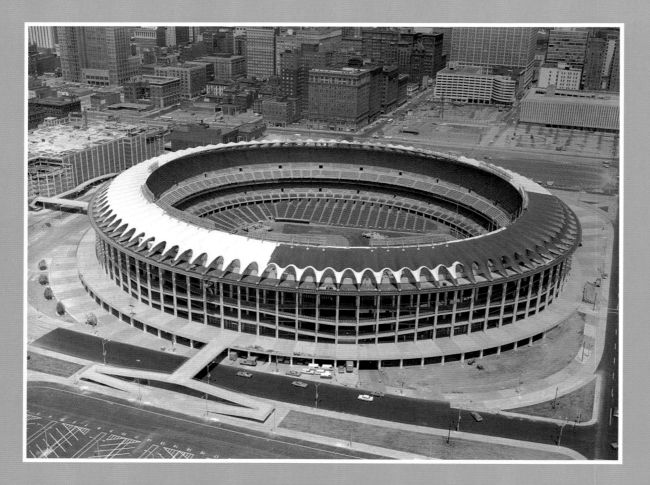

games at home on television. Another 1990s trend was the sale of naming rights to corporations. Before 1995, stadiums were usually named after the owner who built them (Ebbets Field), the team that inhabited them (Yankee Stadium), or the municipality that paid for them (Oakland Coliseum). But in 1995 the naming rights for Candlestick Park were sold to 3Com, a technology company, for $4 million. Fourteen other teams followed suit over the next six years, culminating in a record $100 million deal between the Houston Astros and Enron, the now-infamous energy company. With (often short-lived) ballpark names, revolving ads behind home plate, corporate jingles between innings, and even the Miller Beer logo on the caps of the Milwaukee Brewers, fans were being subjected to more advertisements at the ballpark than ever before.

Still, major league attendance at the beginning of the twenty-first century is better than it has ever been. The St. Louis Cardinals drew 110,000 fans for the entire 1918 season, an amount they now routinely surpass in a weekend series. Teams continue to build innovative ballparks, many of them variations on old themes. Camden Yards has a warehouse looming over the playing field, just as the Huntington Avenue Grounds in Boston did. Jefferson Street Grounds, used by the Philadelphia Athletics in the 1870s, had a swimming pool behind the outfield fence; so too does today's Chase Field in Phoenix. At Robison Field in St. Louis, a roller coaster delighted fans in the 1890s, just as a roller coaster behind the right-field fence delights today's fans at Peoples Natural Gas Field in Altoona, Pennsylvania. The lighted fountains at Kansas City's Kauffman Stadium may seem unique, but such fountains first arrived on the major league scene in the 1880s, when the New York Mets played at St. George Grounds. Ballparks will never again be built of wood for fire safety reasons, but the spires and gables at the remodeled Bowman Field in Williamsport, Pennsylvania, are reminiscent of the wooden parks of the 1890s. Luxury boxes may seem like a modern invention, but they were first installed by Albert Spalding at Chicago's Lake Front Park in 1883.

Of course, there are differences too. Instead of costing a quarter, admission to a ballpark can now cost in excess of $500 for a key game in the season. Ballpark construction has now broken the billion-dollar barrier. It now takes two to four years—and in the case of the Yankees, $2.3 billion—to build a ballpark, whereas many nineteenth-century parks were constructed in only a week.

new kind of ballpark. The new era began in earnest in 1992, when Oriole Park at Camden Yards opened in Baltimore. It was the anti-Astrodome, with a quaint brick exterior, wrought-iron grillwork, real grass, asymmetrical dimensions, and a vibrant urban setting. Its dignified dark green seats and earth tone colors were the antithesis of the gaudy, plasticized ballparks of the 1960s. The success of Camden Yards ushered in an era of ballpark building unseen since the days of Shibe Park, and more important, reestablished the ballpark as a vital part of urban America. Within a decade, similar new parks had been built in eleven major league cities, some of which—including AT&T Park in San Francisco and PNC Park in Pittsburgh—are among the best ballparks ever built. Even teams that didn't build new parks were influenced by Camden Yards, and artificial turf was replaced by real grass in existing stadiums in St. Louis, Kansas City, and Cincinnati. By 2014, only two of the 30 teams in

Major League Baseball still played on artificial turf, and just one (Tampa Bay) in a permanently enclosed dome.

The ballpark renaissance of the 1990s sparked a renewed interest in ballpark nostalgia, and in addition to the parks themselves, the last decade has produced a plethora of ballpark memorabilia, ballpark lithographs, ballpark replica models, and ballpark books. While the 1990s produced some of the best stadiums ever, it also saw the ballpark become more of a place to see and be seen, rather than a place to watch a baseball game. In the decade between 1991 and 2001, which saw the opening of 15 new stadiums, the average cost for a family of four to attend a game nearly doubled. As a result, the makeup of the crowd changed in many ballparks, and families and working people were gradually replaced by corporate clients and the well-to-do. While brokers sat in ballparks trading stocks on their cell phones, real fans watched the

In baseball's third century, the ballpark experience is as vibrant as it ever has been. Just as prior generations cherished Sportsman's Park's beer garden, the Polo Grounds' staggeringly deep center field, or Ebbets Field's nooks and crannies, today's fans will long remember the Camden Yards warehouse and the bayside promenade of AT&T Park. Ballpark construction continues with recent stadiums for the Mets, Nationals, Yankees, Marlins, and Twins, and a new park for the Braves is scheduled to open in 2017.

In this book we trace the evolution of the ballpark and look at the lost stadiums, the places where so much sporting history was made, yet today are gone. Today this hallowed ground of baseball is covered by housing developments or parking lots or Interstates. For so many classic buildings, preservation has come too late, the wrecking ball arrived long before the phrase "adaptive reuse" was coined. But Bush Stadium in Indianapolis gives us a tantalizing glimpse of what might have been, given sympathetic developers and a more enlightened attitude to preserving America's rich baseball heritage.

OPPOSITE *Cookie-cutter stadiums such as the Busch Memorial Stadium in St. Louis were an uneasy compromise between hosting football and baseball in the same park.*
RIGHT *The ballpark that broke the mold. Camden Yards in Baltimore re-established the importance of the dedicated baseball stadium with a beautiful natural grass outfield.*

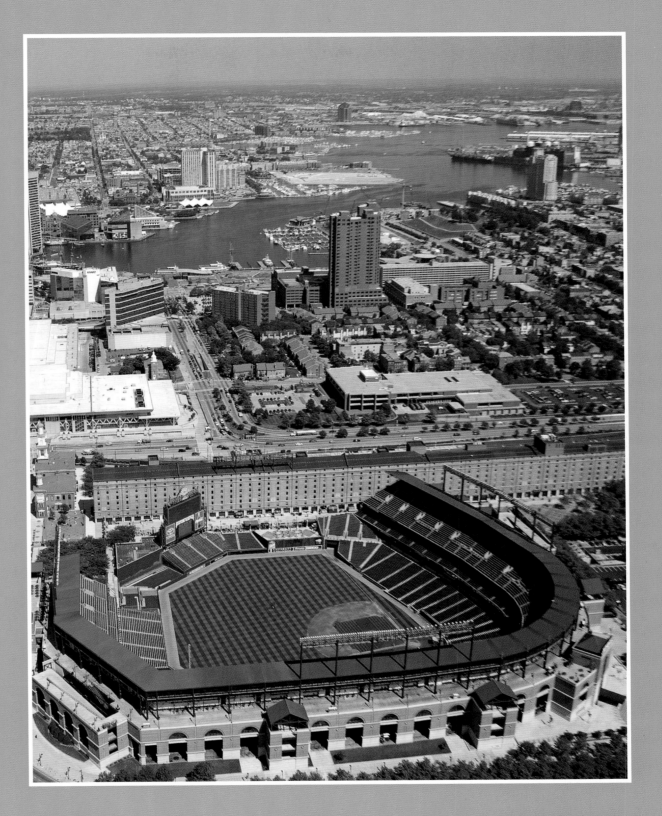

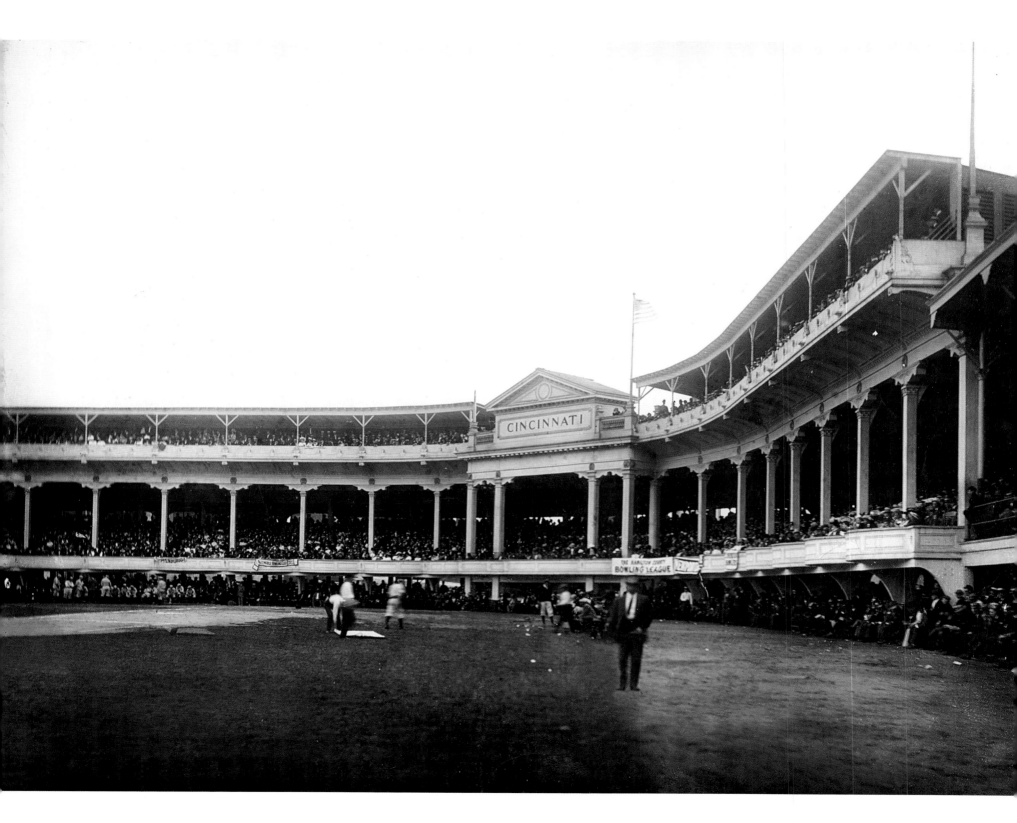

Palace of the Fans, Cincinnati DEMOLISHED 1911

For some 86 years, the cheers of baseball fans and the crack of the bat resounded where Findlay Street meets Western Avenue in Cincinnati, Ohio. The earliest ballpark there, League Park, served as the Red Stockings' home field beginning in 1884 (the team shortened its name to the Reds in 1890). On May 28, 1900, one of the park's two grandstands caught fire. The Queen Anne-style structure burned to the ground in the middle of the season. While the park was being reconfigured the team played its games on the road.

To replace the destroyed stands, Reds owner John Brush built the Palace of the Fans, connecting the new park to the surviving structure of the old. The Palace of the Fans' neoclassical-style grandstand echoed a building style made popular at the Columbian Exposition in Chicago seven years earlier. The style featured hand-carved Corinthian columns. The stadium boasted private boxes and carriage stalls for drive-up viewing. Like the Polo Grounds in New York, the Palace of the Fans could accommodate carriages for secluded viewing, provided the owners didn't mind watching the game from center field.

The Reds returned to the refurbished ballpark on June 28th, just a month after the fire. With its concrete and iron foundation and superstructure, the Palace was just the second baseball stadium to primarily use materials other than wood in its construction. Only the Baker Bowl in Philadelphia predates the Palace of the Fans in this regard.

The new ballpark's grand re-opening game against the Chicago Cubs launched the 1902 season. The contest drew some 10,000 fans, but the place didn't inspire much on-field success. During their decade at the Palace, the Reds spent most of the time in the "second division"—or bottom half—of the league. No matter, though, the fans kept coming to the games. It quickly became apparent that the new grandstand's seating area was too limited: during special games fans overflowed onto the field along the outfield fence. Fights and disputes flared up among the spectators and occasionally it took quite some time to restore order off the field.

Perhaps the most important event at the Palace of the Fans happened when inventor George Cahill performed an experiment on the evening of June 19, 1909. Cahill is notable for having invented the glareless duplex floodlight projector—essentially making night baseball a possibility. Cahill installed temporary lighting at the Palace and indeed play took place that evening and was deemed a success. By the time Cahill died in 1935, his lights were being installed at parks all around the nation in an attempt to boost attendance by providing fans the opportunity to view a game after work.

A few years after its opening, concern grew around the condition of the Palace of the Fans. Firstly, the neoclassical style had become dated as it harkened back to the previous century. Then, city inspectors noticed the structure was starting to fail. They deemed floors, girders and supports unsafe and in a state of decay. Another fire caused enough damage to force the issue. The last game played at the park took place October 12, 1911, against the Cubs, the same team the Reds faced on the stadium's opening day. They beat the Cubs 4-3. Later that year, the Palace of the Fans was demolished.

For opening day of 1912, the Reds would have a new ballpark to play on the same site: Redland Field, later renamed Crosley Field. The site of this lost ballpark has mostly been turned over to commercial uses. A regular city park with a playground sits in place of the old grandstand.

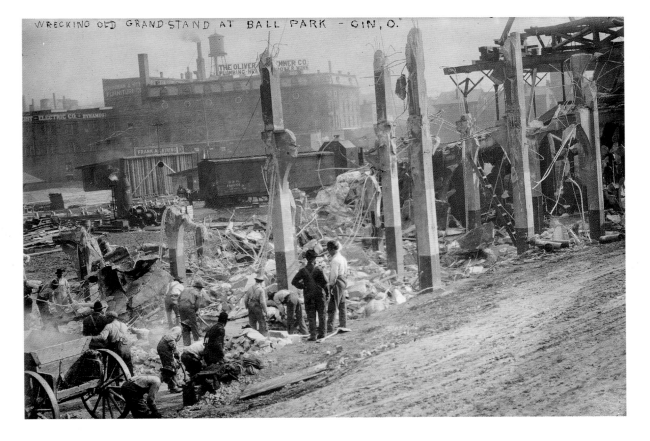

WRECKING OLD GRANDSTAND AT BALL PARK – CIN, O.

LEFT *After only a decade in use the elaborate structure fell into decay and was deemed unsafe by city surveyors.*

OPPOSITE *The grandstand was designed with Roman and neoclassical (Greek) influences. It may have been a palace for the fans, but the designers failed to include a clubhouse or a dugout for the players.*

Huntington Avenue, Boston DEMOLISHED 1912

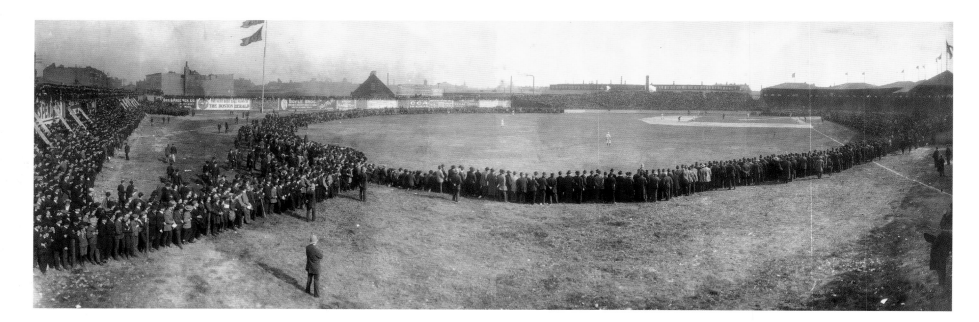

The **Huntington Avenue** American League Base Ball Grounds was one of the most popular and well-attended baseball fields in Boston in the early twentieth century. The large open-air field on Huntington Avenue, just west of Massachusetts Avenue and opposite the Boston Opera House, was the first home of the Boston Red Sox.

Ground was officially broken in the Fenway area of the city for the new baseball grounds in 1901. It was to have a capacity of 11,500 spectators with a covered grandstand and high wooden fences encircling the field. The open land chosen had often been used for traveling circuses and was extensive by modern standards—530 feet to center field, later expanded to 635 feet in 1908. It was not considered a perfect baseball field by modern standards as there were scattered sand patches where grass seemed to refuse to grow and a tool shed inconveniently placed in deep center field that seemed incongruous to the game. The Huntington Avenue ballpark was separated from the South End Grounds, home of the Boston Braves, by the railroad yards of the New York, New Haven and Hartford Railroad. The baseball field was the venue for the World Series game between the modern American and National Leagues in 1903, and was to be the site of the first perfect game in the modern era, thrown by Cy Young in 1904.

In 1908 it was expanded with the center field and right field being enlarged. However, it was still an open-air sporting ground and not a true stadium, and as the game developed it became less desirable as a place for Major League Baseball games. John Taylor, the Red Sox' owner and son of the *Boston Globe* publisher, decided that the grandstand was not adequate for the large numbers of baseball fans and that his team deserved an appropriate and modern stadium. Taylor had Fenway Park built, not far from the old Huntington Avenue Grounds, and after the 1911 season ended they moved to their new stadium on a former landfill site. The Huntington Avenue Grounds was demolished in 1912 after a decade of use.

Today, the site of the former ballpark is the Solomon Court at the Cabot Center of Northeastern University. A statue of Cy Young was erected where the pitcher's mound and home plate once was located, which is a fitting memory to this once "Temple of Sport."

TOP *Multitudes of sports fans line the edge of the baseball field for the game on October 8, 1904, with the Boston Americans (soon to be the Red Sox) playing against New York.*

ABOVE *Mayor of Boston John F. Fitzgerald throws out the first ball of the season in 1910.*

OPPOSITE *The large, open-air baseball field was on Huntington Avenue in Boston's Fenway. This photo from 1911 shows the Boston Red Sox playing the Detroit Tigers.*

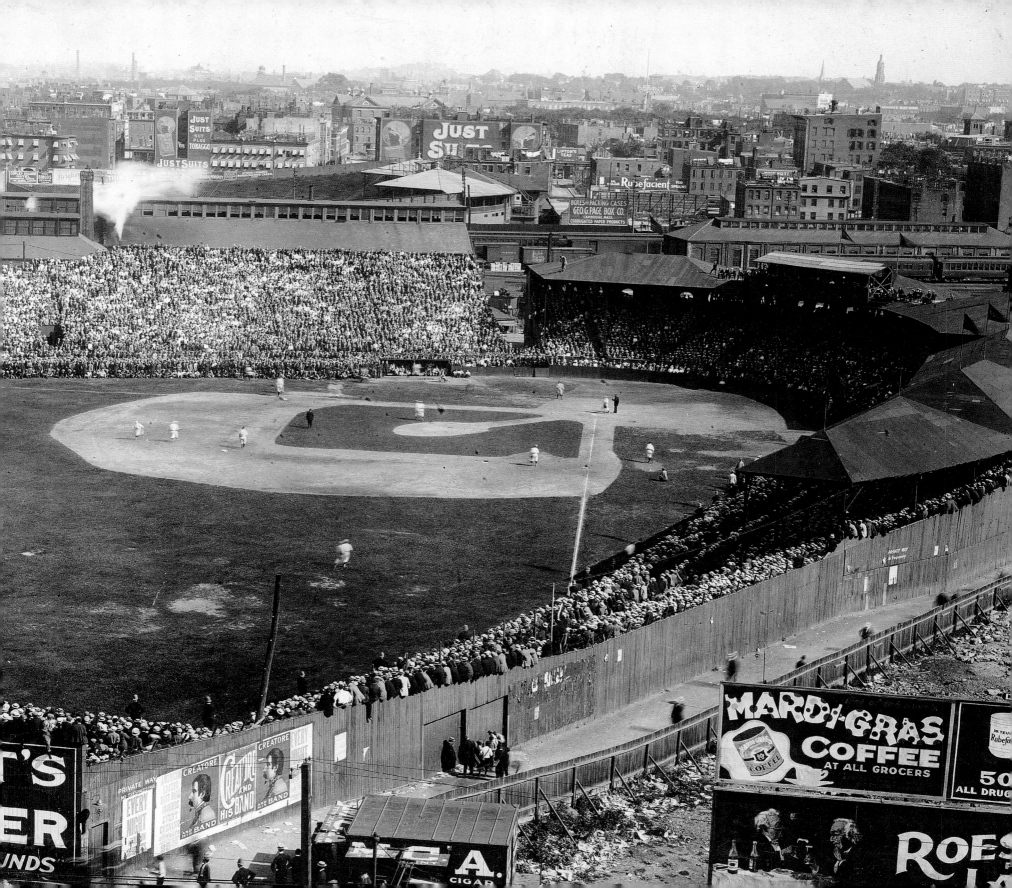

South End Grounds, Boston DEMOLISHED 1914

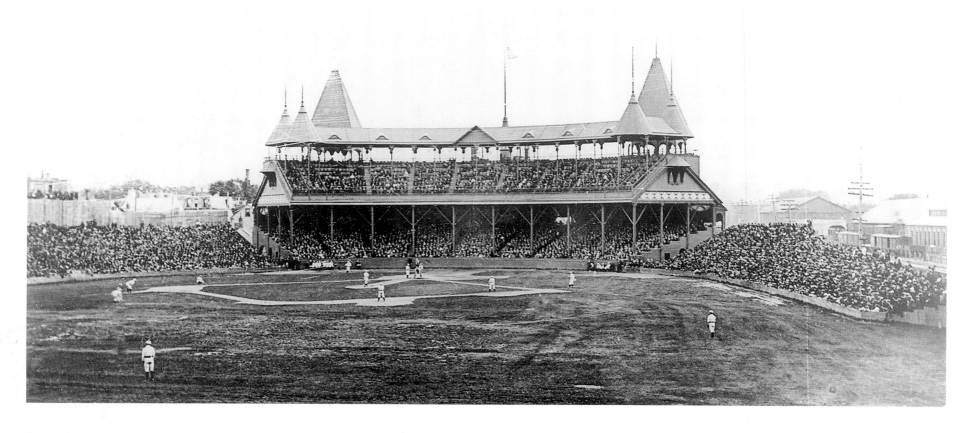

South End Grounds in Boston opened on May 16, 1871, predating by some 30 years the Huntington Avenue Grounds. The park was known by several names: Boston National League Base Ball Park, the South End Grounds, the Walpole Street Grounds, Union Baseball Grounds and Boston Baseball Grounds. At first it consisted of simple stands on a wide-open field.

Grand Pavilion replaced those stands in September 1887. A newly constructed medieval-styled grandstand opened the new season on May 25, 1888. The structure, perhaps better suited for viewing jousting knights, featured double-decked seating and witch's cap turrets. Additional uncovered seating ran down the right- and left-field lines, with bleachers in right-center field. The wood and iron stadium seated around 6,800 fans.

Regrettably, this first of baseball palaces lasted

only six years before it burned to the ground on May 15, 1894. The fire started in the third inning of a game between Boston and Baltimore; by one account some mischievous children set debris on fire under the right-field bleachers. Despite efforts to put out the fire, it spread across the outfield fence, down the left-field line, engulfed the Grand Pavilion and continued to destroy another 200 or so buildings in the neighborhood. The Grand Pavilion was lost in what became known as the Great Roxbury Fire of 1894.

The *Boston Globe* blamed the home team, the Beaneaters, for the rapid spread of the blaze. The city had installed a hydrant on the grounds, but the team hadn't paid the fee to supply it with water. Hence the *Globe* wrote, "it would appear for the sake of saving $15, the grandstand, worth $80,000, was imperiled." The team's owners also failed to

insure the structure. About ten weeks later, the grounds reopened with much humbler "fireproof" improvements.

Its replacement—the third South End Grounds, built on the same site—was nowhere near as grand and few pictures survive of the ballpark. Still, it served as the home of the Beaneaters (later known as the Braves) until 1914.

The Braves moved out and played home games at Fenway Park in 1914 and 1915 while South End Grounds III was demolished in 1914. Today the site of this lost ballpark is a parking lot adjoining Northeastern University's Columbus Parking Garage and a station for the Massachusetts Bay Transit Authority.

ABOVE AND OPPOSITE *Two views of the Grand Pavilion, which graced the South End Grounds from 1888 to 1894.*

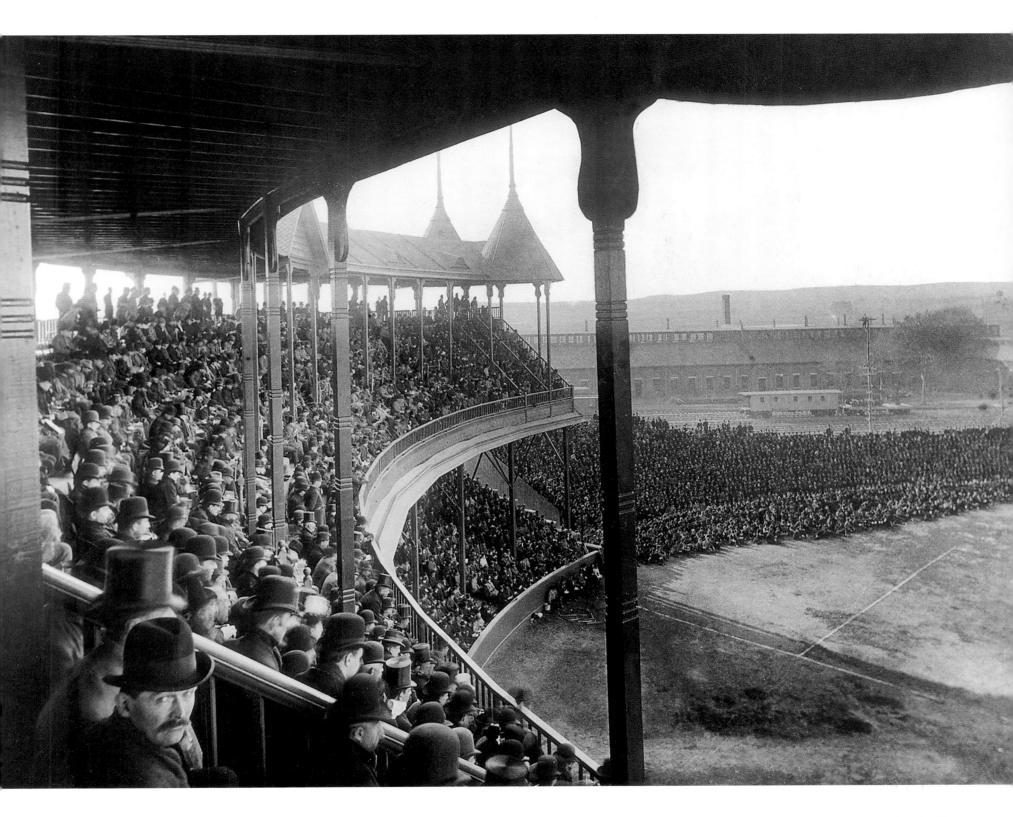

West Side Grounds, Chicago TORN DOWN 1920

Up until 2016, the greatest successes of the Chicago Cubs baseball franchise had come not at Wrigley Field, but at the old West Side Park. The team began life as the Chicago White Stockings in 1870, and started playing at West Side Park before moving to the Grounds, located near what is now the University of Illinois at Chicago Hospital, in 1893. The team, by then known as the Chicago Colts, played their first National League game against the Cincinnati Reds at the Grounds on May 14. Establishing a heartbreaking pattern that generations of fans would come to know, the Reds came back to win the game with a four-run homer in the ninth inning. To add insult to injury, the winning run was scored by Charles Comiskey, who would become the owner of cross-town rivals, the Chicago White Sox.

The Grounds were an intimate place to watch baseball, in a similar way to Wrigley Field. It was set in the middle of a residential area and spectators often sat on the rooftops of buildings on Taylor Street, so they could avoid having to buy tickets to enter the park. The West Side Grounds were just a few blocks away from the L Station at Polk Street.

The famous double play combination of "Tinker-to-Evers-to-Chance" saw action at the Grounds. Before the triumph of 2016, this was where the team last won the World Series; they appeared in the championship four times from 1906 to 1910, winning in 1907 and 1908.

There are many legends surrounding the Grounds. One is that because the pitcher faced westward when he looked at home plate, the nickname given to left-handers was "southpaw"—a term that remains today.

According to a Cubs historian, in 1908 a woman unwilling to miss the last few innings of a game, gave birth in the bleachers of the park.

In 1915, the team was acquired by advertising executive Albert Lasker, together with restaurant owner Charles Weeghman. Weeghman also owned a stadium on the North Side—Weeghman Park— that was home to his short-lived Federal League baseball team, the Chicago Whales. Play was moved there for the 1916 season and the park was later renamed Wrigley Field after the chewing gum magnate William Wrigley bought the Cubs.

West Side Grounds went on to host Buffalo Bill's Wild West show, as well as amateur baseball games, but the wooden pallpark was torn down in 1920 and the site sold to the University of Illinois.

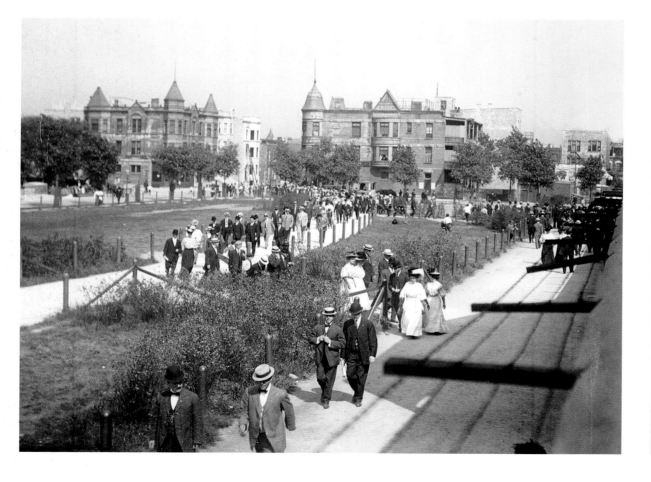

OPPOSITE *Entrepreneurs employed wildcat bleachers perched on neighboring buildings at the West Side Grounds, just as they continue to do at Wrigley Field. Although today the Cubs own most of them.*

LEFT *The park was so close to the Polk Street L Station that ladies in their finery could easily walk to the train. After the move from West Side Park to West Side Grounds many fans continued to refer to their new ballpark as West Side Park.*

WAY OUT IN LEFT FIELD

Beyond the left field walls of the West Side Grounds was a facility for mentally ill patients that formed part of Cook County Hospital. It is claimed that this hospital is the origin for the phrase "way out in left field" as an expression meaning "crazy." There is a group called the "Way Out in Left Field Society" that maintains that patients in the facility could be heard from the ballpark yelling and cheering on the players.

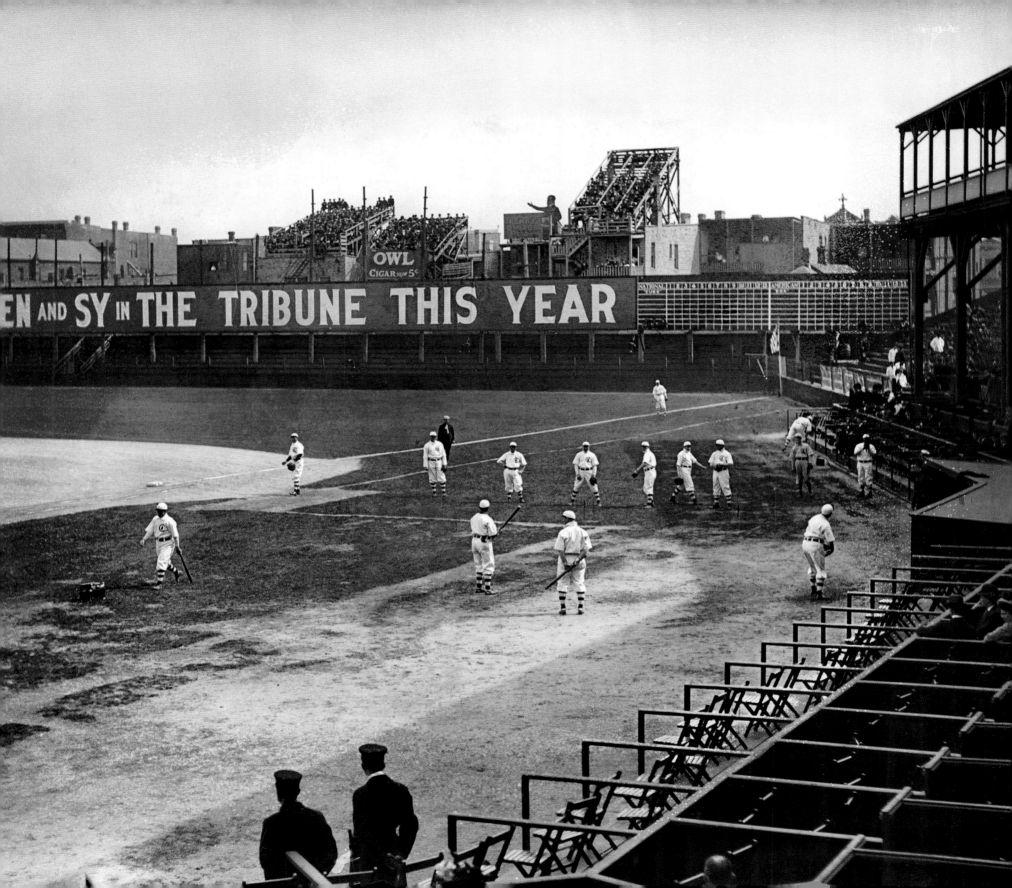

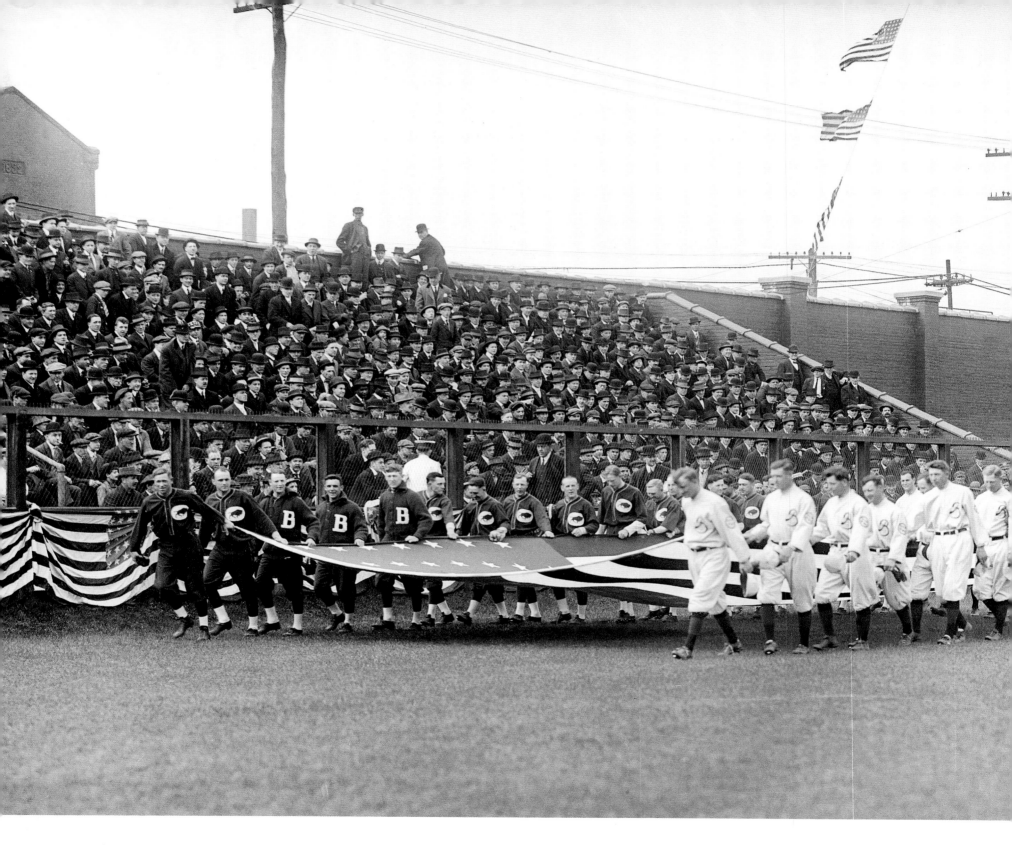

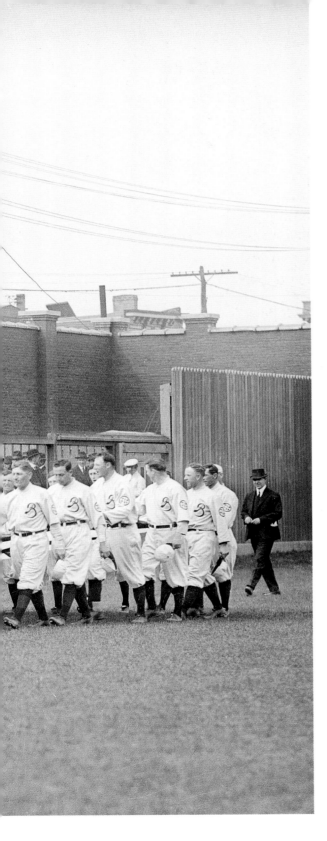

Washington Park, Brooklyn

SURVIVED BY ITS WALL IN 1926

Bounded by Third and Fifth streets, Fourth and Fifth avenues, Washington Park in Brooklyn was used for ice skating and referred to as Washington Pond or Litchfield's Pond. The park had been used in the 1860s by amateur teams such as the Albions and Ironsides, and news reporters were excited about the short-lived fad of "baseball on ice" there.

The Brooklyn Baseball Club marked it as their preferred ballfield in 1883. The minor league interstate Brooklyn club settled into their new field taking the name the Atlantics, but in the 1888 season they were known as the Bridegrooms since several of the team members were recently married. The field featured a double-decked wooden grandstand that burned in 1889. A replacement stand brought seating to an extra 3,000.

The Brooklyn team joined the National League in 1890 and moved away in 1892 to Eastern Park. Nearby streetcar tracks inspired a new name: the Trolley Dodgers, eventually just the Dodgers. Washington Park turned over to cycle races and circuses until influential Dodgers owner Charles Ebbets brought the team back in 1898 to a new

Washington Park built with a capacity of 18,800. It was on the other side of Fourth Avenue from the original Bridegrooms park. The Dodgers won two National League pennants in 1899 and 1900 here, before attendance grew so large that Ebbets had to move the team again. It didn't help that tenements built nearby provided a great free view of the park. The Dodgers lost their last home game here to the New York Giants on October 5, 1912.

The field was used next by the Brooklyn Tip-Tops —the only major league team named to advertise bread—as members of the Federal League. Grand improvements were made to Washington Park including a 13-foot-high cement wall encircling the park and light standards for night games that weren't ever used by the Tip-Tops as the Federal League folded in 1915. The improvements were demolished in 1926, all except for a two-block long portion of the clubhouse wall, still standing along Third Avenue, and serving as the façade of a Con Edison corporate yard. Some believe this wall to be the oldest standing baseball-related structure in the United States.

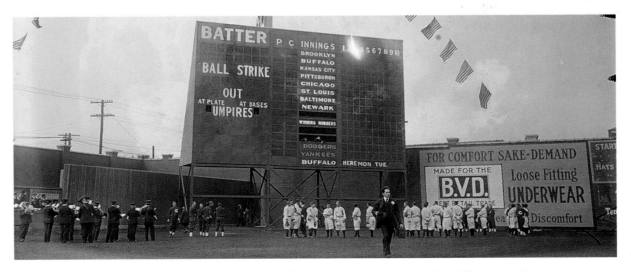

LEFT AND ABOVE *The Buffalo Buffeds and the Brooklyn Tip-Tops share flag-raising duties at Washington Park on opening day in 1914.*

Ketchikan Harbor Ballpark, Alaska

DREDGED AWAY 1935

When the federal census was taken in 1900, the newly incorporated town of Ketchikan, Alaska, recorded 460 souls. These hardy people made their living from mining, fishing and forestry. Yet, a reference to baseball appeared in the *Ketchikan Mining Journal* just three years later. The story on May 3, 1903, reported that a plat had been filed in the records office for a new, official place to play the game.

In the early part of the twentieth century there wasn't much else to pass leisurely time in small Alaskan towns other than the game of baseball. The little town where the mouth of Ketchikan Creek meets the Tongass Narrows was no exception. As long as the tide was out, of course. High tide coupled with a brisk southeast wind would find the ballpark under more than ten feet of water. Because it also doubled as the harbor.

Players might have to move a beached skiff or anything the incoming tide had washed up before play could get under way. Also, the return of the tide might trump extra innings. All that aside, the residents of Ketchikan had a ballpark on the only stretch of level land large enough for a baseball diamond. Not surprisingly, games took place according to the tide table, and at high tide, home plate was well underwater.

If a player hit the ball to left field, and the left fielder didn't catch it, the ball likely plopped down in the sandy mud. Hit to right, and the ball could get lost among piles of lumber, piles of sawdust or other wooden items from the adjoining sawmill. Special rules applied then: balls lost in the yard went for two bases; those landing on top of the mill's dry kiln and any ball deemed too far out to sea as the tide rolled in were considered home runs.

The story goes that one of the best outfielders in town was none other than Ketchikan resident Harriet Hunt's dog Toby. The little black dog could be trusted to swim out farther than any human ballplayer in pursuit of the long ball.

Teams from all over the state came to Ketchikan, by a technicality the first incorporated city in Alaska, to compete on the town's tidal ballpark which, by 1909, boasted grandstand seating. Teams from

Juneau, Prince Rupert and Metlakatla visited, sometimes with Ketchikan residents footing travel expenses for the visiting team.

Eventually word spread about the little town in Alaska with its talented baseball team. Navy and merchant ships made special efforts to visit Ketchikan in order to compete with the town's players or eye the impressive display of talent put on by the team's pitchers and catchers practicing on the downtown docks.

Then in 1920, the *Ketchikan Chronicle* reported a new dry land ballpark was under construction "Ballpark Will Be Ready by First of April 1921," the newspaper promised its readers. During the Depression, Ketchikan received federal funding to improve its harbor facilities. By 1935 the area that was the city's tidal ballpark had been dredged out of existence and is today known as Thomas Basin.

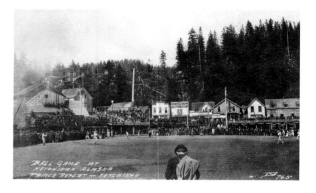

ABOVE *A match against local rivals, Price Rupert. Ketchikan won 1-0 in the 12th, before the water returned.*

OPPOSITE *A baseball tournament in the harbor circa 1910.*

BELOW *The presence of the harbor grandstand reveals that this photograph was taken after 1909.*

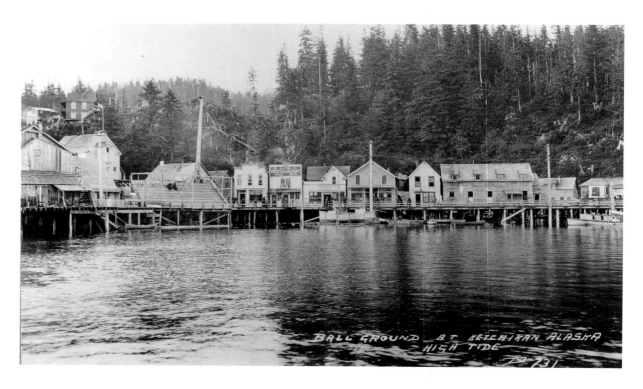

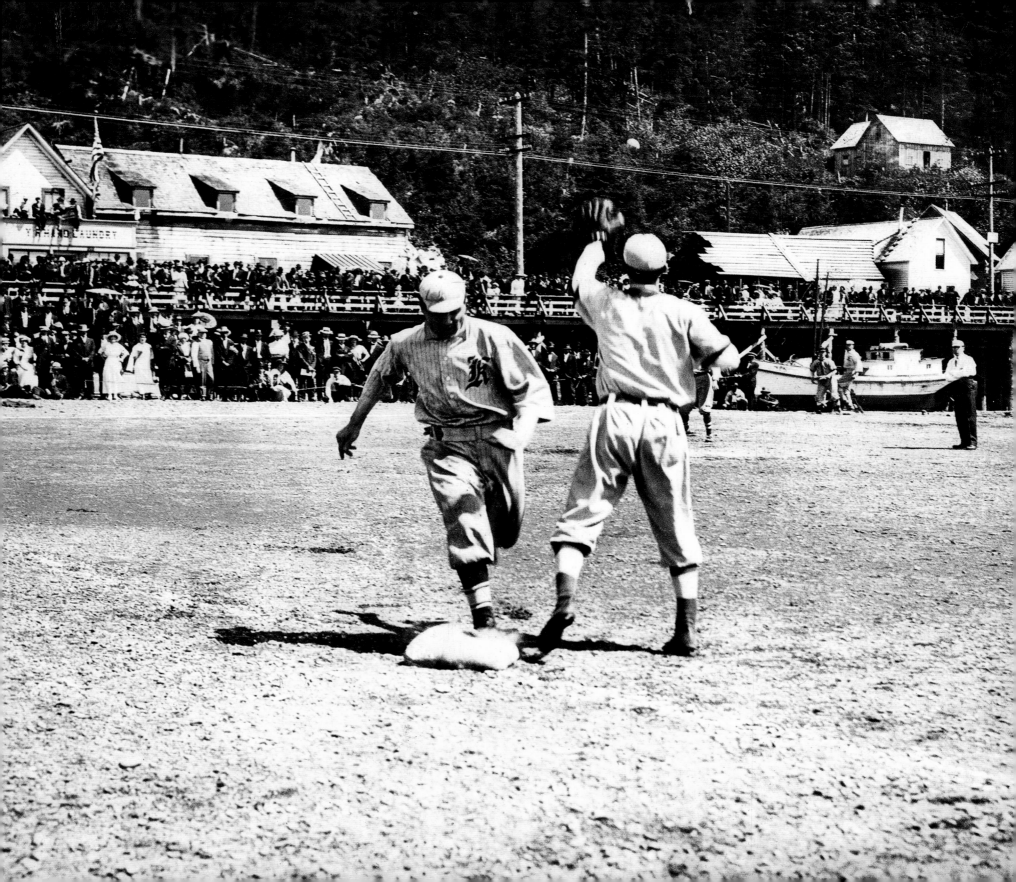

Ewing Field, San Francisco DEMOLISHED 1938

Pedestrians who stroll down Masonic Street, between Turk and Anza streets in San Francisco walk past a small street called Ewing Terrace. The latter street swings off Masonic to form a neat circle. Not many of those pedestrians know that this circular terrace stands where baseball fans gathered in 1914 to cheer the San Francisco Seals on to victory, nor do they know the unusual reason the ball team abandoned the park after just one year.

Every season from 1907 to 1930, the Pacific Coast League's San Francisco Seals played their home games at Recreation Park. However there was one exception, 1914.

James Calvin 'Cal' Ewing had become a major owner of the Seals and considered the Bay Area rivalry with the Oakland Oaks important to the success of the Pacific Coast League of which he was one of the organizers.

Seals fans didn't like Recreation Park's short fences and overcrowded bleachers, and they had to share the park with the team they called "the commuters," the Oaks. So Ewing decided to invest in the most modern of fire-proof ballparks to the tune of $100,000.

However the planned move to Ewing Field started to come apart even before the Seals moved in. In the off-season, while the park was under construction, Ewing sold his interest in the team to the Berry brothers, owners of the Los Angeles Angels. They suspected the weather would be a major drawback and didn't want the team to play there. After prolonged negotiations it was decided the Seals would try Ewing Field for the 1914 season as an experiment. The season opened on May 16th against Portland in front of an overflow crowd, but it wasn't long until players and fans were complaining about the weather.

San Francisco's famous fog frequently settled over the field right at game time. Players joked that they had to send messengers to inform the outfielders that an inning had ended.

The fog was not Ewing Field's only nemesis. More free "seats" were available at nearby Lone Mountain. Fans could simply climb to the mountain top and take in a free game, which they had to do on opening day as the ballpark was filled to capacity.

And if it wasn't fog wrecking a game, the wind didn't help. When the Seals lost 3-0 to their great rivals Oakland, the worst team in the league, the *San Francisco Chronicle* put the blame on the wind: "Perhaps it was the cold wind that whistled around Lone Mountain… that made the spectators shiver and long drives which would be homers at Recreation Park inconsequential."

In 1915, the very next year, the team moved back to Recreation Park. The Berry brothers achieved what Cal Ewing couldn't, they bought Recreation Park and were able to improve it themselves. The move made Ewing Field a white elephant, the only baseball park ever to close its doors to baseball because of fog.

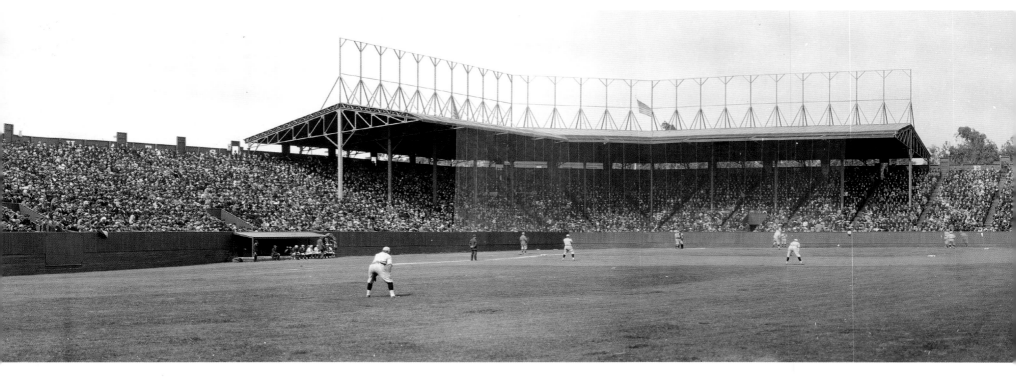

The park was not finished, though, and went on to host local amateur games, a circus, the Navy, who played the bizarre game (never to take off) of Pushball. An open-air performance of the opera *Aida* in 1916 was canceled not because of fog, but torrential rain.

Then, in 1923, it got a major boost when the grandstand was enlarged to hold 26,000 college football fans. A sold-out crowd watched St. Mary's and Santa Clara play the first major football game at Ewing. The weather couldn't postpone a football game.

On June 5, 1926, "fireproof" Ewing Field caught fire. A strong wind sent embers from Ewing Field across the city. Those embers ignited some 100 separate blazes. After the fire, Ewing stood forsaken until June 1938 when the Heyman Brothers Construction Company purchased the land from the San Francisco Archdiocese. Their workers began demolishing the ballpark on October 31, 1938. Almost nine months later on July 29, 1939, the company advertised that interested buyers could come to "Ewing Terrace" to see the homes for sale for $7,950 and up.

ABOVE *The Navy staged "Pushball" in the park, one of the many attractions that included football, circuses and grand opera, all organized to pay the rent after baseball left abruptly in 1914.*

BELOW *Ewing Field on opening day 1914.*

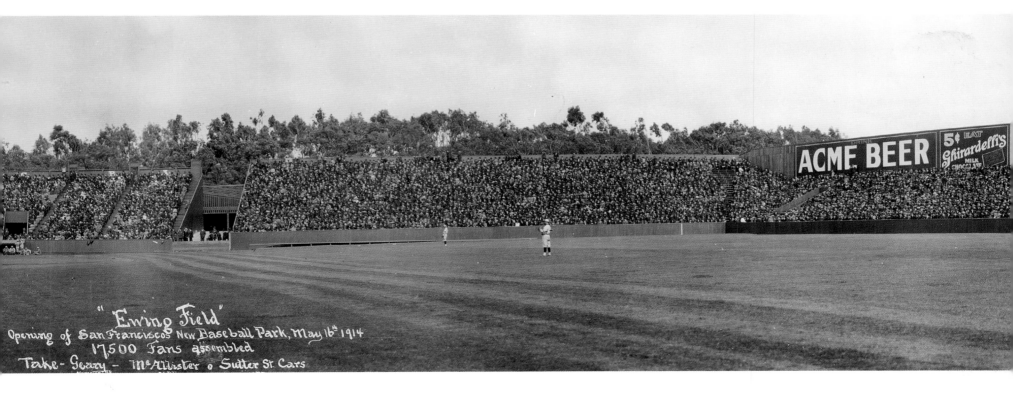

"Ewing Field"
Opening of San Francisco's New Baseball Park, May 16th 1914
17,500 Fans assembled
Take - Geary - McAllister & Sutter St. Cars

Greenlee Field, Pittsburgh **RAZED 1938**

Perhaps more than any other city in America, Pittsburgh has a long and rich history of Negro League baseball. The Pittsburgh Keystones, an early team in the Negro National League, played at Ammon Field in the Hill District.

The most famous team was the Homestead Grays, who started as a team of steelworkers in the nearby town of Homestead, and evolved into the most powerful team in the Negro Leagues. Led by Josh Gibson and Buck Leonard, the Grays, who often played at Forbes Field when the Pirates were out of town, won nine consecutive pennants in the 1930s and 1940s.

On May 7, 1932, an unusual doubleheader at Forbes featured the Pirates and Phillies in the first game and a Negro League contest between the Grays and Philadelphia Hilldale Giants in the second.

In 1932, a new Negro League franchise, the Pittsburgh Crawfords, was founded by the African-American gangster Gus Greenlee. The team was named after the Crawford Grill, a famous Greenlee-owned nightspot that featured live entertainment by the likes of Billie Holiday and John Coltrane.

Greenlee mercilessly raided other teams for their best players, building a conglomeration of superstars that included future Hall of Famers Josh Gibson, Cool Papa Bell, Satchel Paige, Oscar Charleston, and Judy Johnson. In 1933, Greenlee built a stadium, Greenlee Field, only a few blocks away from the Crawford Grill. It was the only black-owned stadium in baseball, and the Crawfords played there until 1938, when financial losses forced Greenlee to disband the team and tear down the ballpark.

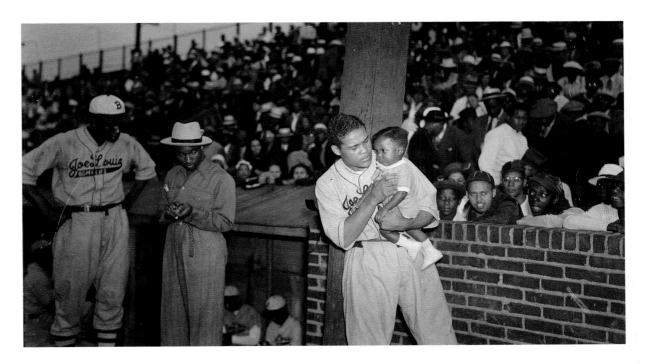

ABOVE RIGHT *Boxer Joe Louis holding his baby cousin Joe Louis Barrow, with Joe Louis Bombers softball teammates on Greenlee Field in September 1938.*

RIGHT *The Pittsburgh Crawfords pose with their team bus in front of Greenlee Field. Notable players include Oscar Charleston (far left), Cool Papa Bell (12th from left), and Josh Gibson (15th from left).*

OPPOSITE *Greenlee Field in action. On July 16, 1932, Satchel Paige pitched a no-hitter against the New York Black Yankees and also got two hits himself as the Crawfords won 6-0.*

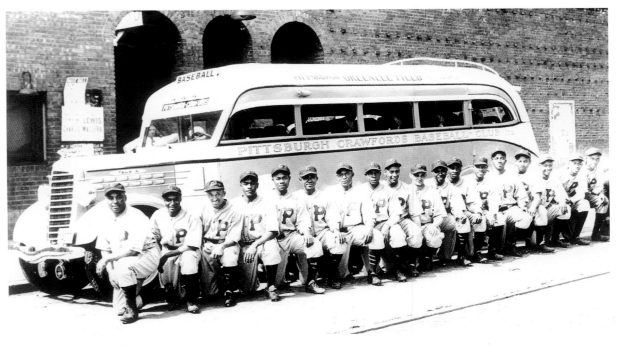

South Side Park, Chicago BURNED 1940

There were three baseball parks on the South Side before Comiskey (now U.S. Cellular Field). The first was at an uncertain location near 47th and Pershing. It housed the first Chicago baseball team, the Chicago Browns, a member of the original Union League, in 1884. The park only lasted one year. The second was at 35th and Wentworth. The Chicago team from the Players League was housed here in 1890. Charles Comiskey, later owner of the White Sox, was a member of this team. From 1891–93, the National League club that would become the Chicago Cubs called the South Side Park home.

The South Side Park is the best known of the three. It sat on the north side of Pershing Road near South Wentworth Avenue. During the 1893 Columbian Exposition, it was home to the Chicago Wanderers, a popular cricket team. While the cricket team played here, it was only a field, but in 1900, a grandstand was built to accommodate fans. It held only 15,000 spectators, a size that the new baseball teams would outgrow quickly. That year, the new American League Chicago White Sox moved into the ballpark and called it home until 1910.

The park was known as a "pitcher's field" because of the deep outfield. Center field and the corners were far away from home plate, earning the

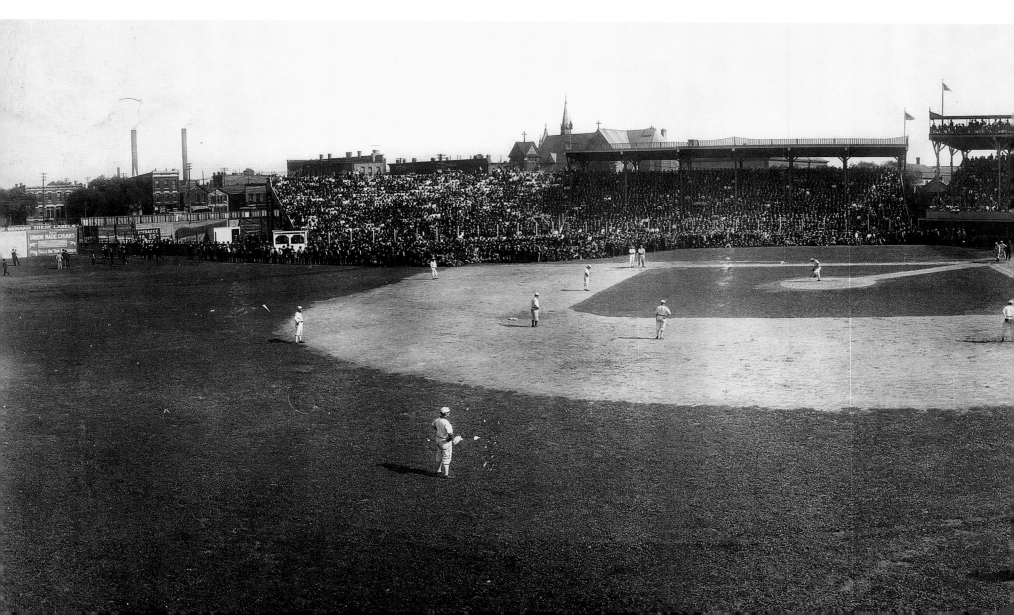

White Sox the nickname, "The Hitless Wonders." For two consecutive seasons, no home runs were hit by the home team at South Side. The only cross-town World Series between the Cubs and the Sox was played here in 1906.

In 1909, the grandstands burned to the ground. They were rebuilt immediately and lasted for another 31 years—considered a long time for wooden bleachers—but the tenure of the White Sox at South Side did not last as long, and in 1910, the White Sox left the South Side Park for Comiskey, mostly due to the limited seating. Baseball was the rage in the early 1900s and owner Charles Comiskey wanted more room for the fans. In 1911,

South Side became the home stadium of the Chicago American Giants of the Negro League. It was renamed Schorling's Park for American Giants owner Rube Foster's partner, a saloon owner named John Schorling. Foster was the manager as well as the part-owner of the American Giants, and managed the team from a box seat in the stands rather than sitting on the bench.

The American Giants won six pennants while at the South Side Park. The team was so dominant in Negro League baseball that in one season they won 123 games, and lost only six—no baseball team has ever achieved this level of dominance. They would continue to be the top team in the Negro League

into the 1920s, using the defensive advantage of South Side Park by emphasizing fielding, pitching and speed. They played in Schorling's Park until 1940, when a Christmas Day fire destroyed the park.

BELOW *The deep outfields of South Side Park made it known as a "pitcher's ballpark."*

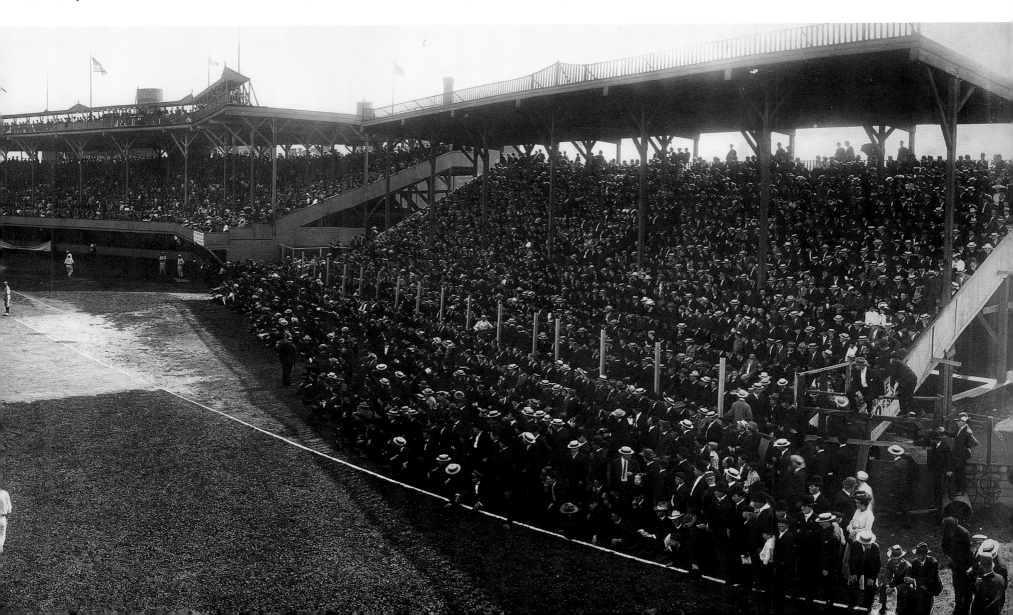

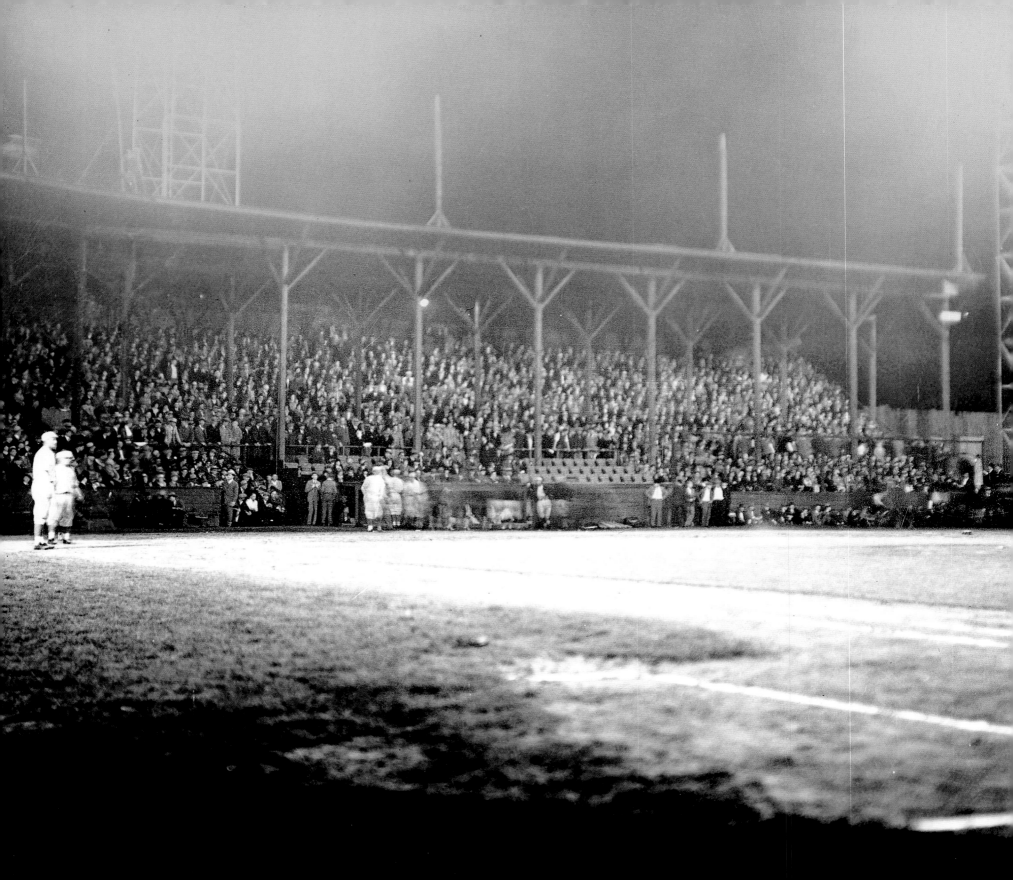

Holcomb Park, Des Moines SOLD FOR SCRAP 1945

In Des Moines, Iowa, the high school athletes still play baseball at the North High School's Grubb Community Stadium at Holcomb and Sixth avenues. This ballfield dates back to 1914, when manager Frank Isbell managed the Des Moines Boosters. The Boosters played their games in the Western League, and the park also bore the name Western League Park.

The Boosters and the Des Moines Demons, a Western League minor league team that played ball here as well, had much success at Holcomb. Throughout the 1920s players broke records at the park and major league teams scooped them up. The Boosters' Shags Horan with his .411 batting average, highest in city history, went to play for the New York Yankees in 1924. Pitcher Pat Malone, a future Chicago Cubs star, would go 28-13 in 1926, setting the all-time-best record for a pitcher at Holcomb.

The park hosted six Western League championship teams in its 24-year history and produced five All-Star players. These included Lefty O'Doul, who went on to star for the New York Giants and manage the Pacific Coast League's San Francisco Seals; Mike Kreevich, who played for the Chicago Cubs and Mace Brown, the first relief pitcher ever to make the Major League Baseball's All-Star team.

Holcomb Park's most significant moment came on May 2, 1930, when the first professional night game under permanent lights was played. With attendances in a slump due to the Depression, leagues looked to the installation of lighting and night games to bring the crowds back. Demons' owner Lee Keyser led the effort. Some say he saved baseball.

Keyser invested some $22,000 in lighting Holcomb Park. That figure well exceeded the initial price tag for the park. With help from General Electric, the park was well lit in time for that first night game against the Wichita Aviators on May 2, 1930. Commissioner Kenesaw Mountain Landis attended and the game was broadcast on national radio. Some 12,000 fans were in attendance on that historic night and they went home delighted: the home team Demons defeated the Wichita Aviators 13-6.

"One hundred forty-six projectors diffusing 53 million candle-power of mellow light and the amazing batting of Des Moines' nocturnal-eyed players made the opening night of the local baseball season a complete success Friday night," the *Des Moines Register* reported the next day.

According to the *Register*, "By that summer's end, the switch had flipped in 38 ballparks." These were mostly minor league ballparks, until the Cincinnati Reds hosted the first major league game under the lights on May 24, 1935. Chicago's Wrigley Field, built the same year as Holcomb Park, followed an opposite trajectory. The Cubs' long-time home field would be the last major league ballpark to install lighting for night games and resisted the glare until 1988.

In response to the lighting success, the Demons had a banner year in 1930. Stan Keyes posted the best record of any power hitter in Des Moines history that year with 27 doubles, 18 triples and 35 home runs—the most homers hit in any one year by a Des Moines player...until the following year when Keyes beat his own record, posting 38 home runs.

Despite starting a movement that changed the sport, the Demons team folded in 1937, leaving Des Moines without a professional team. When World War II broke out, Holcomb's light fixtures were moved to a munitions plant so workers could crank out bullets around the clock. The remaining wooden and steel stands were scrapped in 1945.

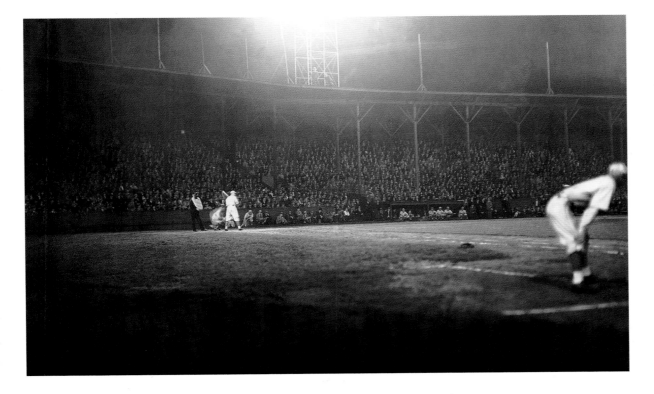

OPPOSITE AND LEFT *Holcomb Park in 1930. Although the first official minor league night game took place in Independence, Kansas, on April 28, 1930, the game was played under what some claim were temporary arc lights. Independence lost to the Muskogee Chiefs 13-3 but claimed their own place in baseball history. However it was Lee Keyser in Des Moines who first declared in 1929 his intention to play regular night baseball.*

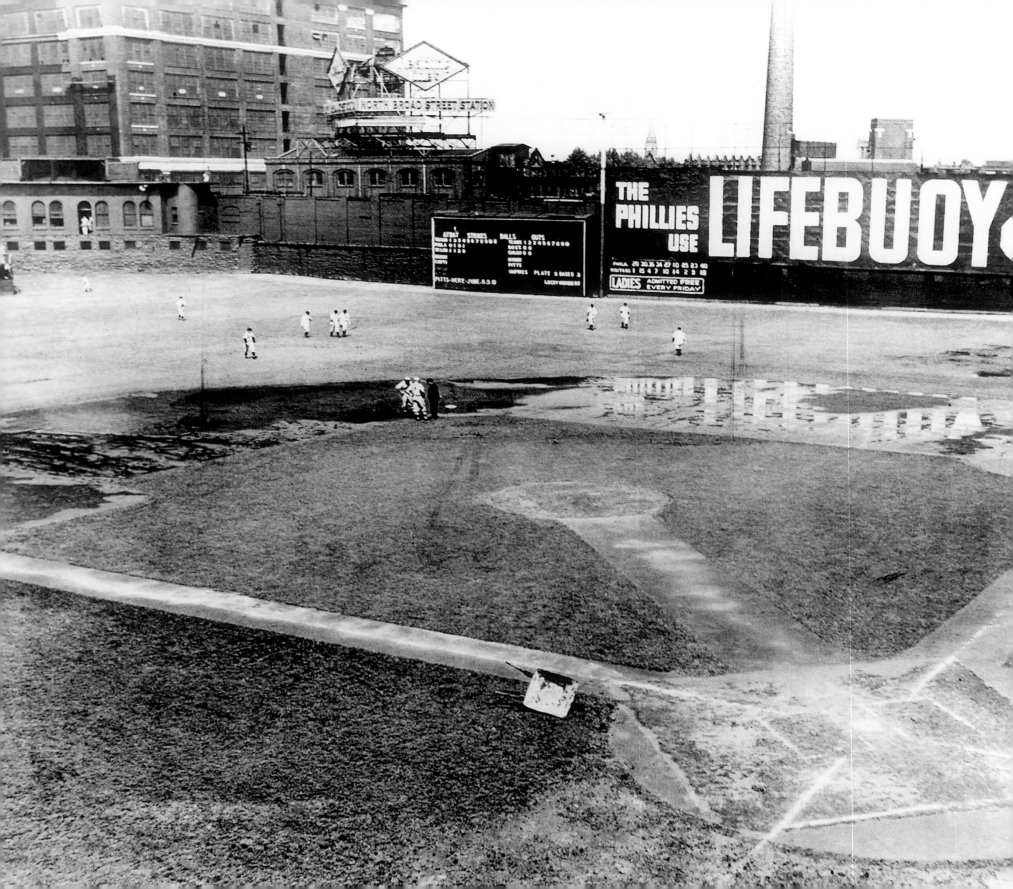

Baker Bowl, Philadelphia DEMOLISHED 1950

Philadelphia has made some significant contributions to the legacy of American baseball. The Philadelphia Phillies is one of the nation's oldest, as well as one of the National League's first teams. Its Philadelphia Athletics was a charter member of the American League. In the first decades of baseball, the city's Reach Sporting Goods store outfitted most of the professional teams. However, Philadelphia's lasting contribution to the sport is mud.

Seventy-five years ago, Lena Blackburne, a third base coach for the Athletics, came up with a solution to an umpire's bitter complaints about the quality of the baseballs. Blackburne discovered just the right muck at the bottom of the Delaware River near Rancocas Creek. Even in an age of electronics and high-tech stadiums, Lena Blackburne Baseball Rubbing Mud is still scooped from that mud hole.

The Philadelphia Phillies have often required fan patience in the face of adversity—beginning with the Baker Bowl, first home of the Phillies, and its troubled owner William F. Baker. The original 1887 wooden stadium went up in flames in 1894, and was replaced the next year by a brick and steel structure with experimental cantilevered upper decks to improve sightlines. Eight years later, the third base stands collapsed, killing 12 fans and severely wounding scores more.

Baker often found himself in desperate financial straits, reputedly from crime syndicate debts. At some point he even sold off the stadium's office furniture. During the 1929 season the star slugger for the Phillies, Chuck Klein, had begun to outdistance Babe Ruth in home runs. Afraid that Klein would demand a more lucrative contract, Baker ordered the 40-foot, right-field fence raised by an additional 20 feet. "The home run is too cheap so we have to do something about it," Baker complained. That 60-foot high fence was later covered with a huge billboard boasting "The Phillies use LIFEBUOY." Their lackluster seasons prompted the fans to insist that, despite the soap, the team still "stunk."

The Baker Bowl hosted many memorable events, including Babe Ruth's last professional game on May 30, 1935. Negro League games took place in the stadium used by local team the Hilldale Athletic Club.

The Phillies played their final game at the Baker Bowl on June 30, 1938, before moving to Shibe Park. They lost. The stadium sat vacant for a decade before it was demolished in 1950.

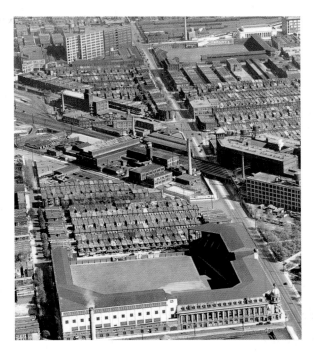

OPPOSITE *The right fence at Baker Bowl was just 280 feet from home plate, but it made a great advertising hoarding.*

BELOW *Fans in the bleachers wait for the first game against the Red Sox in the 1915 World Series at Baker Bowl. It was the only game that the Phillies would win.*

ABOVE *Shibe Park with its distinctive cupola at bottom right was a short stroll from the Baker Bowl, top right.*

BELOW *W. F. Baker and his wife, preparing to throw the ceremonial first pitch in 1915.*

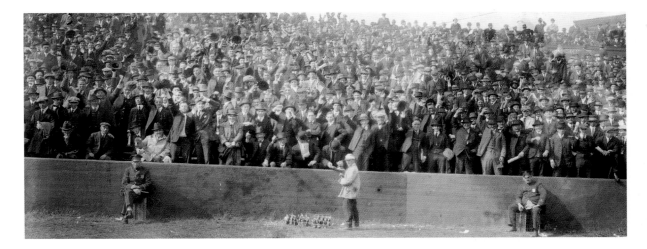

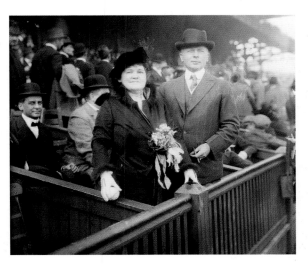

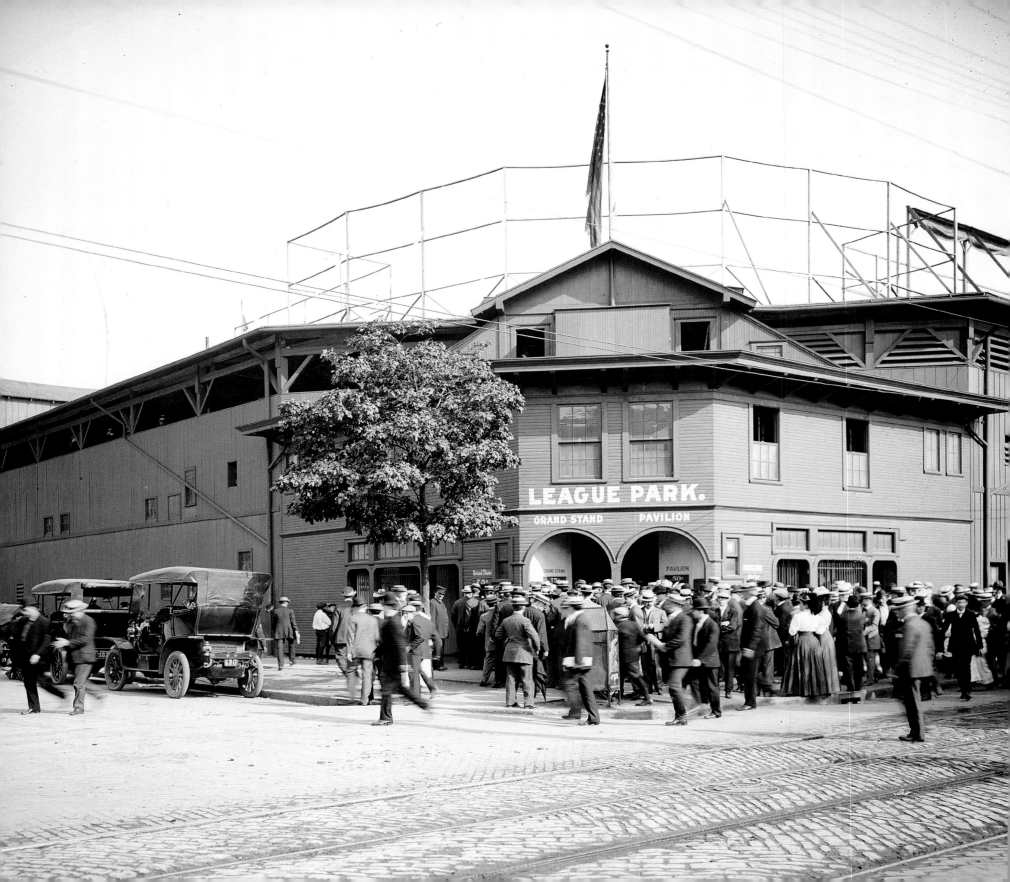

League Park, Cleveland DEMOLISHED 1951

Various cities used the name "League Park" during the early twentieth Century. In Cleveland, League Park was the home of the Cleveland Spiders and stood at Dunham Street, later renamed East 66th Street, and Lexington Avenue. It rose up after lightning struck, splintered and burned the Spiders' grandstand at their stadium at East 37th Street and Payne Avenue in 1890.

After the Spiders posted a dismal 20-134 record in 1899, the team folded. A minor league team, the Cleveland Lake Shores, stepped in and took their place. In 1901, as charter members of the new American League, the Lake Shores took on a new name, one that lasts until today, the Indians.

By 1910, the wooden facilities at League Park had seen better days, and a new concrete-and-steel stadium was constructed on the site with more than double the seating at 21,414. The 40-foot-tall center-field wall was a home run killer. In comparison, Boston's Green Monster at Fenway Park measures three feet shorter, just 37 feet. In 1929, Babe Ruth became the first player to reach 500 career home runs at League Park, hitting the ball over the shorter right-field fence.

League Park played host to the 1920 World Series. The second game featured three historic plays, all in Cleveland's favor. This included the only unassisted triple play in World Series history by second baseman Bill "Wamby" Wambsganss; the first grand slam in World Series history (right fielder Elmer Smith crushed the ball over the right field fence and clear across Lexington Avenue); and the first home run by a pitcher (Jim Bagby) in a World Series game.

Other notable moments at League Park include New York Yankee Joe DiMaggio's final hit in his 56-game streak.

Starting in 1932, the Indians struggled to fill the nearly 79,000 seats in the brand-new Cleveland Municipal Stadium. The Depression stifled attendance and the team moved most games back to the more familiar setting of League Park. Weekend or special games would be played at the new Municipal Stadium (or Cleveland Stadium as it was also known). By 1940, the majority of games had been moved out of League Park, and by 1946 the Indians had left the park for good.

Once the Negro American League Cleveland Buckeyes folded in 1950, the park was no longer used as a regular venue for games and most of the park fell to the wrecking ball in 1951. The Cleveland Browns football team used the field at the park as a practice facility until nearly 1970.

The city of Cleveland approved a plan to redevelop the area that was League Park in 2011. Part of League Park's exterior 40-foot wall and the ticket office still stand and their restoration and improvement were essential parts of the plan. The ticket office became the Baseball Heritage Museum, and a new baseball diamond and other recreational facilities were opened in 2014.

OPPOSITE *From 1916 till 1927 League Park was known as Dunn Field after new owner "Sunny Jim" Dunn.*

BELOW LEFT *The ballpark had to fit in with the Cleveland street grid. The fence was only 290 feet down the right-field foul line.*

BELOW *League park around 1905.*

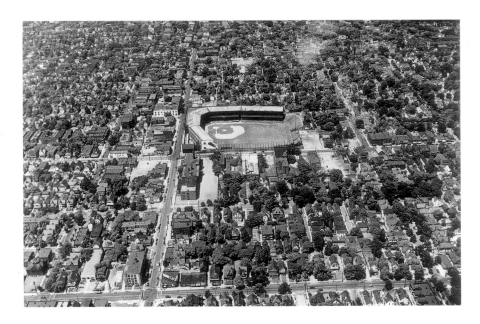

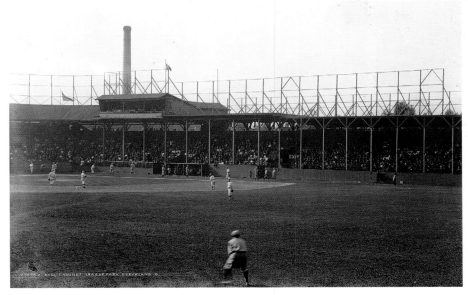

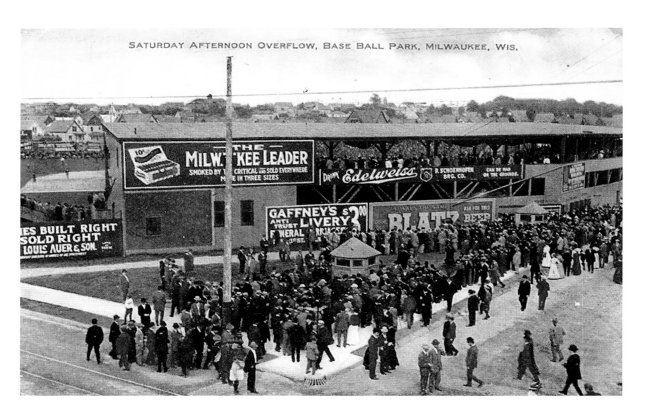

SATURDAY AFTERNOON OVERFLOW, BASE BALL PARK, MILWAUKEE, WIS.

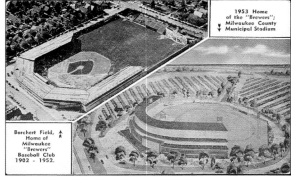

ABOVE *Borchert Field and its 1953 replacement County Stadium twinned on a postcard.*

LEFT *A postcard of Borchert Field from 1911.*

BELOW *Pitcher "Quiet" Glenn Elliott pictured sometime between 1948-1949 deep in center field. While playing for the Braves in 1947 Elliott made history as the pitcher who gave up Jackie Robinson's first major league hit.*

OPPOSITE *A stadium view from 1936.*

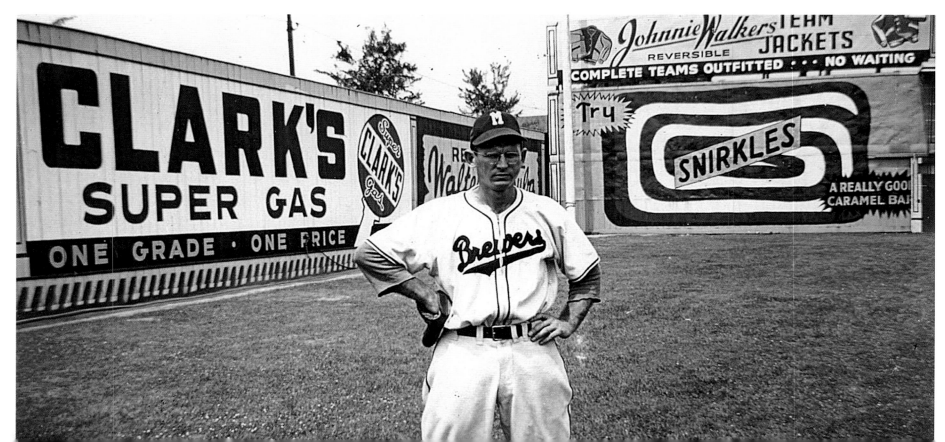

Athletic Park/Borchert Field, Milwaukee

RAZED 1953

Borchert Field in Milwaukee dates to 1888, when it was known as Athletic Park. It sat on a rectangular block shaped by West Burleigh, West Chambers and Seventh and Eighth streets. The awkward location forced fair-ball territory into a shape that resembled home plate, shortening both right and left fields. The grandstand boasted an ornate cupola and held about 3,500 people, part of a maximum capacity of 10,000 in the overall stadium.

Athletic Park was home to the Milwaukee Creams, a team that borrowed its name from the Cream Citys, a team that began playing baseball in Milwaukee in October 1865. (Milwaukee earned its moniker "Cream City" from the color of the local clay used to fashion cream-colored bricks.) During the Spanish-American War, the park would temporarily serve as a training facility for the National Guard.

By 1903, the Creams moved out and the Brewers moved in, causing the place to occasionally take the name Brewers Field. Two other teams called the park home. The Negro Leagues' Milwaukee Bears played ball here, as did and the All-American Girls Professional Baseball League's Milwaukee Chicks—both teams lasted just one season.

The Brewers renamed Athletic Park "Borchert Field" in 1928 to honor the team's former owner Otto Borchert. Sports writers then took to calling the place "Borchert's Orchard." Permanent lights were added in 1935.

Bill Veeck acquired the American Association AAA Brewers from 1941 to 1945 and described the place, as "an architectural monstrosity." In the 1940s, during Veeck's time at the park, "The P. T. Barnum of Baseball" offered some pretty special giveaways. Rather than plastic bobble-head dolls, Veeck gave out livestock, butter or fresh vegetables as an attraction for fans. He also refurbished the aging park after a storm tore the roof off the grandstand.

The storm struck on the evening of Thursday, June 15, 1944. Unfortunately the Brewers were in the midst of a game with the Columbus Brewers at the time. "Grandstand and roof ripped by wind and hailstorm," the *Milwaukee Sentinel* reported the next day. The chaos that ensued injured 35 fans, four critically.

By 1950, the park had become a disappointment. The old streetcar lines that once gave the park its convenience were now unpopular and the otherwise residential area limited automobile parking.

The major league came to Milwaukee in 1953 when the former Boston Braves pulled into town. Borchert Field was deemed too small for the new Milwaukee Braves and the city swiftly constructed County Stadium in time for the Braves' first season.

The Brewers left town for Toledo, Ohio, after their final game, September 21, 1952. This would be the last time a team named the Brewers played in Milwaukee until the arrival of the current major league team in 1970.

In late 1952, the lease with the Brewers expired. That mattered little; the team was moving south. Borchert Field was replaced with a playground until 1963 when Interstate 43 pushed through and completely covered the site of the former ballpark. Today around 150,000 drivers pass over the site daily. In 2008, the organization Yesterday's Negro League Baseball Players Foundation erected a plaque that describes the history of Borchert's Orchard on the northwest corner of Clinton Park, near the site of Borchert Field.

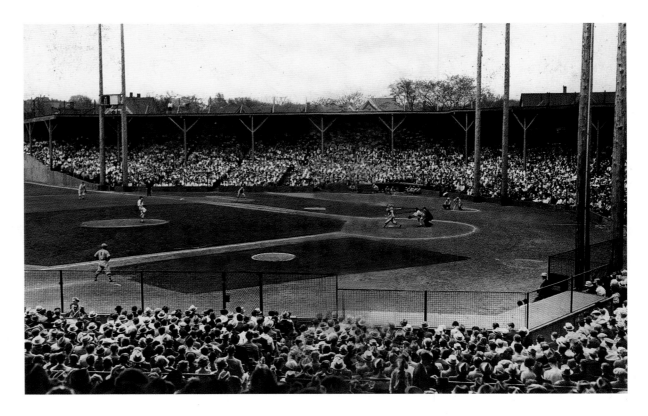

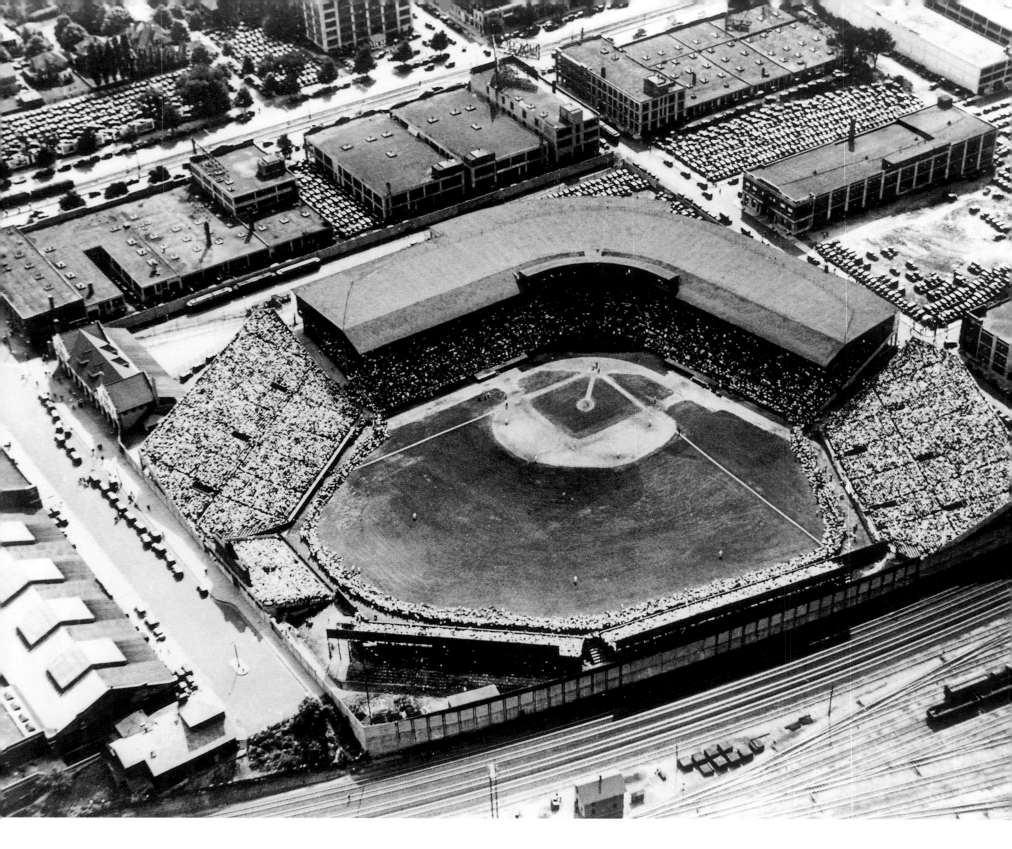

Braves Field, Boston RECONFIGURED 1955

Braves Field was a ballpark that formerly stood on Commonwealth Avenue between Babcock and Gaffney Streets in Boston. The stadium was home to the Boston Braves National League side from 1915 to 1952, until the team moved to Milwaukee, Wisconsin. For many years, ardent sports fans crossed the city on the Green Line trolleys to attend baseball games at "The Wigwam."

At the turn of the twentieth century the Allston Golf Club occupied the location of the future stadium. The area of Commonwealth Avenue from Governor's (now Kenmore) Square to Brighton Avenue was being developed with both the Fuller car dealership and the Commonwealth Armory.

By 1915, the golf club had disbanded and James Gaffney, a former alderman and now owner of the Boston Braves, decided to build a steel and concrete baseball stadium on the site and relocate his team from the South End Grounds in the South End. He said that he wanted to see the game played in a wide-open field conducive to allowing numerous inside-the-park home runs.

The stadium was designed by Osborn Engineering and built in what was then the outskirts of Boston, in a large rectangular plot with a seating capacity of 40,000 spectators. When it opened it was the biggest baseball park in the country. Interestingly, Gaffney had the grass on the infield brought from the Sound End Grounds ballpark to preserve the tradition from the old park to the new. Braves Field would be home to the National League Boston Braves for 37 years, although there was a short interruption when they took on a different identity.

In 1936, the Braves were renamed the Bees and Braves Field was renamed the National League Park, popularly called the Bee Hive. The Bees nickname only lasted five seasons before being changed back to the Braves in 1941.

With its capacity to hold more fans than Fenway Park, Braves Field was actually used by the Boston Red Sox in the 1915 and 1916 World Series, as evidenced by the program right. At the start of the lively ball era, fans became unhappy with owner Gaffney's constant tinkering with the ballpark— inner fences were built and regularly moved around. One time the orientation of the entire field was shifted in a clockwise direction, toward right field.

The Braves played their last game at Braves Field on September 21, 1952, losing to the Brooklyn Dodgers. Just weeks before the start of the 1953 season, then-owner of the Braves, Lou Perini, announced that the club was moving to Milwaukee and to their new stadium, County Stadium. Braves Field, with no further use for its scoreboard, sold it to the Kansas City Municipal Stadium. The ballpark was sold to Boston University which had begun to consolidate their campus along Commonwealth Avenue from the hodge-podge of buildings on Beacon Hill.

The old ballpark remained until 1955, when the university reconfigured the stands, demolishing all but the pavilion grandstand, which was retained as the core of a football, soccer, field hockey and track-and-field stadium. The new stadium was initially called Boston University Field but was later renamed Nickerson Field in honor of William E. Nickerson, a member of the Boston University Board of Trustees.

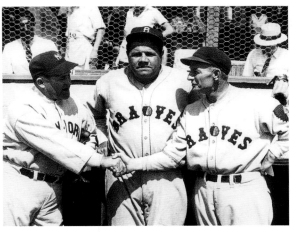

TOP *Sports fans walk from the Commonwealth Avenue trolley that dropped them at Gaffney Street, the side entrance to Braves Field.*

ABOVE *Babe Ruth, in Braves kit, stands between his past and present manager, Joe McCarthy of the Yankees at left, and Bill McKechnie of the Braves at right, Boston, 1935.*

OPPOSITE *Seen from the air, Braves Field was an irregular-planned baseball park on Commonwealth Avenue.*

Souvenir
SCORE BOOK
Price Ten Cents

RED SOX VS PHILADELPHIA
AMERICAN LEAGUE NATIONAL LEAGUE

Jos. J. Lannin Pres.
Boston Red Sox

Wm. F. Carrigan
Mgr. Boston Red Sox

Patrick J. Moran
Mgr. Phil. Nationals

W. F. Baker Pres.
Philadelphia Nationals

1915
WORLD'S SERIES
BRAVES FIELD · BOSTON, MASS.

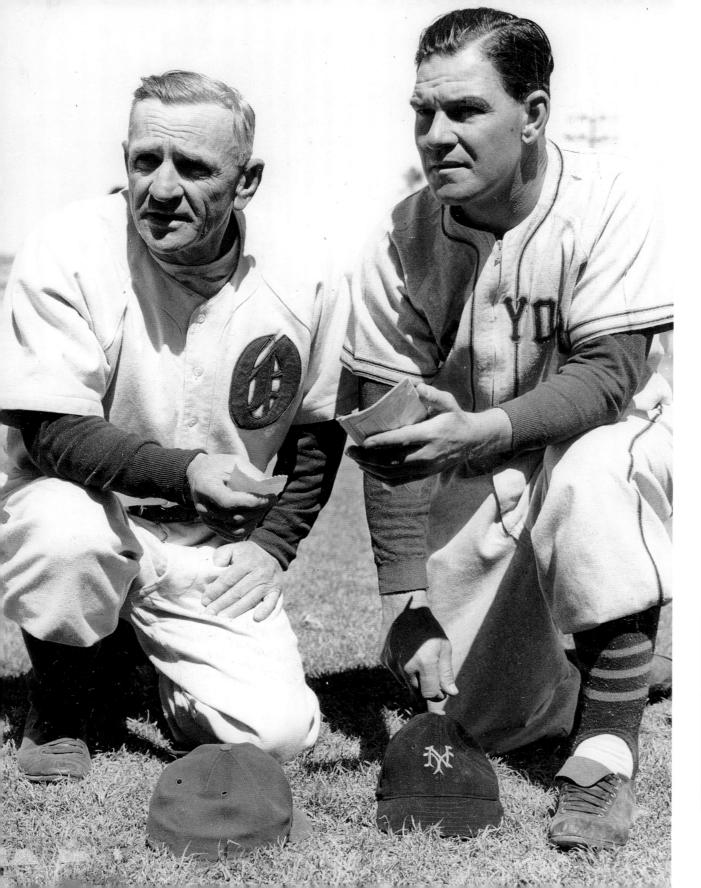

LEFT *Casey Stengel (left) was manager of the Oakland Oaks and led them to the Pacific Coast League championship in 1948. His success drew the attention of the New York Yankees and the following season he was back in New York. He is pictured here before a 1948 exhibition game with the New York Giants manager Mel Ott. Ott would go on to manage the Oaks for two seasons starting in 1951.*

ABOVE *Action from a 1941 Oakland Oaks game against the San Diego Padres.*

BELOW *The first player of African descent to play in organized baseball, Jimmy Claxton, made his debut at Oaks Park in 1916.*

OPPOSITE *Oaks Park circa 1925.*

Oaks Park, Emeryville FLATTENED 1957

Residents of the east side of San Francisco Bay who can remember them, often think of the Pacific Coast League's Oakland Oaks with a certain reverence. For the first half of the twentieth century, minor leagues east of the Mississippi were subservient to major league teams and no major league teams existed further west than St. Louis to overshadow the Pacific Coast League. As a result, Californians thought quite highly of their minor league, and from the 1880s until the 1950s, it was major enough for the Golden State.

No relation to the modern day Oakland Athletics, the Oaks were a team with plenty of promise when they broke ground on a new ballpark in Emeryville in 1913, right after winning their first Pacific Coast League pennant. Oaks Park was located near the intersection of Park and San Pablo avenues. It cost some $80,000 to build and accommodated around 10,000 fans.

The owners of the Oaks built the park on land that included the spot where Joseph Emery, the city's namesake, had lived from 1859 until his death in 1909. The Oaks broke ground for the ballpark on December 15, 1912. Construction got underway on February 1, 1913, and the ballpark was ready for the first pitch on March 15th.

The Oaks struggled in their first decade at the park, but in 1916, during an otherwise lackluster season, the team made history. New player Jimmy Claxton pitched both games of a double-header on May 28th. Jimmy's friend introduced him as a Native American from Canada, but his background also included ancestors of African descent. When his ethnicity was revealed days after his first start, the owners decided they couldn't allow him to continue playing. Claxton was fired from the Oaks, though not before the Zee-Nut Candy Company came by to snap photos of the team members for a baseball card set. Claxton's card, among the most sought after of all time, promotes the first black player to play in organized professional baseball in the twentieth century, and the last for another 30 years.

Located conveniently near a Key System streetcar stop and several popular bars and restaurants, Oaks Park enjoyed many well-attended games. The Oaks won the pennant in 1927, their first in the park. They'd eventually win two more, in 1948 under legendary coach Charles "Casey" Stengel, and in 1950 with the help of another future Yankee alumnus, Alfred "Billy" Martin.

The first lights at Oaks Park were turned on in 1931. Further additions took place at the ballpark in time for the 1944 season, adding 3,000 more seats, improving the lighting and repositioning the clubhouses behind home plate so the catcher's signals wouldn't be visible to the opposing dugout.

Crowds were falling off at the now-dilapidated Oaks Park in the 1950s and in 1955 they finished seventh in the eight-team league, with the worst attendance of all eight. The Oaks moved to Vancouver, Canada, in 1955 where they became the Vancouver Mounties. Since then they have changed cities six times, evolving into today's Albuquerque Isotopes. The team is still a member of the Pacific Coast AAA minor league.

Oaks Park was demolished in 1957 and the spot was used for a time as a bottling plant for Pepsi-Cola. In 2000, animation studio Pixar, famous for creating the films *Finding Nemo*, *Cars* and *Toy Story* built its extensive campus on the location of this lost ballpark and it's now a parking lot for the filmmaker.

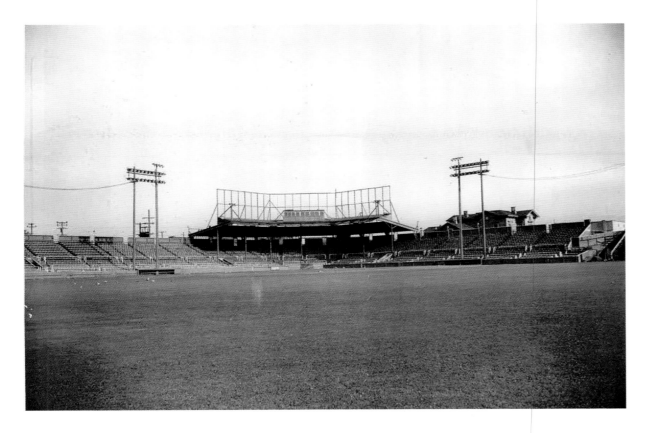

Gilmore Field, Hollywood RAZED 1958

Gilmore Field in Hollywood once entertained the glittering stars of stage and screen. At Gilmore Field you could find Marilyn Monroe and Mickey Rooney batting in a charity game. Players on resident team the Hollywood Stars had their fame overshadowed by their celebrity owners who included the likes of Gary Cooper, Barbara Stanwyck, Cecil B. DeMille, Bing Crosby, George Burns and Gracie Allen, to name but a few. Famed restauranteur Robert Cobb, owner of the Brown Derby restaurant and inventor of the Cobb Salad, brought the luminaries onboard as investors when he purchased the baseball team in 1938. Ten years later, in 1948, supporters of President Harry Truman's re-election could have seen future Republican President Ronald Reagan stand shoulder to shoulder with Truman (a democrat) during a rally at Gilmore Field.

But all glitz and glamor aside, Gilmore Field's story has roots in the oil industry. Oil baron Earl Gilmore started his career hauling five-gallon cans from his father's well near the La Brea Tar Pits to the few automobile owners living in Los Angeles around 1900. By the time the 1930s rolled around Earl ran one of the largest oil companies on the west coast.

Earl Gilmore was a born promoter. The Gilmore Oil Company he took over from his father benefitted from Earl's many ideas to advertise his product. This included sponsoring Gilmore-designed race cars and racing events, efforts to break the land-speed record, jingle-writing contests, circuses stocked with lions (the company mascot—from Gilmore's own lion farm), lion-shaped candies and comic books for the kids. And starting in 1934, sporting events.

Gilmore Field was the younger brother to Gilmore Stadium, which had been built nearby specifically for football and midget car racing. Both facilities were Earl Gilmore's idea: the stadium went up in 1934, the baseball field five years later in 1939. At Gilmore Stadium, the midget racers burned his oil, but spectators also took in prominently featured billboards promoting Gilmore's many oil-based products. The same was true of Gilmore Field.

Perhaps Earl Gilmore realized the earliest benefits of naming rights as his company name was mentioned daily on Hollywood's radio and television stations whenever they covered games. The 12,987-seat baseball field, located near where Beverly Boulevard meets Fairfax, hosted some experimental televised Hollywood Stars games in 1939. The team stopped action in the fifth inning to drag the infield, a move that drove up sales at the concession stands.

The field, of course, made appearances in Hollywood movies, including *The Stratton Story* (1949) with James Stewart and *711 Ocean Drive* (1950). For its final performance in 1958, Gilmore Field played the role of a lost ballpark in one episode of the television series *Rescue 8*. The show featured several scenes in a baseball stadium that was in the process of being demolished.

The Stars played in the park until 1957 when the relocation of the Brooklyn Dodgers to Los Angeles caused a west coast reorganization that sent the minor league Stars off to Salt Lake City. The move was conveniently timed with Columbia Broadcasting System (CBS) plans to expand its headquarters. The Stars' departure gave CBS a chance to purchase the park and turn it into a parking lot for Television City. A plaque on a wall at CBS Studio 46 marks Gilmore Field's former location

BELOW LEFT *Gilmore Field in the1940s.*

BELOW *Marilyn Monroe at the sixth Annual "Out of this World' Series at Gilmore Field in 1952. At the time she was promoting the film* Niagara.

OPPOSITE *The stadium as it looked on October 13, 1952.*

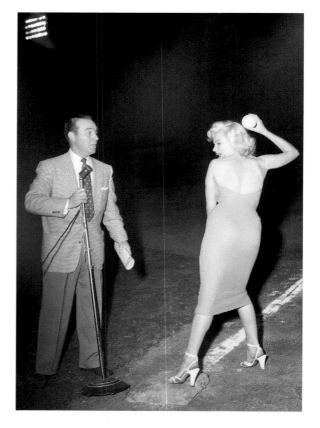

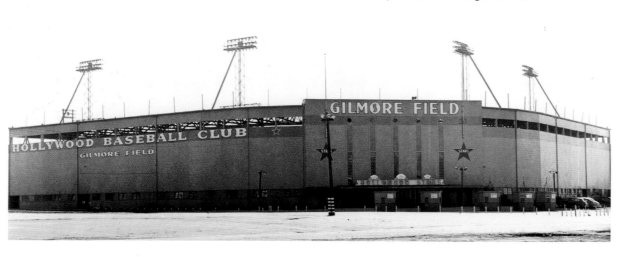

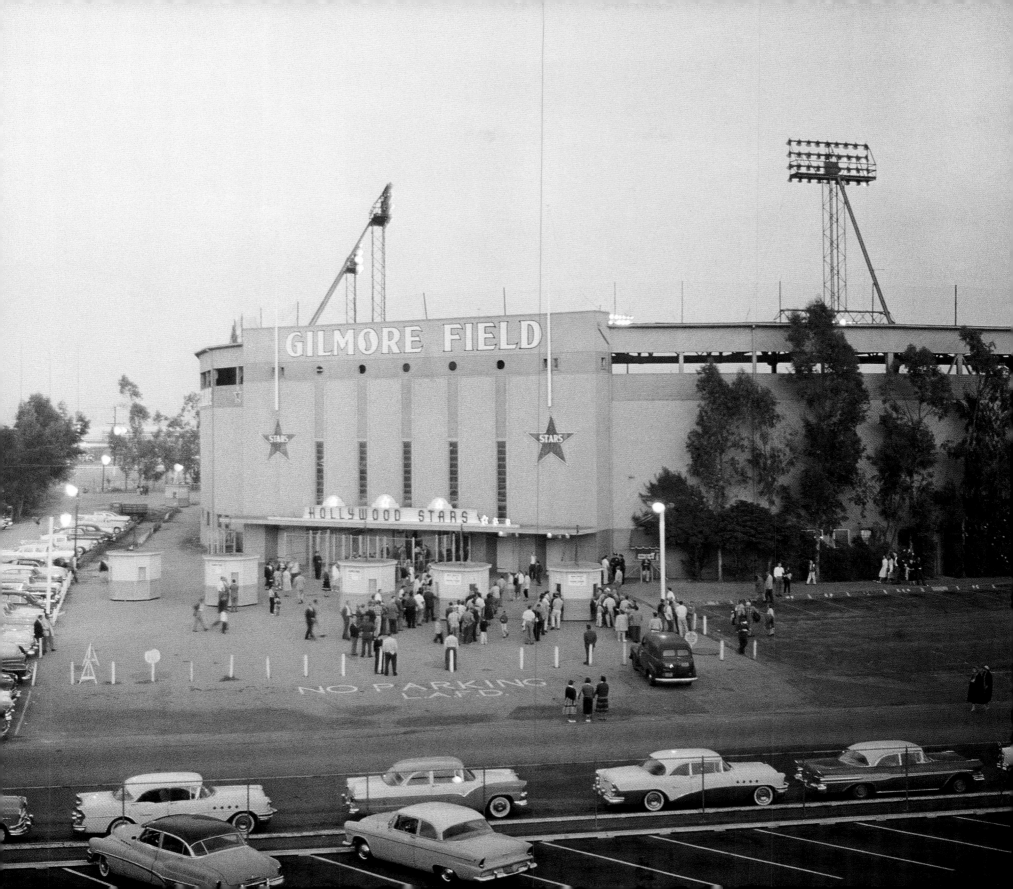

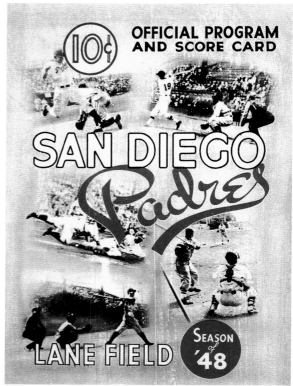

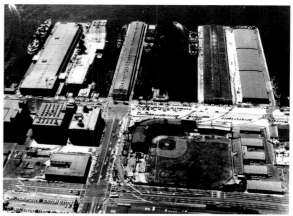

ABOVE *Like the San Francisco Giants' AT&T Park, Lane Field was the distance of a home run away from the Pacific.*

LEFT *A glittering career in front of him, the teenage baseball sensation Theodore "Ted" Williams poses at Lane Field in 1937 before his December move to the Red Sox.*

Lane Field, San Diego DEMOLISHED 1958

Lane Field served as home for the Pacific Coast League's San Diego Padres from 1936 to 1957. The ballpark bore manager Bill "Hardpan" Lane's name. Lane had earned his nickname for his apparent lack of sentimentality in dealing with players on his roster. He arrived in San Diego from Los Angeles with his Hollywood Stars baseball team after the Los Angeles Angels had doubled the rent for using Wrigley Field.

At first the Stars played their games on a field that had begun life nine years earlier as a nameless U.S. Navy athletic field. This field had football bleachers, as well as a track that enthusiasts used to race their motorcycles and automobiles. Lane pulled some strings and coaxed the city into making arrangements for the Works Progress Administration to rebuild the venue as a baseball park. It took the administration's workers just two months to complete the task.

Lane's new field seated 8,000 fans. The roofless stadium had no lights and lacked a backstop behind home plate. When they modified the field for baseball, WPA workers kept the Navy's Mediterranean-Revival style entrance. With a new venue to play ball came a new name for Lane's Stars, the Padres.

The new Padres played their first game at Lane Field on March 31, 1936. Lane added a roof over the stadium's seats in 1937. Attendance rose, not because of the new roof, but because of the appearance of a talented teenage outfielder. During their second season the Padres won the Pacific Coast League title. Ted "The Kid" Williams, just eighteen years old at the time, led the team to the championship.

Padres fans who sat in Lane Field's wooden bleachers loved watching the Padres, but did not enjoy the splinters they often took home with them. However they did manage to win the Pacific Coast League pennant in 1954 at Lane Field under the management of Lefty O'Doul, who had come to the helm two years earlier. It was only in the mid-1950s that a major error was discovered in the layout of the diamond at Lane Field. The distance from home plate to first base was 87 feet and not the regulation 90.

Not long after 1954, the championship team began to look for a place to build a new ballpark. Rickety old Lane Field had fallen into disrepair. The field's proximity to San Diego Bay and the salt water had wreaked havoc on the wooden stadium. Some blamed the termites rather than the elements for hastening the ballpark's demise.

The Padres left Lane Field after the 1957 season for Westgate Park in Mission Valley. The team played their first games there on April 28, 1958, a day-night double-header against the Phoenix Giants.

A company called Cruise Ship Parking purchased the Lane Field property and paved the place over for a parking lot to accommodate cruise ship passengers.

In 2003, the city placed a plaque commemorating Lane Field at the intersection of Broadway and Pacific Highway. Then on March 16, 2015, Lane Field Park was opened as a gift to the city from LFN Developers who had built a Marriott Hotel on land adjacent to the former parking lot. The park boasts illuminated markers where the bases, baselines and pitcher's mound stood from 1936 to 1958, a monument with a quote from Ted Williams, along with the outline of the batter's boxes.

Today's visitors to San Diego can imagine the site of the San Diego Padres' old ballpark by standing at a spot along the waterfront halfway between where the historic ships *Star of India* and the USS *Midway* are docked.

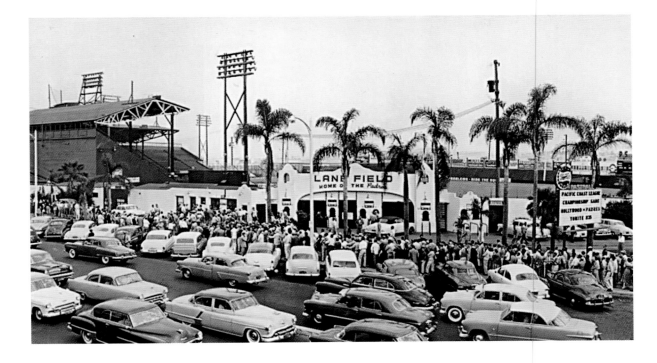

LEFT *Bill Lane took advantage of an underused Navy field and also got the WPA to build him a stadium.*

Seals Stadium, San Francisco DEMOLISHED 1959

Seals Stadium, home to the San Francisco Seals and, for a time, the San Francisco Mission Reds, opened on April 7, 1931, at 16th and Bryant streets. "Doc" Strub, the president of the Seals, invested $600,000 in the 16,000-seat stadium. The Reds left town in 1938, but the Seals played in the stadium until 1957.

In 1948, the Seals set a season record for attendance for a minor league team that stood for 40 years with some 670,000 fans in the seats. Such attendance records inspired struggling East Coast teams to move west. In 1953, the Boston Braves moved to Milwaukee. Two years later, the Philadelphia Athletics became the Kansas City Athletics. In 1957, the Brooklyn Dodgers decided to come west. They opened the 1958 season as the Los Angeles Dodgers. That same year, Major League Baseball's New York Giants pulled up stakes and became the San Francisco Giants.

The San Francisco Giants pushed the long-standing popular rivalry between the Seals and the Oakland Oaks into the background as a new Dodger-Giant rivalry formed almost overnight. The first Giants game played at Seals Stadium was on April 15, 1958. The Giants beat the Dodgers 8-0. Among the new San Francisco teammates was pioneer black baseball player Willie Mays. "The Say-Hey Kid," as he came to be known, earned nearly every hitting honor in baseball.

The Seals said goodbye to the Bay Area, departing for Phoenix the same year the Giants arrived. They played ball as the Giants' minor league affiliate until the 1998 expansion created the Arizona Diamondbacks. The D-backs took over the Seals affiliation and renamed them the Tucson Sidewinders. The Fresno Grizzlies are today's Giants' minor league affiliate.

Just two major league seasons were played at Seals Stadium before the stadium met the wrecking ball in November 1959. In 1960, the Giants began their 40-year stint playing ball at Candlestick Park. The Seals Stadium site is now the Potrero Center shopping mall. A plaque on the sidewalk at 16th and Bryant streets is all that remains today.

OPPOSITE *An aerial view of Seals Stadium in April 1958 as the recently moved Giants took on their new West Coast rivals, the Dodgers.*

BELOW LEFT *Traditional headgear at a traditional ballpark, but after two seasons the Giants would move to Candlestick Park.*

BELOW *Seals Stadium in the late 1950s.*

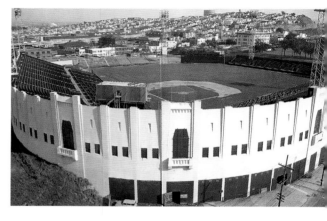

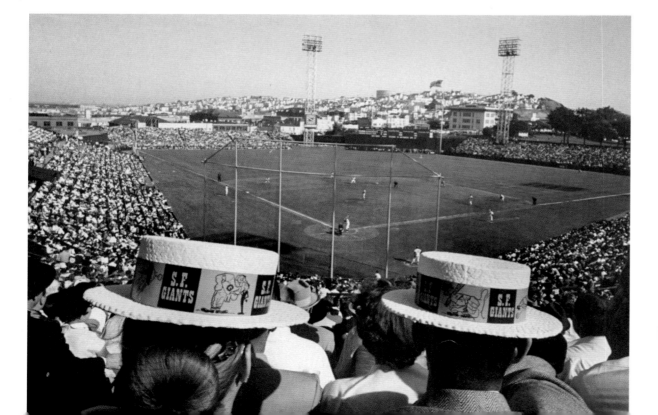

WHERE HAVE YOU GONE, JOE DIMAGGIO?

Prior to 1953, playing as a San Francisco Seal was a fairly lucrative job. No major league teams existed west of St. Louis and players in the Pacific Coast League (PCL) were at times paid higher salaries than major leaguers. Many players got their start with the Seals and moved on to major league stardom, perhaps the most notable being Joe DiMaggio. DiMaggio's brothers Dom and Vince were also Seals players, but it was Joe's 1933 61-game hitting streak that set fans afire. It wasn't until Oakland Oaks pitcher Ed Walsh, Jr. no-hit the Seals on July 26th that Joe's streak ended. From Seattle to San Diego the PCL teams drew impressive attendance totals, driving the Seals to expand the stadium in 1946 to 18,500 for big post-war crowds.

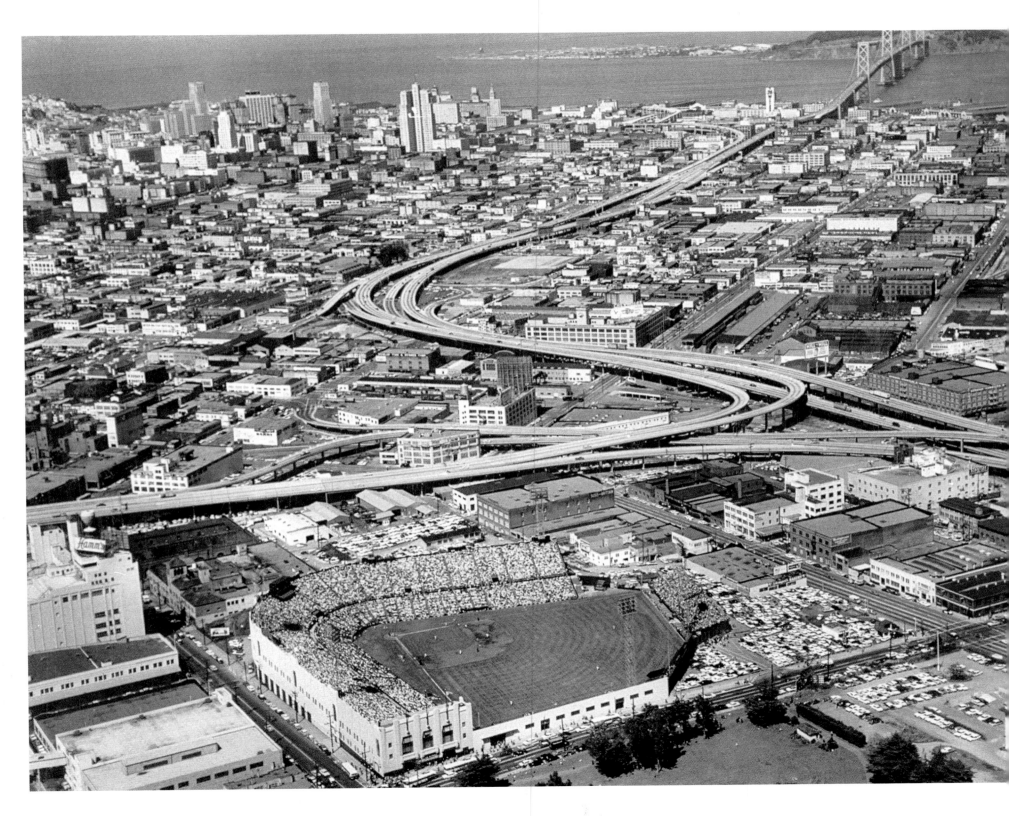

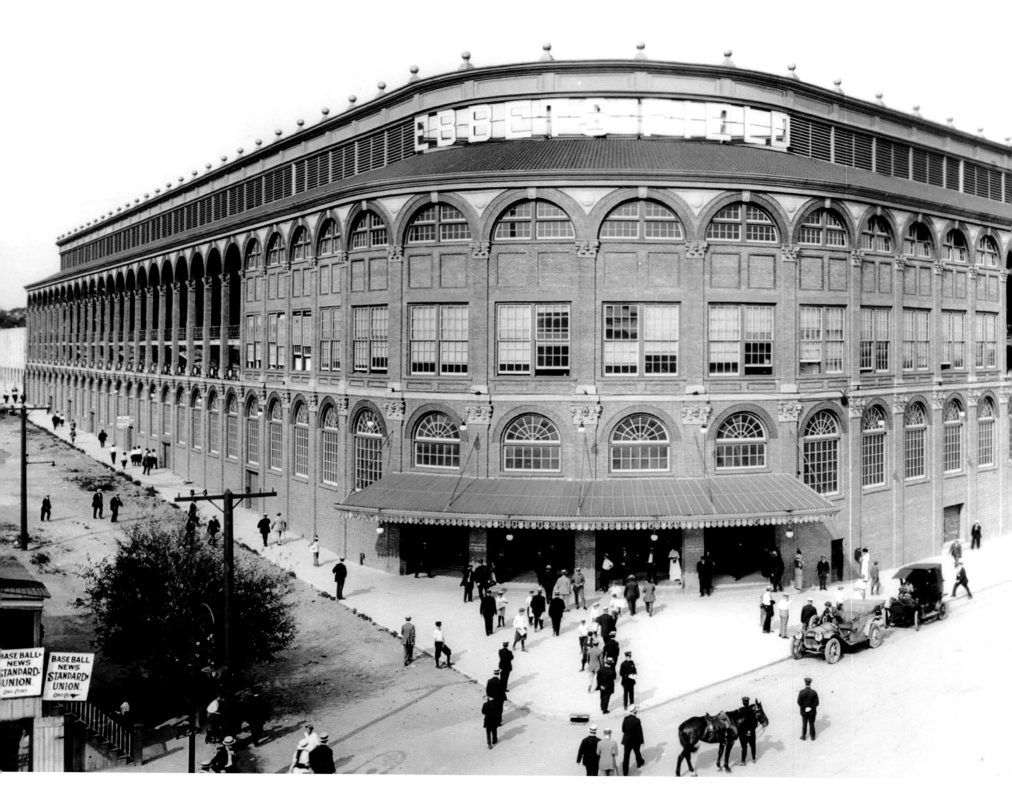

Ebbets Field, Brooklyn RAZED 1960

They were called the Grays, Bridegrooms, Fillies, Superbas, Robins, Nationals and Trolley Dodgers, but they were all forerunners for Brooklyn's most famous and beloved team, the Brooklyn Dodgers. The franchise began in 1883 when George Taylor, city editor of the *New York Herald*, joined with three other baseball fans, Charles Byrne, a real estate magnate, his brother-in-law Joseph Doyle, and the casino owner Ferdinand Abell, to form the team first known simply as the Brooklyns and soon after as the Brooklyn Grays. Abell put up most of the money, Byrne acquired the site for the team's ballpark, the first Washington Park, and Doyle became the team's first manager. They began in the Inter-State League, a minor league, and switched to the American Association, the predecessor to the American League. After winning the AL championship in 1889, the team jumped over to the National League and won the NL championship in 1890, the only major league team to win consecutive championships in two different leagues.

During the 1890s and early 1900s, the team was known by a series of nicknames, most of them bestowed by newspaper reporters in the free-wheeling style of sportswriters of the day. The name "Trolley Dodgers" came about when the team moved, in 1891, to Eastern Park, a site in East New York where fans had to cross the new electric trolley tracks laid that year. After seven of the players got married in the same year, the team was dubbed the "Bridegrooms." Managers came and went and their surnames inspired more team names. Under Dave Foutz (1893–96), it became "Foutz's Fillies" and under Ned Hanlon (1899–1905), who led the team to two consecutive NL pennant wins in 1899 and 1900, it became the "Superbas." Hanlon brought in several stars, including Brooklyn-born "Wee" Willie Keeler, known for his still-famous saying, "I hit 'em where they ain't." Manager Wilbert Robinson led

his "Brooklyn Robins" to the World Series of 1916 and 1920. Losing both times, the team also became famous for the fans' perennial cry, "Wait until next year."

Just as the Tip-Tops had been known as the Brooklyn Federals, the Dodgers were also called the Brooklyn Nationals because of their league membership. None of these names appeared on their jerseys, which at times were simply printed with the name "Brooklyn." The name "Brooklyn Dodgers" did not appear on the team's uniforms until 1932, long after the Dodgers were ensconced in their home at Ebbets Field. Back in 1898, Charles Ebbets had become the team's president and

ABOVE *On the opening day, April 5, 1913, Miss Genevieve Ebbets, youngest daughter of Charles Ebbets, throws the first ball.*

OPPOSITE *Ebbets Field in its opening year, 1913. The stadium capacity was 18,000, rising to 31,902 in 1952.*

LEFT *Fans queue for hot dogs outside Ebbets Field on October 6, 1920. A crowd of 22,559 saw the Brooklyn Robins, as they were known at the time, beat the Cleveland Indians 3-0 in the second game of the World Series.*

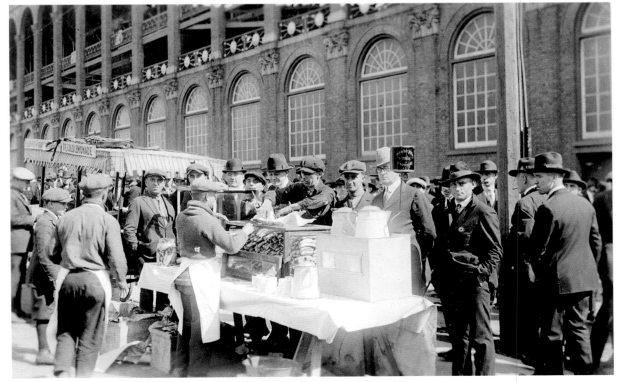

brought it back from East New York to Washington Park. The park had burned in 1889, but Ebbets rebuilt it with a roof over the grandstand. His dream was to build a new fireproof stadium and, in 1913, he realized it with the opening of Ebbets Field, an intimate coliseum of steel, glass, brick and concrete in an undeveloped area east of Prospect Park. Despite its grand surroundings, the team often ended up in last place, and after Ebbets died in 1925, its debts mounted in the 1930s. The Dodgers reached their golden years with winning streaks in the 1940s and 1950s, cheered by an eccentrically enthusiastic crowd of fans. Dodgers president Branch Rickey made history in 1945 when he signed Jackie Robinson, the first African-American who would go on to play in Major League Baseball since the ban on nonwhites was unofficially but rigidly established in the 1880s.

Major League Baseball ended in Brooklyn at the peak of the Dodger years. Although the team finally won a World Series in 1955, Dodger president Walter O'Malley was worried about its future in the old ballpark. Baseball had begun as an urban sport, but Ebbets Field was now too small and too hemmed in by urban development to meet the demand for more seats and big parking lots. O'Malley wanted to move to a bigger site in downtown Brooklyn, near the Atlantic Avenue Railroad Terminal, but New York City would only offer Queens, while Los Angeles offered over 300 acres in Chavez Ravine. In September 1957, the Brooklyn Dodgers played their last game at Ebbets Field and the following season became the Los Angeles Dodgers.

In 1960, the old stadium was demolished to make way for a massive housing project. The site offered in Queens became Shea Stadium, home of the New York Mets in 1964 and replaced in 2009 with Citifield, modeled on Ebbets Field. In 2001, minor league baseball came to Brooklyn with the opening of the Cyclone's new stadium in Coney Island. But the glory days of Major League Baseball in Brooklyn, a century in the making, remain just a memory.

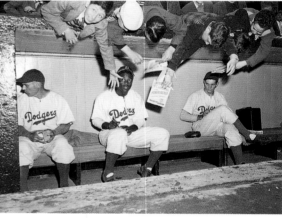

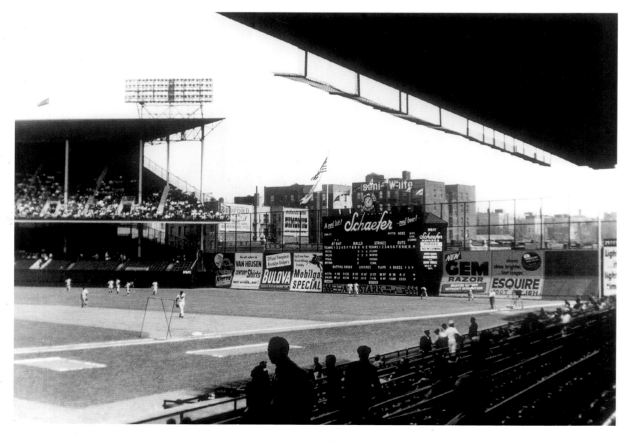

LEFT *Ebbets Field and its famous Schaefer Beer scoreboard.*

TOP *Like laundry lines and backyard fences, Ebbets Field became an integral part of the neighborhood.*

ABOVE *Fans clamor for the autograph of Jackie Robinson. He started his major league career at Ebbets Field for the Dodgers on April 15, 1947, starting at first base.*

OPPOSITE *Built on an empty site in 1913, Ebbets Field was surrounded by urban development by the 1950s.*

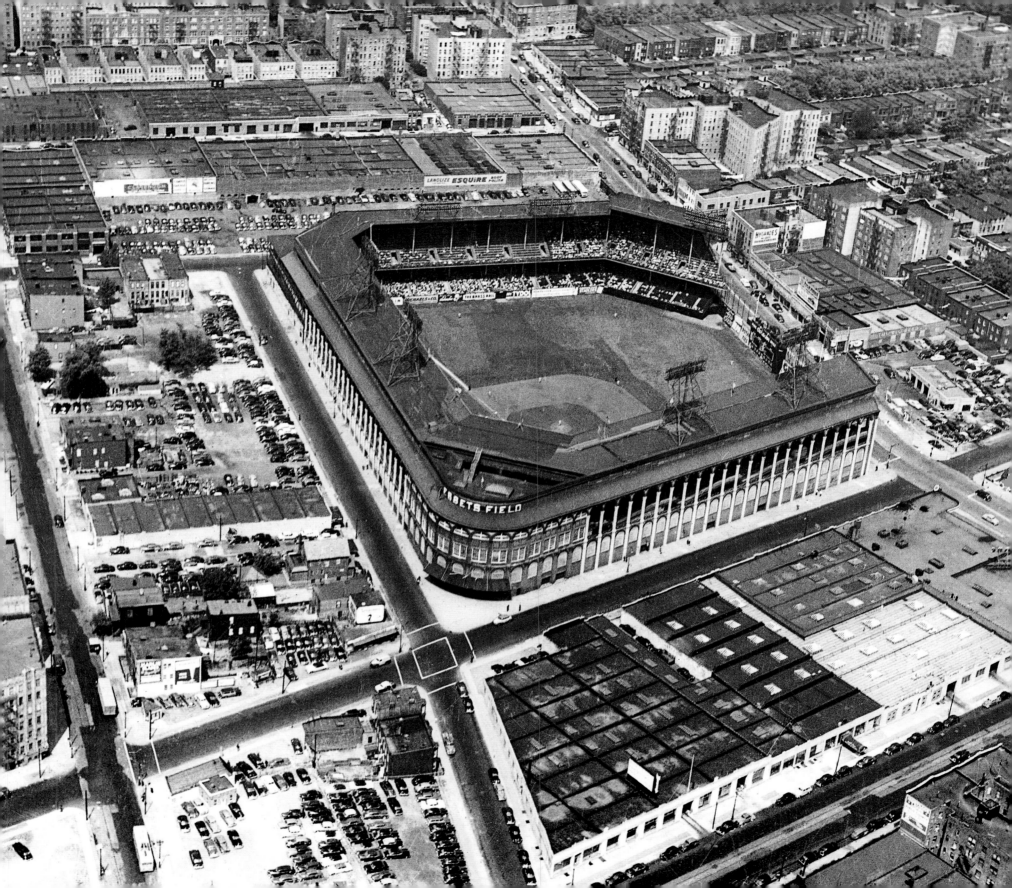

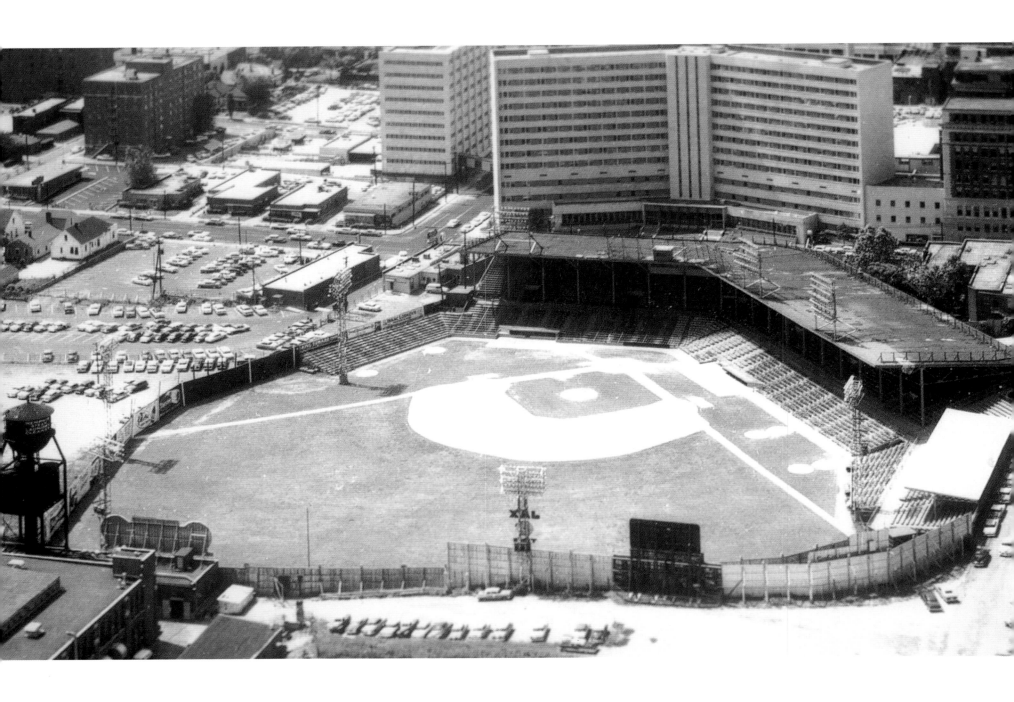

Russwood Park, Memphis DESTROYED BY FIRE 1960

Russwood Park in Memphis, Tennessee, began life in 1896 at 914 Madison Avenue as a simple wooden grandstand for some 2,800 fans. At first it bore the name Elm Wood Park, and then Frank's Park for Charlie Frank, the man who built the baseball diamond and managed the first team to play ball at the park in 1901—the Memphis Egyptians. The team played ball in the Southern Association and won back-to-back pennants in 1903 and 1904. In 1909, the team changed its name to the Memphis Turtles.

Their park was uniquely configured in a six-sided block of the city bounded by Pauline and Hospital streets and Madison Avenue. The unusual configuration put center field closer to home plate than either right or left field. Humped in the middle to provide drainage, some said the team's second name came from this "turtleback" feature of their home park.

In 1915, when Russell E. Gardner purchased the team, the ballpark was renamed Russwood Park. The team had become the Memphis Chickasaws in 1912 after a fan vote that recalled not only the name of a Native American tribe but also that of an earlier Memphis baseball team. Sports writers quickly shortened the name to "the Chicks." Gardner expanded the park's seating to around 11,000.

The Chicks played in the Southern Association from 1912 until 1960 and won six pennants in that time. However they didn't feature in the very last game played at their home stadium. A pre-season exhibition game between the major league's Cleveland Indians and Chicago White Sox drew around 7,000 fans on April 17, 1960.

As the decades had rolled by, development had encroached on the baseball diamond. Memphis Steam Laundry's facility stood to the north, John Gaston Hospital went up on the field's west side and a wing of Baptist Memorial Hospital sat across Madison Avenue to the south. Patients at the Baptist Hospital first noticed the smoke coming from Russwood Park after the Easter Sunday game.

Firemen arrived to find the ballpark's bleachers, still largely constructed of wood, ablaze. Soon after, firefighters watched as a 20-mile-an-hour wind whipped the fire. When the firefighters realized there was little they could do to combat the intense heat destroying Russwood Park they concentrated their efforts instead on saving the park's neighbors.

Flames approached the walls of the maternity ward at John Gaston Hospital. Hundreds of patients in the 12-story Baptist Hospital were also threatened and full-scale evacuations became necessary at both facilities. What some at the scene described as a "tsunami of flame" headed for the two hospitals; windows cracked and their frames actually caught fire. Orderlies carrying infants raced through smoke-filled hallways.

Miraculously everyone was saved. In what was one of the few five-alarm fires in all of Memphis history, not one person was seriously injured. As a result the public came to call the conflagration that consumed this lost ballpark "an Easter miracle." The cause of the fire is unknown to this day. The only part of the park that remained unburned was the grass.

The park was never rebuilt. With no permanent home, the Memphis Chicks disbanded after playing just one more season. The former site of Russwood Park has since been filled with more medical buildings and their associated parking lots, leaving a historic marker to tell the tale.

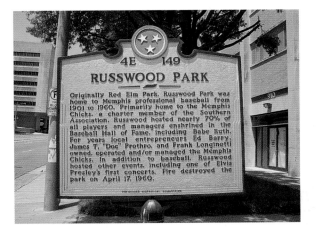

TOP *Fire crews could do nothing to save the ballpark once the fire had taken hold in the wooden bleachers.*

ABOVE *Today a marker from the Tennessee Historical Commission tells the ballpark's story.*

LEFT *Enraptured Elvis fans fill the outfield in 1956 as the King performs at Russwood Stadium on July 4th.*

OPPOSITE *The ballpark with its unusually-shaped outfield as it looked shortly before its fiery demise.*

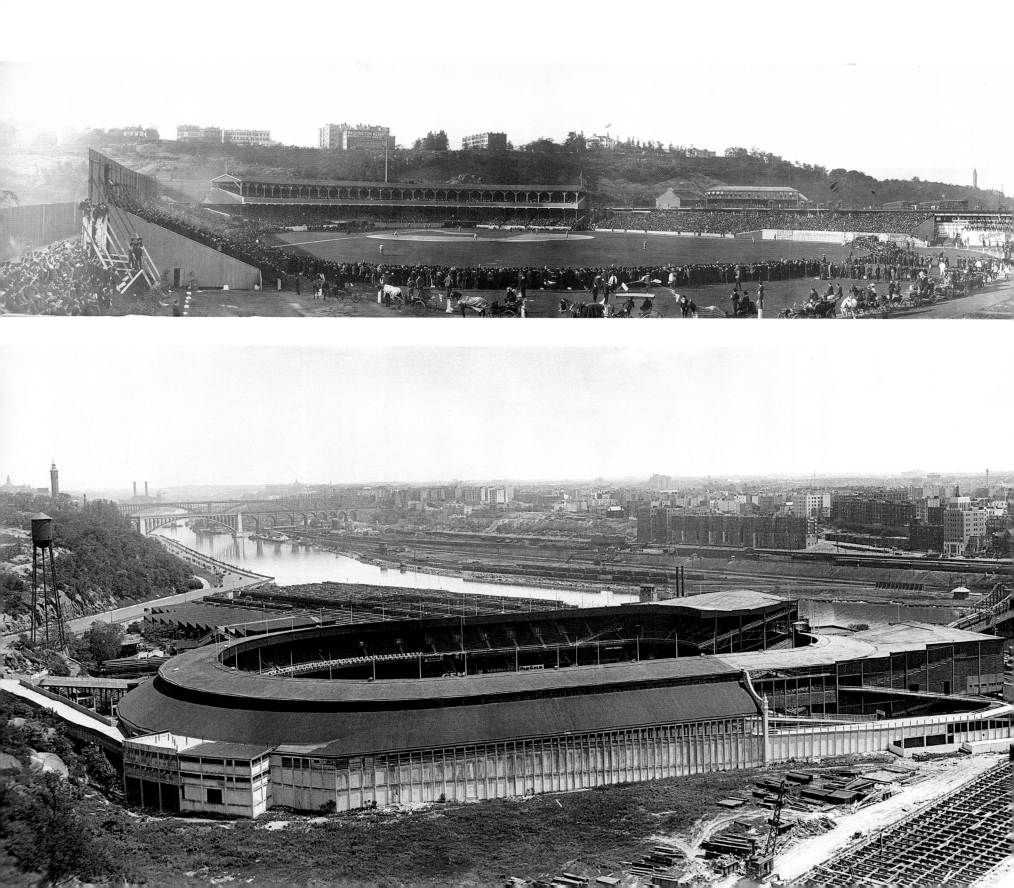

Polo Grounds, New York RAZED 1964

The New York Giants originally played in a polo grounds and the name of their adopted ballpark stuck. They moved into a second version of the Polo Grounds in 1889, and a third in 1891. The latter park, situated below Coogan's Bluff at the corner of Eighth Avenue and 159th Street in Harlem, served as the team's home until 1957.

Giants owner John Brush pioneered several innovations, including a phone messaging system,

which made it easier for Wall Street businessmen to attend weekday games, and a running track behind the center field fence where fans could park their carriages while they watched the game. When the stadium was full—as on October 8, 1908, when an estimated 250,000 fans tried to attend—those without tickets gathered atop Coogan's Bluff to watch for free. It was also here that Harry M. Stevens single-handedly revolutionized ballpark

concessions by popularizing scorecards and inventing the hot dog. This third Polo Grounds burned to the ground on April 14, 1911, due to the fact that it was made entirely of wood, but construction began immediately on a fourth.

By the end of the 1911 season, the fourth and final version of the Polo Grounds was complete, with a horseshoe-shaped, steel-and-concrete grandstand and a capacity of 34,000. It was one of the most ornate stadiums ever built, and the decor included an Italian marble facade all the way around the upper deck, which was engraved with the coat of arms of each city in the National League. The Polo Grounds had the deepest center field in baseball, but with a right-field line just 257 feet away from home plate, it was a haven for left-handed sluggers.

From 1913 through 1922, the Giants shared the Polo Grounds with the Yankees, and it was here, not Yankee Stadium, where Babe Ruth had his greatest seasons. He slugged .796 from 1920 to 1922, while the Yankees were the Giants' tenants.

The stadium was the site of many memorable moments, including Ray Chapman's fatal beaning by Carl Mays in 1920, Willie Mays' dazzling catch in the 1954 World Series, and what is described as Bobby Thomson's "Shot Heard 'Round the World" in the 1951 playoffs against Brooklyn. During the latter season, the Giants were aided by an intricate sign-stealing scheme in which infielder Hank Schenz and coach Herman Franks sat in the Giants' clubhouse in dead center field, observing the opposing catchers' signals through a telescope, and relaying them electronically to Giants batters.

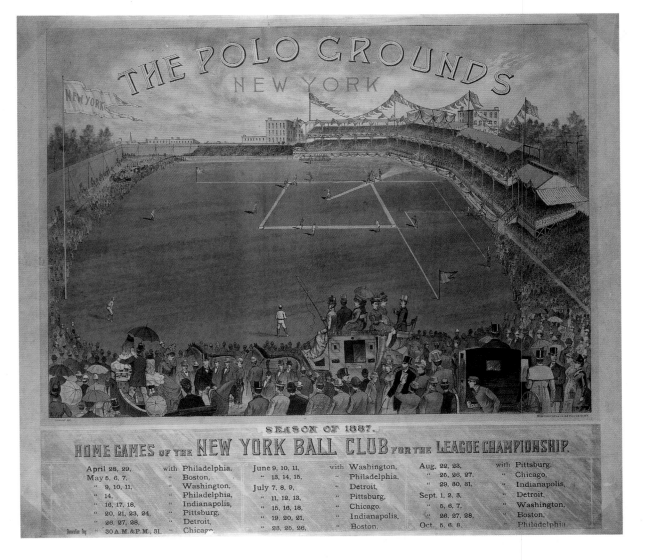

OPPOSITE TOP *A full house at the third Polo Grounds in 1905 with the Giants taking on the Philadelphia Athletics in the World Series.*

OPPOSITE BOTTOM *A side-long view of the fourth and final Polo Grounds bounded by Coogan's Bluff on the left and the Harlem river on the right.*

LEFT *This illustration of the Giants' original Polo Grounds in 1887 shows an open center field where fans with horse-drawn carriages parked to watch the game.*

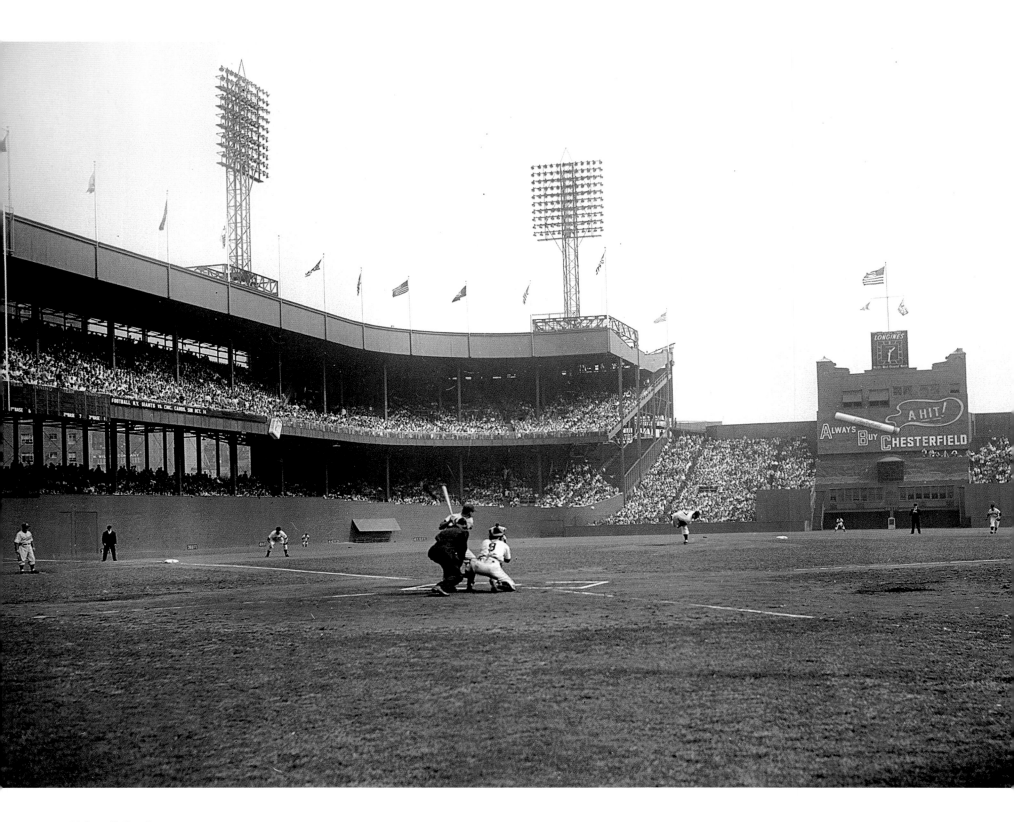

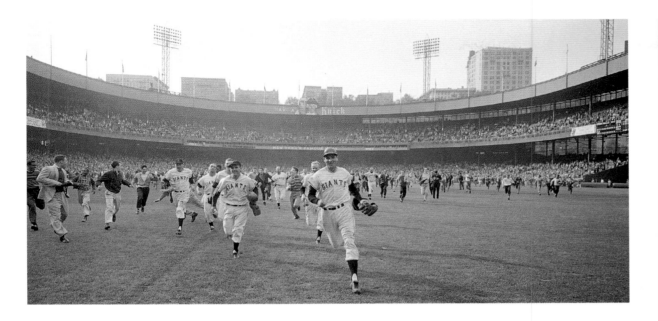

REQUIEM FOR A FRANCHISE

Attendance was dropping in the late 1950s, and in 1956 the Giants owner was persuaded to move the team to San Francisco. He was convinced by Brooklyn Dodger president Walter O'Malley that the two rival New York teams would draw more fans by playing each other in new ballparks in California. The Giants played their last game in the Polo Grounds on September 29, 1957. In its last years, the dilapidated stadium was shared by the New York Mets, a new baseball team designed to replace the Dodgers, and the New York Jets football team. The Jets played the last game at the Polo Grounds on December 14, 1963, which proved to be another loss for New York. In 1964, the demolition crew arrived, wearing New York Giants T-shirts. The wrecking ball, painted to look like a baseball, was the same one used to demolish Ebbets Field four years earlier. The Polo Grounds Towers, a public housing project built in 1968, now sits below Coogan's Bluff. The only remnant of the Polo Grounds is the John T. Brush stairway down Coogan's Bluff, named for the Giants owner who built it in 1913.

In 1956, with the Giants' attendance figures suffering badly, owner Horace Stoneham was talked into moving to San Francisco by Dodgers owner Walter O'Malley. The last occupants of the Polo Grounds were the New York Mets, an expansion team intended to replace the Dodgers and Giants, who played here (badly) under manager Casey Stengel in 1962 and 1963. An enormous housing project now sits below Coogan's Bluff where the ballpark once stood.

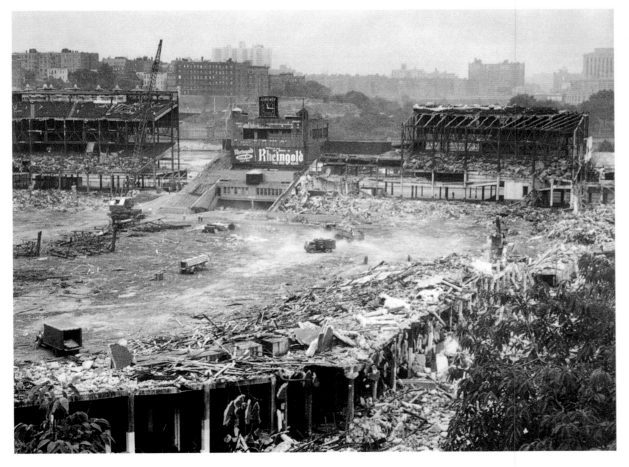

ABOVE LEFT *The Giants, led by Bobby Thomson, run off the field of play for the final time in September 1957.*

OPPOSITE *Game two of the 1951 playoff between the Giants and the Brooklyn Dodgers. Game three, also played at the Polo Grounds, was won by the famed Bobby Thomson home run.*

LEFT *The Polo Grounds fall to the wrecking ball in 1964.*

Griffith Stadium, Washington, D.C. RAZED 1965

Three different major league teams called Washington home during the nineteenth century, occupying a plethora of ballparks, including one, Capitol Grounds, located across the street from the U.S. Capitol on the site where the Russell Senate Office Building now stands.

The first D.C. park to last more than a decade was National Park, built in a hurry in 1911. In March of that year the original ballpark, also known as Boundary Field, burned when sparks from a plumber's blowtorch set the ballpark on fire. The Senators quickly built a replacement which was just about ready to host 16,000 fans and President Taft on opening day in April.

In 1920, the stadium was renamed after Senators owner Clark Griffith, the only man in major league history to serve as a player, manager and owner for at least 20 years each. Griffith Stadium's left-field line was an astounding 407 feet away, making it an extremely tough park for right-handed batters, a circumstance that helped Washington's Walter Johnson become arguably the greatest pitcher in baseball history. It wasn't until 1957—four years before the park's closure—that a Senators player hit 30 home runs in a season.

During the 1930s and 1940s, the Senators shared the park with the Negro Leagues' Homestead Grays, who featured Josh Gibson, a right-handed slugger who was the only batter able to clear Griffith's left-field wall with regularity. In the 12 years they played at Griffith, the Grays won nine pennants, six more than the Senators did in their 50 years there.

As a neighborhood institution, Griffith Stadium was a celebrated arena, host to all cultures and a variety of events. It was one of the very few public places in Washington that was never segregated, although most of its teams were.

Fans at Griffith may have attended major

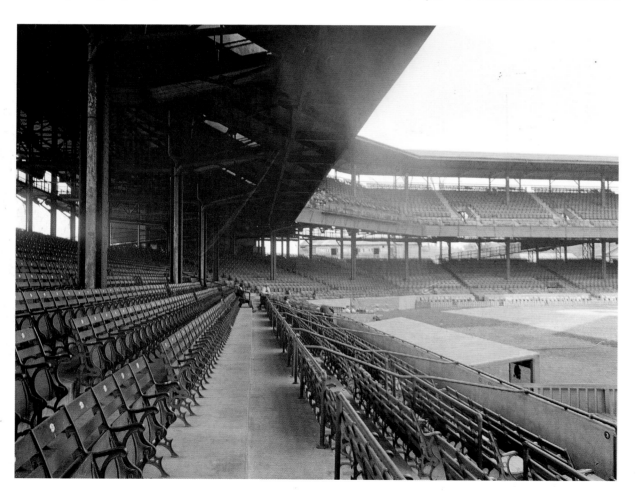

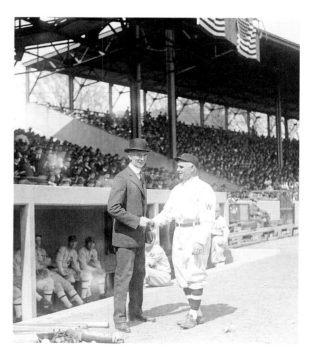

ABOVE *Two old stagers shake hands before the opening day game of 1919. On the left, Cornelius McGillicuddy, aka Connie Mack of the Philadelphia Athletics, on the right, Clark Griffith.*

LEFT *The immaculately maintained ballpark in the 1930s.*

RIGHT *This aerial view of Griffith Stadium taken on July 1, 1937, shows just how close it was located to the surrounding townhouses.*

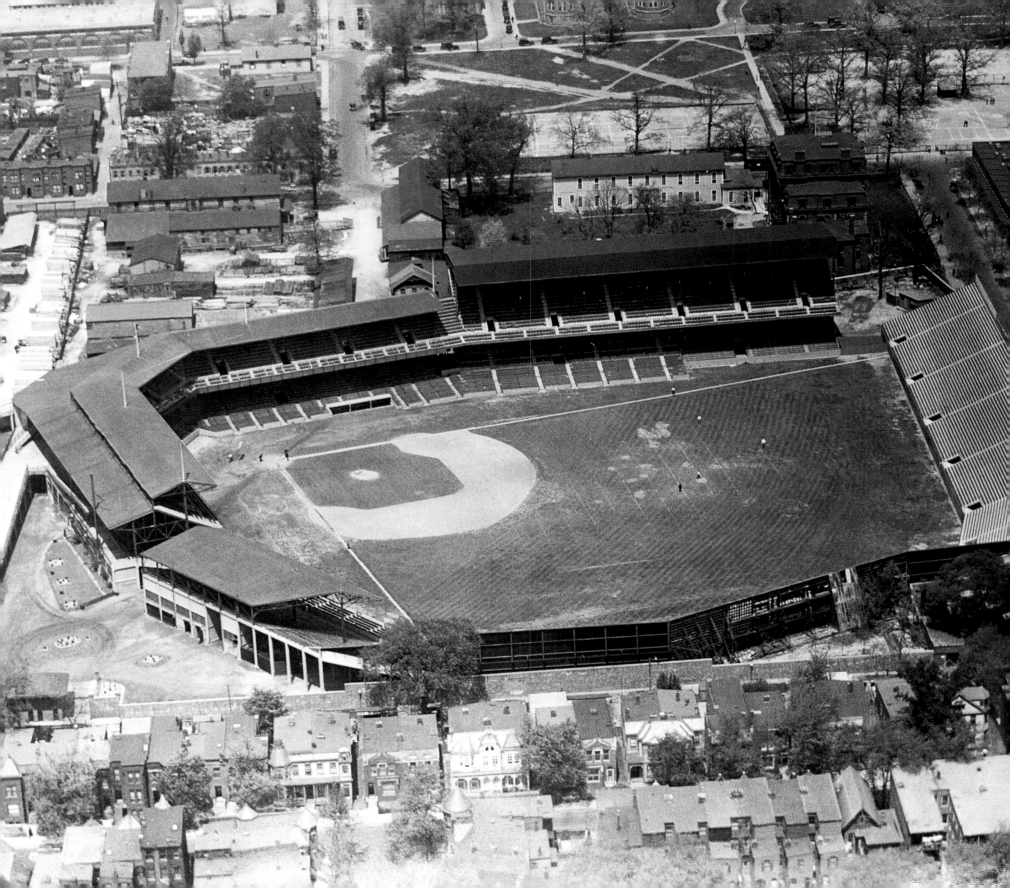

league or Howard University baseball, National Negro League baseball, religious revivals, Howard University football, high school drill competitions, or even the first games of the Redskins, who played here from 1937, until they moved to RFK Stadium in 1961. Local schools also used the arena for sports and recreation activities.

Clark Griffith died in 1955 and his nephew Calvin moved the Senators to Minneapolis in 1960 where they became the Minnesota Twins. A new Senators team emerged in 1961 and spent one season at Griffith before moving to D.C. Stadium in 1962. The final game of baseball at Griffith Stadium took place on September 21, 1961, in front of a crowd of 1498.

Four years later, the stadium was razed to accommodate the expansion of the Howard University Hospital.

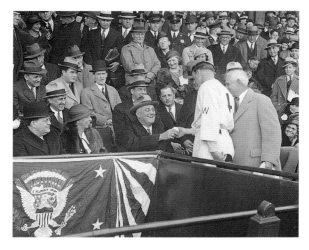

Each U.S. president from William Taft to John F. Kennedy threw a ceremonial pitch at Griffith Stadium. Franklin D. Roosevelt was a keen baseball fan and a friend of Clark Griffith from his days as Assistant Secretary of the Navy in Washington. After Roosevelt was installed as 32nd President in 1933, Griffith visited the White House every season to give Roosevelt season passes. Here, Griffith introduces his team captain to FDR and Eleanor Roosevelt. In 1942, Griffith used his access to the great man to lobby for baseball to continue during World War II.

ABOVE *The opening day program from 1925.*

ABOVE RIGHT *The Griffith Stadium media center, 1915-style.*

RIGHT *The Congressional Baseball Game first started up in 1909, but in 1926 a touch of real-life circus was added to the normal political circus when the Republican and* Democrat baseball teams turned up at Griffith Park with animals that represented their parties.

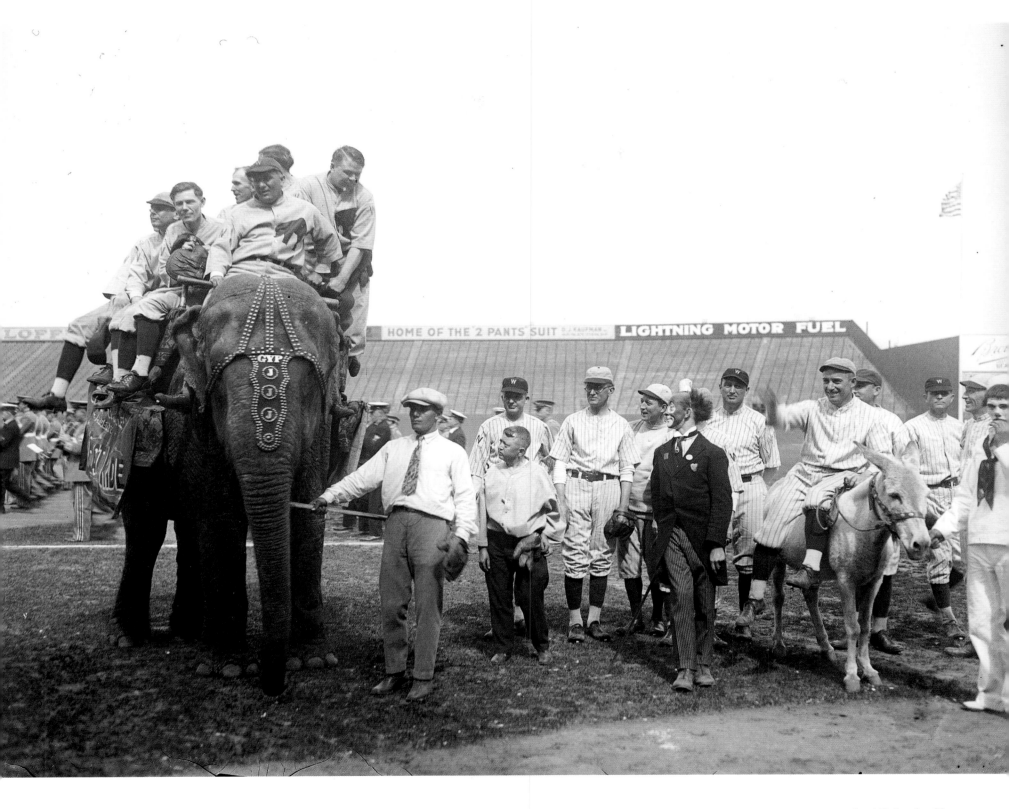

Ponce de Leon Park, Atlanta RAZED 1965

In 1907, a lake was drained across the street from the popular amusement park at Ponce de Leon Springs to build a baseball stadium. It seemed a sensible choice—the springs were a fashionable and respectable leisure activity, readily available to Atlanta residents by horse-drawn trolleys and later by streetcars. And so, drain it they did, and the stadium was finished in time for the 1907 season of the Atlanta Crackers.

Both the Atlanta Crackers and Atlanta Black Crackers played home games at Ponce de Leon Park, but it was not always so. The Atlanta Crackers played at Peters Park in present-day Midtown. They later played at Brisbane Park in what became the Mechanicsville neighborhood, and later still near Auburn Avenue as well as at Piedmont Park from 1902 to 1904. An athletic field had been placed at Piedmont Park in 1896 on the park's west side between the Fourteenth and Tenth Street entrances.

The Crackers played at Piedmont through the 1904 season when the team was purchased by the Georgia Railway & Electric Company and relocated to company land along Ponce de Leon Avenue—the old lake bed, now home to Atlanta baseball—black and white for separate, segregated audiences. The Black Crackers played at Ponce de Leon Park when they were established in 1919 and continued there for many years thereafter.

Ponce de Leon Park seated 6,800 fans and the grandstand was situated adjacent to a streetcar line depositing fans directly to the stadium. In 1923, after a fire consumed the wooden stands, owner Rell Jackson Spiller announced plans to rebuild with steel and concrete. The new ballpark dwarfed its competitors in size—14,000 seats, and cost $250,000.

Ponce de Leon Park did not have a symmetrical field. The fence along left field was 365 feet from home plate, 462 feet in center, and 321 feet in right, so it was a left-handed hitter's ballpark. Most strangely, a large magnolia tree stood in the field of play in deep center field. According to the rules, if a ball hit the tree, it was in play. Only two players are credited with hitting a baseball that far: Eddie Mathews when he played for the Atlanta Crackers and Babe Ruth during an exhibition game.

In addition to Black Cracker and Atlanta Cracker baseball games, the stadium hosted football, wrestling and revival meetings. In April 1949, the Brooklyn Dodgers came to play a three-game series with the Crackers. Televised locally, the games featured two black players, Jackie Robinson and Roy Campanella. This was the first integrated professional baseball game in Atlanta. On April 10, an overflow crowd of 25,000 people came to see Robinson and the Dodgers play the Crackers in the final game—in front of the largest

crowd ever seen at Ponce de Leon Park.

The Black Crackers continued playing in the Negro League, but Jackie Robinson's entrance into sports had broken the color line in baseball. The league continued for the next few years, but disbanded in the 1950s. By 1965, there was no longer a need for Ponce de Leon Park. The city had expanded its horizons and built Atlanta Stadium, a 52,000-seat arena helping fulfill the city's major league ambitions. The Atlanta Crackers played their final season at Atlanta Stadium in 1965 and Ponce de Leon Park was razed the next year. The only physical vestige of the park left behind was the magnolia tree that stood in center field. Today, it stands behind a shopping mall along the eastern path of the Atlanta Beltline.

OPPOSITE *The overflow crowd packs Ponce de Leon Park on April 10, 1949, when the Brooklyn Dodgers came to Atlanta to play a three-game series with the Atlanta Crackers. Over 25,000 attendees watched the game along with a number of national media outlets there to see stars Jackie Robinson and Roy Campanella.*

LEFT *An exhibition game between the Atlanta Crackers and Detroit Tigers reveals a sloping outfield. Ponce de Leon Park was the scene of many exhibition games with major league teams who traveled north from spring training in Florida.*

BELOW *Ponce de Leon Park in 1956 during an Atlanta Crackers baseball game against an unidentified opponent.*

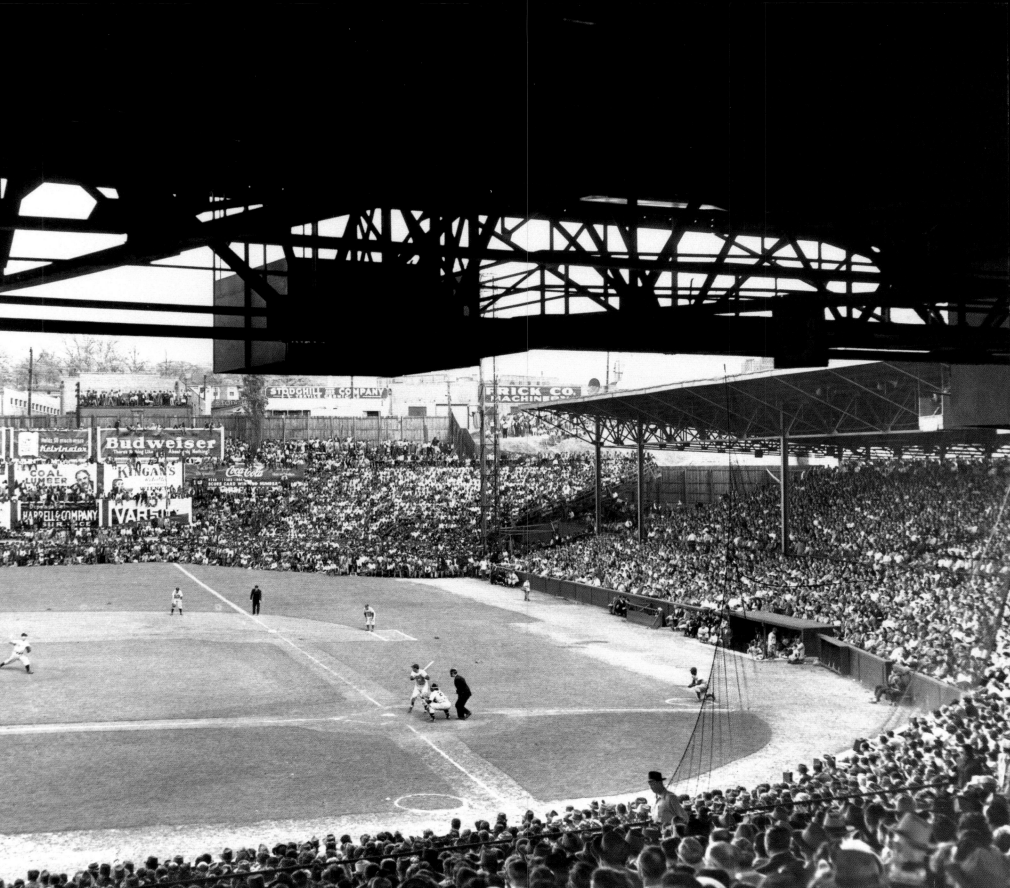

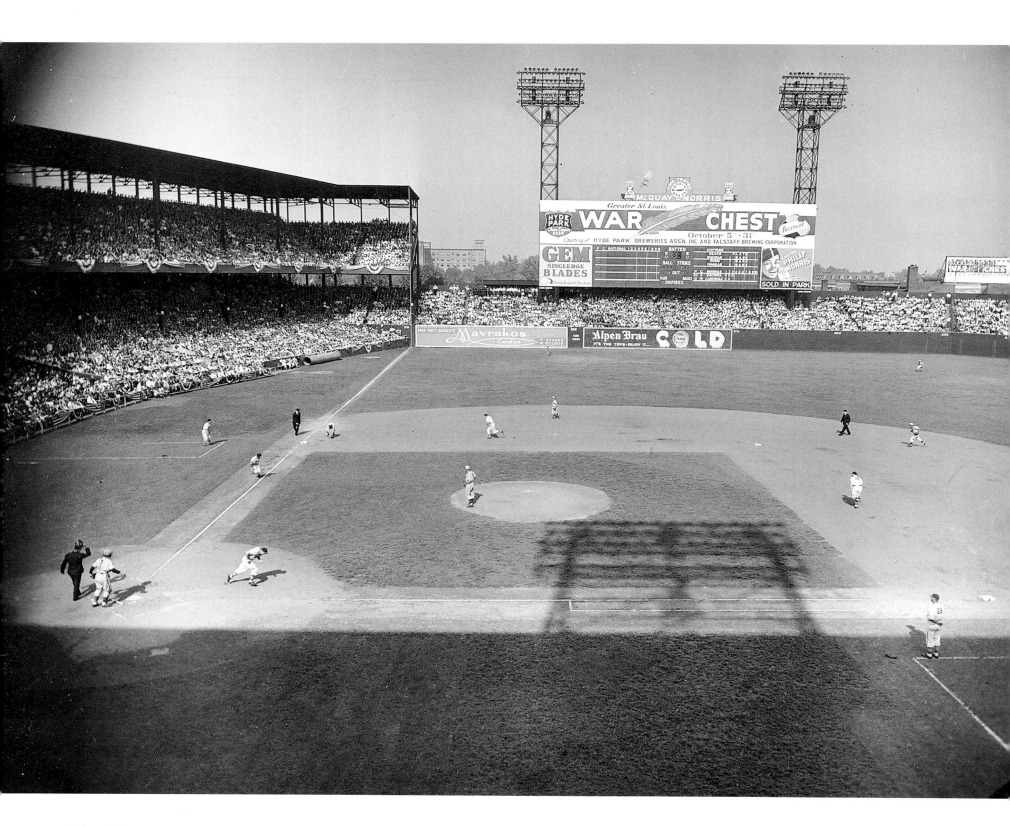

Sportsman's Park, St. Louis DEMOLISHED 1966

The St. Louis Browns were the class of the American Association in the 1880s, and they also played in one of the league's best facilities, the original Sportsman's Park. An American League franchise moved to town in 1902, usurping the Browns' nickname and setting up shop at the corner of Grand Boulevard and Dodier Street, where the original Sportsman's Park had stood.

The new Browns built a steel-and-concrete grandstand there in 1909, and the Cardinals moved in to share the park in 1920. For the next 34 years, Sportsman's Park served as home for both teams. The years were good ones for the Cardinals, who won ten pennants there, and bad ones for the Browns, who finished last ten times.

In 1912, a section of bleachers was built behind the right-field wall. This section, which was screened off so fans couldn't catch home run balls, was designated as the area for African-American fans until May 1944, when Sportsman's Park became the last major league ballpark to integrate.

The stadium's most intriguing figure in the 1950s was Bill Veeck, who lived in an apartment under the grandstand while he owned the Browns. Sportsman's Park was the site of some of his most audacious stunts, including one on August 24, 1951, when he passed out "Yes" and "No" signs to 1,100 fans—including Connie Mack—and let them manage the game by popular vote.

In 1953, Veeck sold the Browns and the team moved to Baltimore, leaving the Cardinals as the only tenants of Sportsman's Park. Except now it was called Busch Stadium after new owner August "Gussie" Busch. The Cardinals, with star players Stan Musial and Enos Slaughter, won seven World Series at the park. The last game was played on May 8, 1966, after which a helicopter swooped in to take home plate to the new Busch Stadium downtown. Busch donated the site for a Herbert Hoover Boys and Girls Club building.

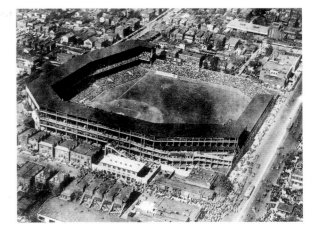

TOP An aerial view from the 1930s.

ABOVE A commemorative plaque has been installed at the site of the old stadium.

LEFT A true Cardinals legend, Stan Musial, says his farewells at Sportsman's Park in September 1963. In 2014 the city of St. Louis named a bridge for him, known locally as the "Stan Span."

OPPOSITE The 1944 World Series pitted the St. Louis Cardinals against the St. Louis Browns, only the third time in World Series history that teams had shared a home field.

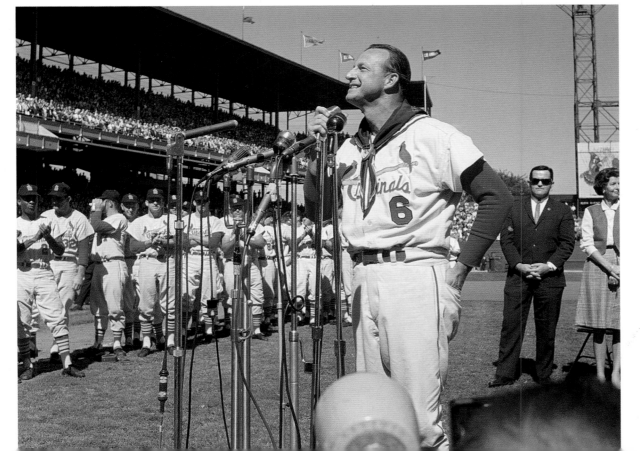

Hanlan's Point Stadium/Maple Leaf Stadium, Toronto **LEVELED 1968**

Canada's sports fans began enjoying organized baseball in 1885 and by 1897 the best team in town was the Toronto Maple Leafs. The team was bought by an unusual purchaser, the Toronto Ferry Company, who moved the team to Hanlan's Point, about three miles south of Toronto on an island on Lake Ontario. It was a popular leisure destination, there was a funfair next door and the point was named for John Hanlan, who owned a hotel there. Fans watched Maple Leafs games from a simple grandstand and bleachers. A ticket to the game cost 50 cents and that price included a ferry ticket to get to the island.

The stadium burned twice, once in 1903 and again in 1909. The second fire also destroyed the adjacent amusement park. The owners replaced the wooden stadium, this time with one made of concrete. They gave Toronto-based architect

Charles F. Wagner the task of designing the new ballpark and gave Wagner's creation a brand-new name, Maple Leaf Stadium. The funfair was also rebuilt.

Wagner was a prominent architect whose resume included factories, churches, residences and a Masonic hall. His concrete stadium seated 17,000 fans. On opening day the Maple Leafs faced the Baltimore Orioles. Fans went home happy. The home team came from behind to defeat the visitors.

On September 5, 1914, Babe Ruth stepped up to the plate with two on and two out. He swung his 42-ounce bat (the average bat size is 33 ounces) and hit the first home run of his professional career over the right-field wall and out of the stadium. The ball splash-landed in Lake Ontario. Or did it? The *Star Weekly* newspaper reported that the ball did not splash into the lake, rather "landed" in the

bleachers. Fans still debate about the fate of the ball. Ruth was pitching for the Providence Grays that day. Not only did he knock in three runs with his homer, he also held the Maple Leafs to just one hit. The Grays won the game 9-0. Today, a historic marker commemorating the Sultan of Swat's first home run marks the site,

It was not all gray for Maple Leaf fans, however. The team had won the pennant two years before the Great Bambino embarrassed them. They would repeat as pennant winners in 1917 and 1918.

Maple Leaf Stadium at Hanlan's Point was beginning to show its age by the mid-1920s. The team shipped out to a new lakefront stadium at the foot of Bathurst Street in 1926, also calling it Maple Leaf Stadium. The bleachers at the old ballpark were deemed unsafe in 1927 and demolished but baseball was still played there until 1937 when the city chose it as the site for Toronto Island Airport.

The new Maple Leaf Stadium was a jewel box-style baseball stadium built on land that had been reclaimed from the lake by the Toronto Harbour Commission. Unlike the previous ballpark it didn't

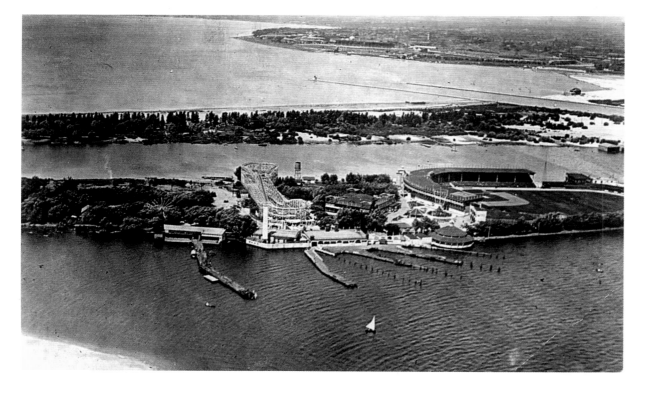

BABE RUTH

Hit his first home run in professional baseball, March, 1914. 135 yds. N.W. In this town George Herman Ruth acquired the nickname "Babe."

require a ferry ride to get there. It cost $750,000 to build, but with renovations and improvements over the years lasted through till 1967, a total of 42 seasons.

In 1951, Jack Kent Cooke bought the Maple Leafs and promoted them heavily on his radio station, building attendance figures that were sometimes on a par with major league stadiums. When he tried to persuade the city council that they could only attract a major league team with a new stadium, the request fell on deaf ears. He sold the team in 1964 and they were sold again in 1967, this time to owners in Louisville, Kentucky. The final paid attendance for a ballgame at Maple Leaf Stadium was a sad 802. It was demolished and apartments built on the site.

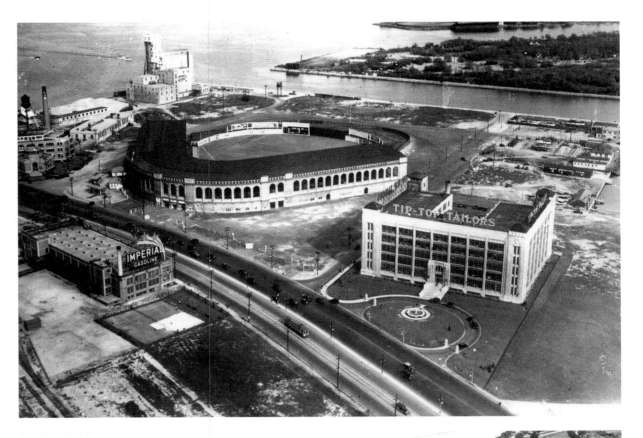

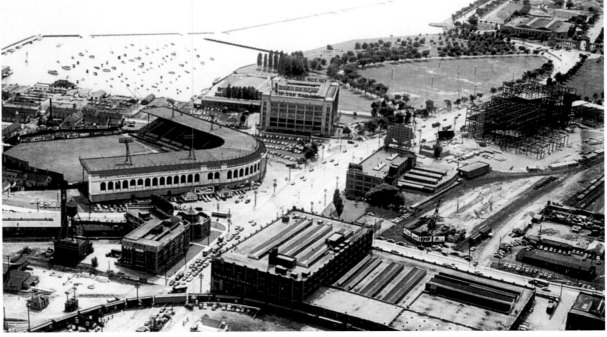

OPPOSITE *Maple Leaf Stadium at Hanlan's Point on Toronto Island, photographed circa 1920.*

LEFT *The historic marker reminds Toronto Island visitors of its place in baseball history.*

RIGHT *Two aerial views of the "jewel-box" Maple Leaf Stadium II in the 1930s and 1940s, with and without floodlighting.*

Johnson Field, Binghamton, New York

BULLDOZED 1968

Binghamton, a classic upstate New York working class city of around 50,000 people historically shared the spotlight with two of its smaller neighbors: Johnson City and Endicott. In most other metropolitan areas the two latter towns, each with a population under 15,000, might be termed suburbs. For locals, Johnson City and Endicott get equal billing with Binghamton. They refer to these three communities that lie along the Susquehanna River as the "Triple Cities."

As a result, the most notable baseball team in the area was known at first as Binghamton Triple Cities. Team members wore the insignia "TC." The team's name was later shorted to the Triplets. The Triplets played on Johnson Field in Johnson City. The story of Johnson Field begins with the story of another team, though—the Binghamton Bingoes—and that team's owner, businessman and philanthropist George F. Johnson.

Johnson arrived in New York in 1881 when Johnson City was known as Lestershire. Johnson worked at the Lester Brothers Boot Company and rose to become a partner with owner Henry B. Endicott. He went on to finance city parks, pools, churches, carousels, clinics, restaurants and libraries, giving employees of the new Endicott-Johnson Inc. towns where they could be proud to live and work.

Johnson had done well for himself and he purchased a share in the New York State League's Binghamton Bingoes in 1899. By 1912 he owned the team outright. In 1913, he set about having a baseball field built for the residents of Lestershire. He asked his brother to oversee construction that year. Johnson felt baseball—and recreation in general—was important to the welfare of his workers and offered free Sunday games for a time. The Bingoes opened Johnson Field on May 6, 1913, a day the residents proclaimed "George F. Johnson Day."

By 1916, the boot company had risen to be among the largest in the United States, if not the world. Johnson's employees not only began producing nearly every single boot worn by the U.S. military in World War I, but they received a progressive 40-hour working week. Lestershire

was renamed "Johnson City" in their employer's honor and declared a "Square Deal Town."

In 1923, a new league brought the Binghamton Triplets to Johnson Field. For another 44 years, the Triplets paraded a series of the game's best players through the park, especially after 1932 and their affiliation with the Yankees. The team remained affiliated with the Yankees until 1961. They then had a two-year stint with the Kansas City Athletics.

Baseball greats came to town to play an exhibition game at Johnson Field each year. These included Joe DiMaggio, Lou Gehrig, Mickey Mantle, even the Sultan of Swat himself, Babe Ruth.

Notable Triplets include Hall of Fame manager Tony LaRussa, pitcher Whitey Ford and Bert "Campy" Campaneris, the All-Star Kansas City Athletics shortstop.

In all, the Triplets would take 10 minor league titles. But since their attendance had begun to dwindle and their ballpark bulldozed, the team disbanded in 1968. Putting all baseball significance aside, Johnson Field was demolished in 1968 to make way for improvements to New York State Highway 17. Today commuters and travelers regularly drive right over the site of this lost ballpark.

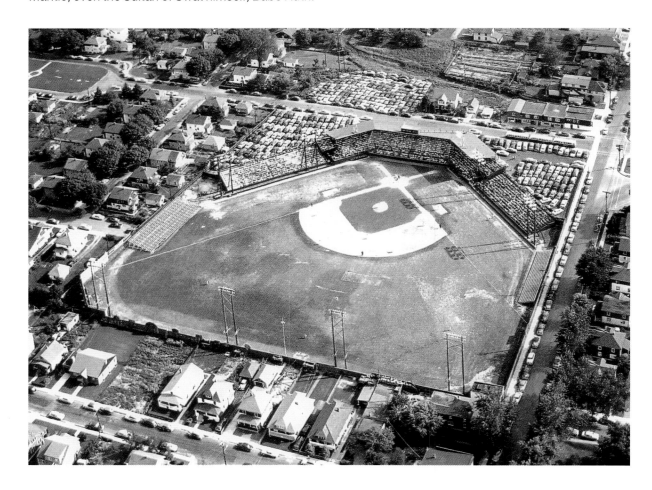

ABOVE AND BELOW A *Triplets program from the 1950s.*

OPPOSITE *An aerial view of Johnson Field in the 1950s.*

RIGHT *A* Sporting News *photo from 1953 featuring the New York Yankees-affilated Triplets. The Triplets won the Eastern League in 1952 and 1953. Yankee captain Thurman Munson played for the team in their final year, 1968.*

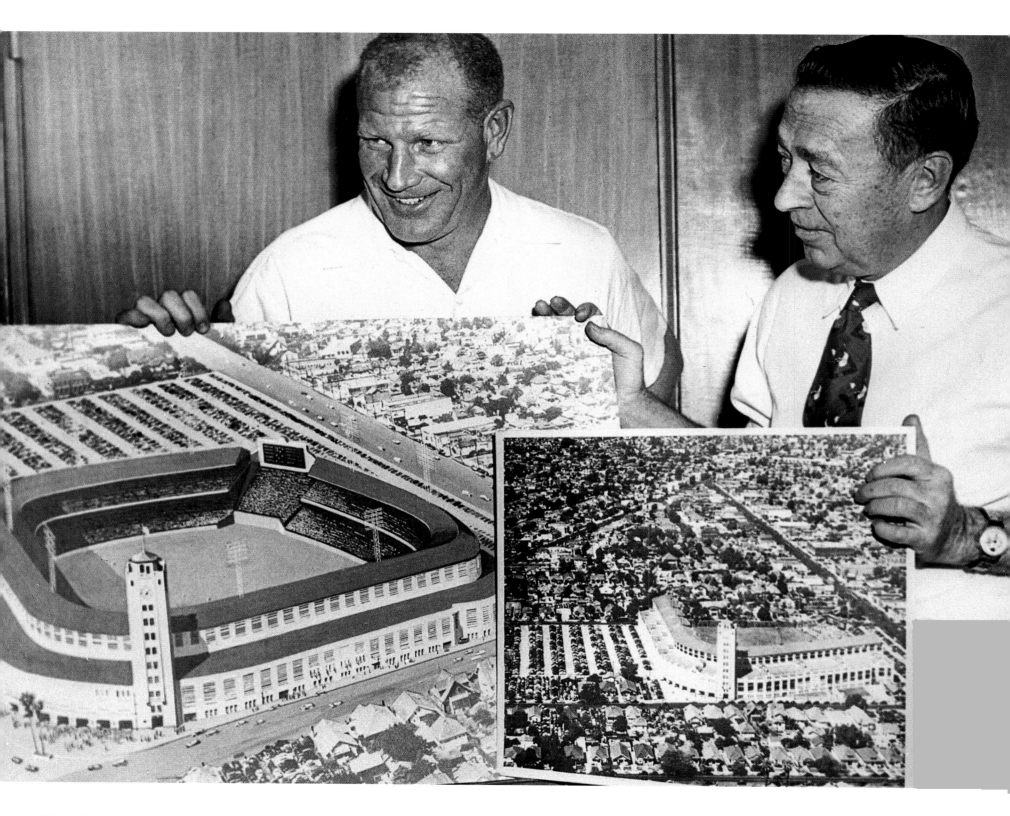

Wrigley Field, Los Angeles DEMOLISHED 1969

Few avid Chicago Cubs fans will like to admit their world-renowned Wrigley Field isn't actually the first. Los Angeles can claim the distinction of housing the first Wrigley Field, a minor league park dating to 1925, when the Cubs' Chicago ballpark was still named Cubs Park.

The park's first game on September 29, 1925, saw the hometown favorite Los Angeles Angels beat the San Francisco Seals 10-8.

Chewing gum magnate William Wrigley, Jr. owned an incredible portfolio of assets that included both the Angels and the Cubs, most of Santa Catalina Island (a great location for spring training) and commercial ventures from baking powder to clay tiles. Eventually both his baseball teams would play in parks that bore his name.

The Angels moved from their field at Washington Park, sometimes called Chutes Park. Built in a Spanish style, Los Angeles' Wrigley Field was bounded by Avalon Boulevard, San Pedro, 41st and 42nd streets. The Angels played there for

33 seasons (1925-1957), sharing the park for 11 seasons with the Hollywood Stars, who eventually found their own home at Gilmore Field. The Angels and Stars, while minor league teams, enjoyed quite a bit of success in the Pacific Coast League facing the West Coasts' other up-and-coming teams.

The field's proximity to Hollywood studios resulted in its appearance in several films. The chosen backdrop for baseball-themed movies, Wrigley Field played a key role in 1927's *Babe Comes Home* featuring Babe Ruth; *The Pride of the Yankees*, written about tragic Yankees' star Lou Gehrig, and classic television shows such as *The Twilight Zone*, and *The Munsters*. Other sporting events held at Wrigley Field over the years included six world-title boxing matches and a U.S. versus England soccer match in 1959.

When the Dodgers moved to Los Angeles from Brooklyn in 1958, the future of Wrigley appeared doubtful. Dodgers owner Walter O'Malley had purchased both the field and the Angels. The

park's seating capacity of just 22,000 wouldn't accommodate the projected attendance figures, despite a Bill Veeck-researched expansion plan. So instead the Dodgers set up shop at the 93,000-seat Los Angeles Coliseum, bringing their minor league team (the Angels) with them. With the opening of Dodger Stadium in 1962, the Angels began playing there, and Wrigley Field remained without a tenant.

By that time the field belonged to the city of Los Angeles which scheduled various events, including a civil rights rally featuring Dr. Martin Luther King, Jr. and a few more soccer matches. By 1969 demolition was under way and Wrigley Field became Gilbert Lindsay Park, a typical city park that features a baseball diamond in the northwest corner of the property.

This field, home to Wrigley Little League baseball and softball teams, is still affectionately called Wrigley Field. The site of the original baseball diamond has been converted to the Kedren Community Mental Health Center.

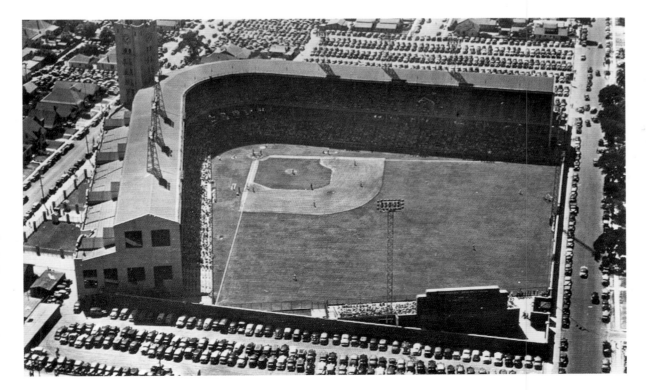

ABOVE *A colorized postcard from the 1930s.*

LEFT *This aerial photo of Wrigley Field shows it ready for opening day in 1925.*

OPPOSITE *Bill Veeck and Cubs president Philip K. Wrigley show off an artist's impression of how Wrigley Field in Los Angeles could look if the stadium were enlarged to hold 50,000. Veeck had spent 14 months looking at the possibility of bringing the major league to the West Coast.*

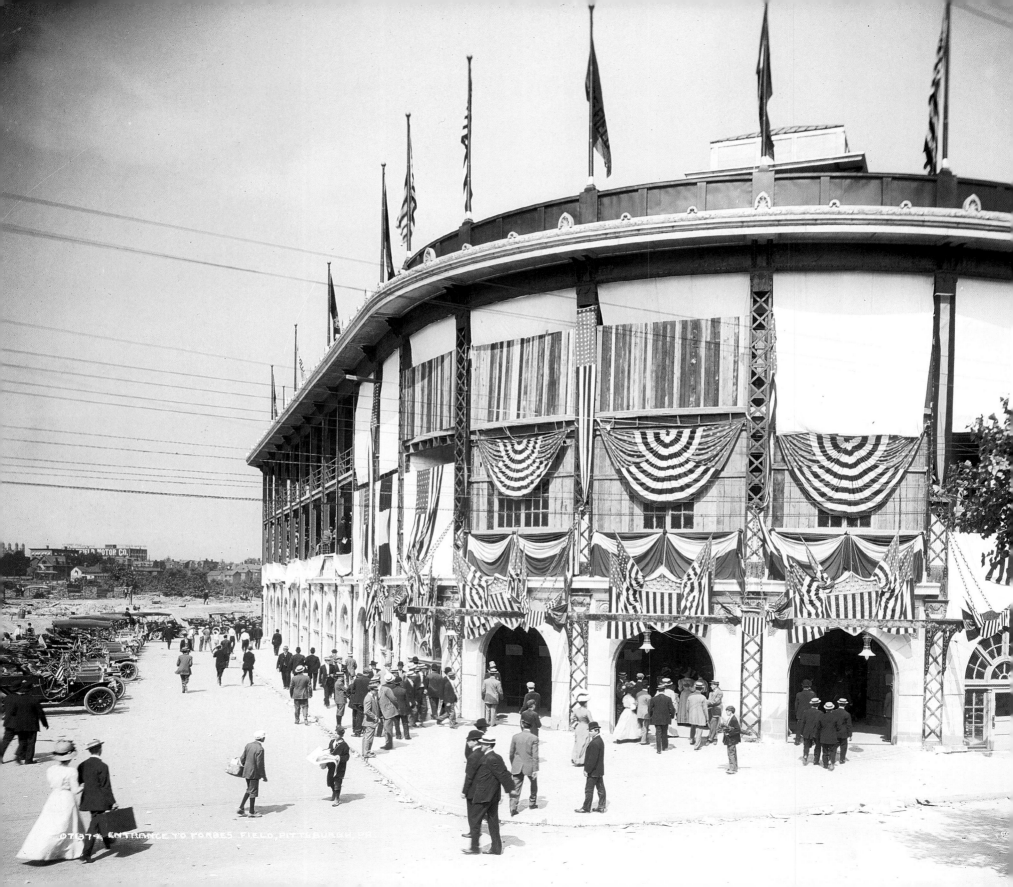

Forbes Field, Pittsburgh DEMOLISHED 1971

Forbes Field was the only baseball venue ever named for a hero of the (1757-1763) French and Indian War, which saw the British capture Fort Duquesne from the French and name the settlement Pittsburgh.

Forbes Field replaced the rickety 16,000-seat wooden "Exposition Park" that sat tight on the Allegheny River and often flooded.

The Pirates owner Barney Dreyfuss partnered with no less than Scottish steel magnate Andrew Carnegie to purchase seven acres of the old Mary Schenley estate, so it was perhaps no surprise that the ballpark should end up being named after a Scottish-born general.

When the field opened for play on June 30, 1909, it revolutionized the way fans visiting a ballpark enjoyed the game. A grandstand with three tiers extended from home plate out to both left and right fields. The stadium also had bleachers that reached from left and right fields out to center field. Forbes Field even had ramps and elevators to take Pirates fans more comfortably to their seats. In addition, Forbes introduced the idea of luxury seating on the grandstands' third tiers.

The fans took to the new park immediately, even though the Pirates lost the opener to the Chicago Cubs. When the Roaring Twenties arrived, so many fans came out to the ballpark that many of them had no seats. They had to stand on the field in order to watch the game. In 1925, a $750,000 expansion increased seating capacity to 35,000. The Pirates extended a double-deck grandstand down the first base line and around into right field. In 1938, they added a press box atop the grandstand roof behind home plate. The press affectionately dubbed the addition the "Crow's Nest." Over time ivy covered the brick wall out in left and left-center field. Lights went on at Forbes Field for the first night game on June 4, 1940.

By the late 1950s, the ballpark was showing its age and the university next door wanted to expand its campus. In November 1958, the University of Pittsburgh purchased Forbes Field for $2 million. The Pirates played their final game at Forbes Field on June 28, 1970. Just as they did on opening day in 1909, the Pirates faced the Cubs, this time in a double-header. The Pirates won both games. Some 40,918 Pirates fans stood and cheered when pitcher Dave Giusti forced the Cubs' Willie Smith to hit into a fielder's choice for the final out of the final game at Forbes Field. Many of the fans then stormed the field grabbing anything and everything for souvenirs.

A pair of fires at the ballpark spelled the end of the buildings—the first on Christmas Eve in 1970 and the second on July 17, 1971. Eleven days after the 1971 blaze, crews arrived to demolish Forbes Field, and the property was put to a more scholarly use. The University of Pittsburgh's Posvar Hall now occupies the site. Home plate remains at its exact location, enclosed in glass inside the building. But it has certainly not been forgotten.

Pirate Bill Mazeroski stood at this plate on October 13, 1960, and hit what many consider the most memorable home run in history. Mazeroski came to the plate in the bottom of the ninth inning in game seven of the World Series with the game tied 9-9. He was the first man up. New York Yankee pitcher Ralph Terry's first pitch was a ball. What happened to Terry's second pitch stunned the Yankees and all of New York. Mazeroski swung and sent the ball over the left-field wall. The Pirates won the World Series with a walk-off home run. Every October 13, fans gather at "home plate" inside Posvar Hall to listen to a recorded broadcast of the game that few Pirates' fans will ever forget.

OPPOSITE *Opening day of the season at Forbes Field circa 1910.*

BELOW *Looking out over home plate at Forbes Field in the 1960s. Home plate has now been incorporated into Pittsburgh University's Posvar Hall.*

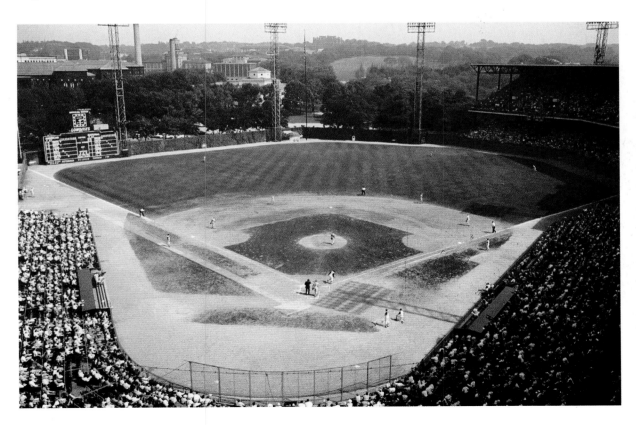

Colt Stadium, Houston SHIPPED TO MEXICO CIRCA 1972

Before Houston had the Astros, their baseball team was the Colt .45s. Championed by local politician and businessman Roy "the Judge" Hofheinz, he and a group of influential Houstonians formed the Houston Sports Association and lobbied to bring Major League Baseball to the city. In October 1960, Houston was granted an expansion franchise team in the National League (which then had just 11 teams). A public contest was held to name the team, and the Colt .45s was deemed Texan enough for the job.

Houston was granted its team on one condition: they make good on their promise to build a grand new stadium to host its games—the world's first covered stadium. This would, of course, be the Astrodome. It was all very exciting news. But wonders of the world aren't built overnight, and the team would need a place to play ASAP.

Colt Stadium was an interim field, costing $2 million but meant to serve as merely a holdover while the glamorous Astrodome was being built. Located just south of the Astrodome building site, the stadium seated 33,000 and had a bare-bones manual scoreboard on the center-field wall. It had the feel of a hugely scaled-up college stadium, with a single tier and absolutely no shade. But the most amazing thing about the stadium was that it came together so quickly—the whole thing went from concept to concrete in less than nine months. Its fast-track construction amazed the baseball commissioners, who frankly thought the timeline presented by Hofheinz and his group spurious.

The Colt .45s opened their professional play at home on April 10, 1962, by thrashing the Chicago Cubs 11–2. They did well, all things considered, but finished eighth and ninth in 1962 and 1963 respectively.

But who really won most often at Colt Stadium? The mosquitoes. All those sweaty bodies were like an all-you-can-eat buffet. Fog, rattlesnakes and the brutal Houston heat and humidity garnered complaints from players and fans—but everyone involved batted more mosquitoes than anything else. One Sunday, over 100 people were sent to the first aid station for heat exhaustion and severe mosquito bites. The stadium was the baseball equivalent of a summer camp.

The Colt .45s played their last game at the old mosquito ranch on September 27, 1964—moving into the Astrodome for the 1965 season and rebranding as the Astros. Hofheinz didn't want anything distracting folks from the brand new ballpark next door so he had the old Colt Stadium painted grey. It sat abandoned for years, serving as a storage shed, training ground and a lab site for Monsanto's AstroTurf. In the 1970s, the stadium was taken apart piece by piece and sold to a Mexican League baseball club called Algodoneros de Torreón (the Torreón Cotton Dealers, which would also eventually be dismantled).

Today, the Colt Stadium site is currently a part of the parking lot to the northeast of the now disused Astrodome. A light pole stands right around where home plate used to be.

OPPOSITE *Bleachers-view at a night game. The Colt .45s only sported the name for two years before becoming the Astros. The team played its last game in the stadium on September 27, 1964—where the home team thrashed the Dodgers.*

BELOW *Colt Stadium with the footprint of the Dome construction in the background. You could see looking down on the crowd that shade was hard to come by.*

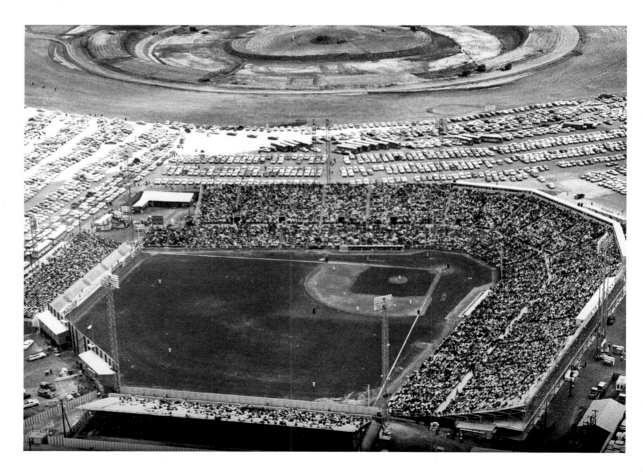

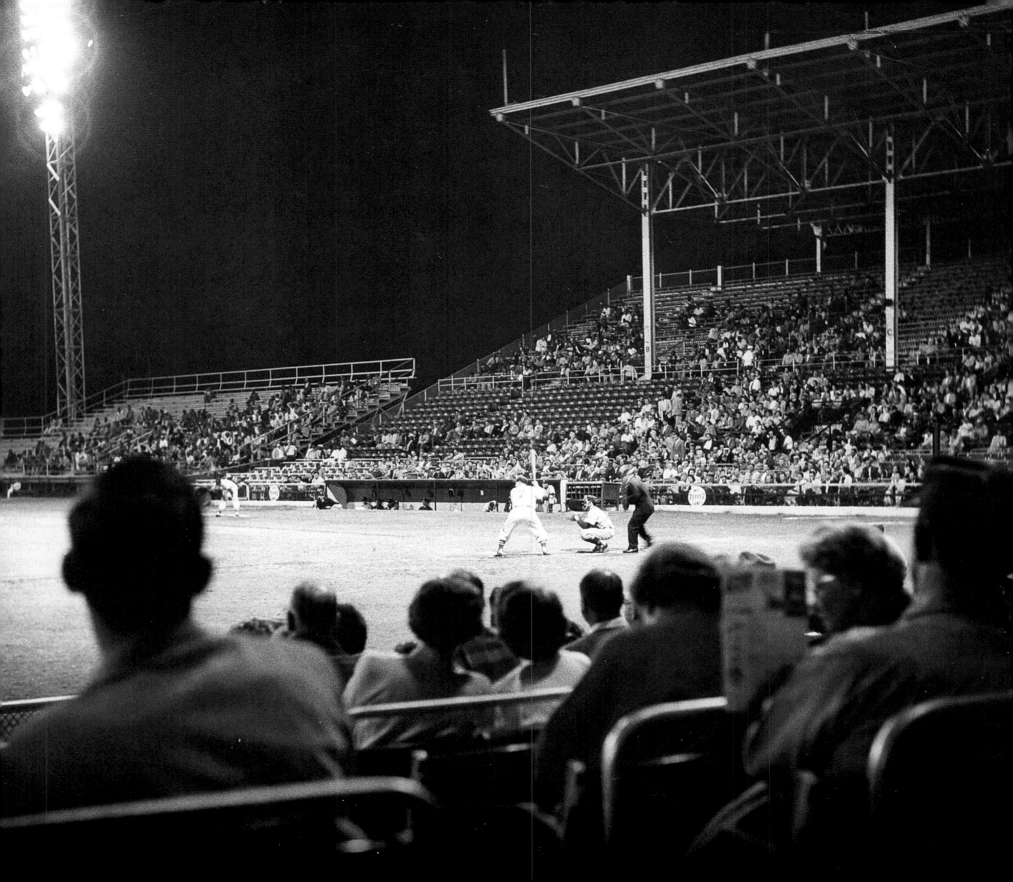

Shibe Park/Connie Mack Stadium, Philadelphia DEMOLISHED 1976

The Philadelphia Athletics began playing ball in 1901 at Columbia Park in North Philadelphia. By 1908, the team was playing well enough to attract crowds beyond the small park's 9,500-seat capacity. This was especially true in 1902 and again in 1905, when the Athletics won American League championships. President Ben Shibe and partner Connie Mack decided to look for a place to build a bigger, more suitable stadium, and after the 1908 season the Athletics moved to a new ballpark.

Shibe and Mack had settled on a property just six blocks from the Baker Bowl, where the National League Philadelphia Phillies played ball. The land was a bargain; it was just a block away from city's Hospital for Contagious Diseases, better known as the "Smallpox Hospital." Shibe knew the hospital was closing, and with its closing, bargain-basement real estate prices would evaporate. They stepped in and purchased the land for their new stadium. The Athletics played their first game at their brand-new ballpark on April 12, 1909.

Shibe Park was modern by anyone's standards as the first baseball park built of concrete and steel. Even its design made a lasting impression with a French Renaissance mansard roof and a tower in the Beaux-Arts style. The ballpark's scoreboard displayed the games' lineups and nobody missed a play thanks to the public address system.

The ballpark and the neighbors were frequently at odds. In 1934, the peace and quiet of Sunday afternoon was broken when the Athletics started playing ball on the day of rest. Folks who lived on 20th Street could watch games for free from their windows. Some climbed to the roofs for better vantage points. Connie Mack didn't appreciate the moochers. In 1935, he had a 50-foot-high "spite fence" built in right field. Four years later night games began; the lights and the noise kept the neighbors awake.

OPPOSITE *An aerial view of Shibe Park from the early 1930s before Connie Mack has his "spite fence" built.*

RIGHT *A photo from the early 1970s. The beautiful cupola was the last element of the site to be demolished.*

The Athletics kept most of the city happy, however. The team won seven pennants and five World Series in the park. In 1938, the Phillies abandoned the Baker Bowl and moved into Shibe Park. In 1947, 41,660 fans packed Shibe Park to see Jackie Robinson make his Philadelphia debut as a Brooklyn Dodger—some 9,000 seats above capacity and the largest crowd ever to see a Phillies game at the park.

In 1953, Shibe Park got a new name: Connie Mack Stadium. The Athletics left town for Kansas City two years later.

The Phillies played their last game at Connie Mack Stadium on October 1, 1970, before heading off to Veterans Stadium the following season.

"Wrecking Crew of 31,822 Breaks up the Old Ball Park," the *Philadelphia Inquirer* proclaimed the next day, "Fans ripped up their seats and ransacked the dugouts. They tore off railings and billboards," the newspaper told its readers.

On August 20, 1971, a pair of arsonists struck. Two brothers snuck into the stadium and started a fire that quickly grew to five alarms. The fire gutted the stadium, destroying the upper deck and the bleachers and collapsing the roof. Water from the firemen's hoses flooded the baseball field. The stadium stood lost and forlorn for the next five years, taking on the sad role of a junk yard in 1974. The wrecking ball arrived two years later and crews demolished the 95-year-old stadium in 1976.

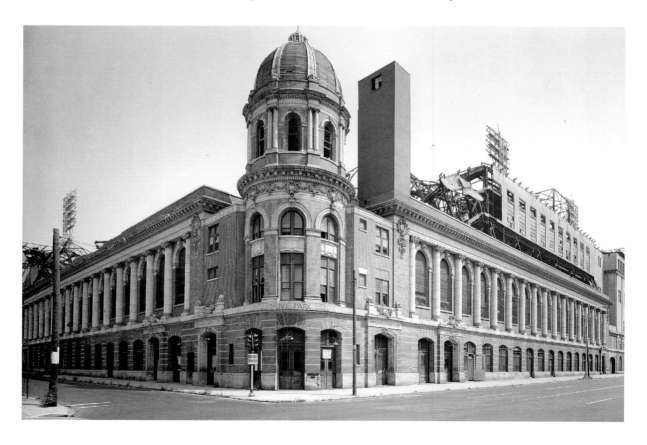

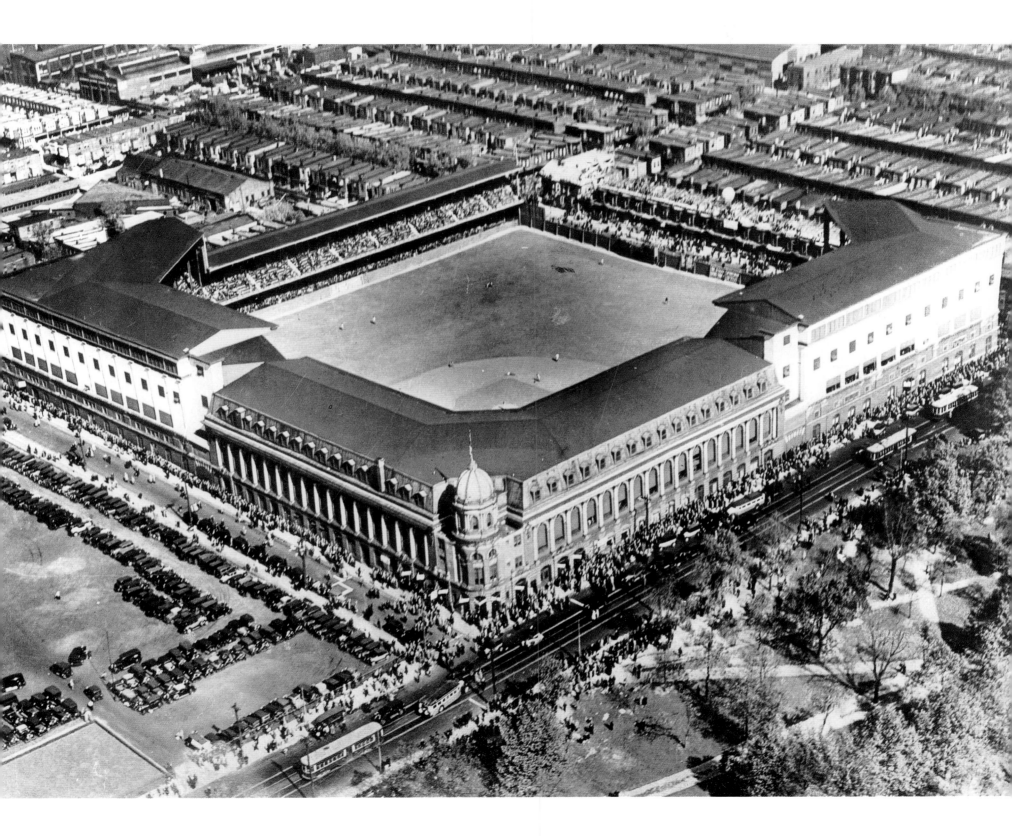

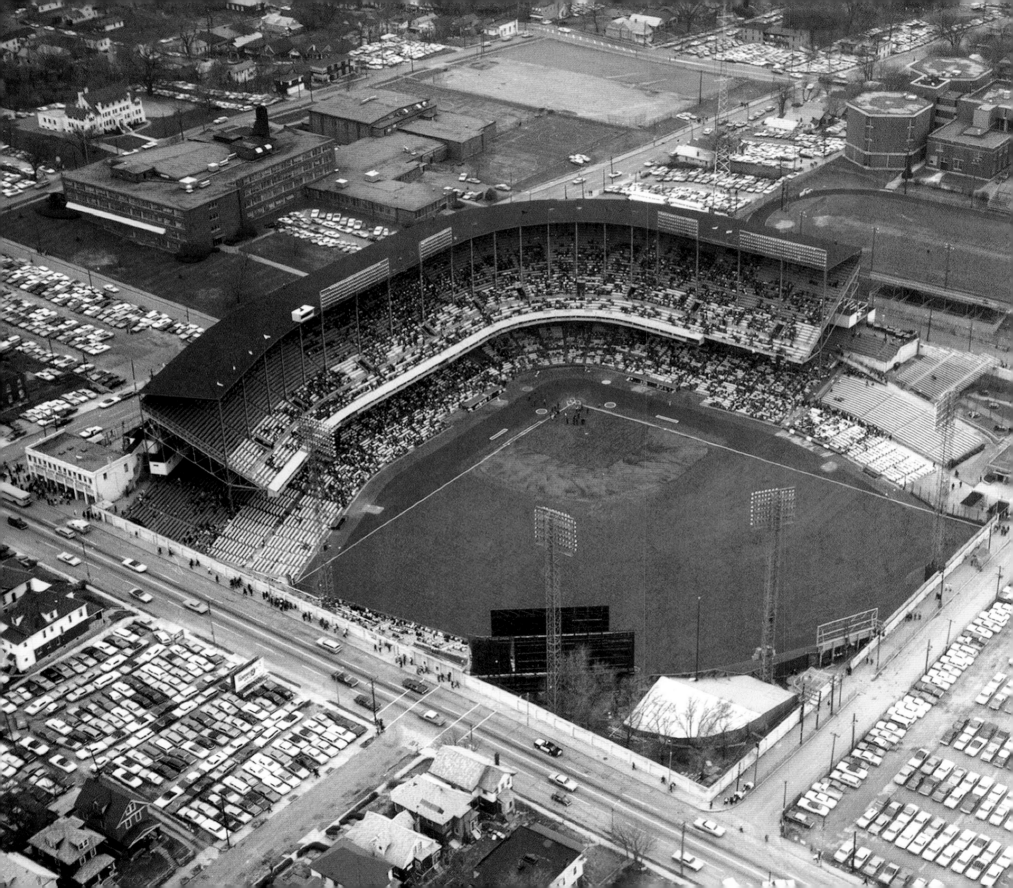

Municipal Stadium, Kansas City DEMOLISHED 1976

Kansas City's sports cathedral, Municipal Stadium, was steeped in sports history. The ballpark hosted a storied Negro League team—the Kansas City Monarchs—winners of the first Negro League World Series in 1924.

Municipal Stadium hosted two Major League Baseball teams, the Athletics and the Royals, and the minor league Kansas City Blues. The park was home to Jackie Robinson's first professional season as a Kansas City Monarch in 1945.

Named after beer magnate and Blues owner George E. Muehlebach when it opened in 1923, Muehlebach Field cost some $400,000 to build. At that time, the park had seating for 17,476 fans in a single-decked grandstand.

Ruppert Stadium—as the park would be called for a few years, after Yankees owner Colonel Jacob Ruppert bought the Blues as a farm team in 1937—would see great Blues (and eventual major league) players like Vince DiMaggio, Phil Rizzuto and Mickey Mantle take the field. After Ruppert's death in 1943, the park took the name Blues Stadium.

Arnold Johnson, a Chicago real estate investor, purchased both Yankee and Blues stadiums along with the soon-to-be Kansas City Athletics in 1953. He then sold Blues Stadium to the city who would lease it back to Johnson's team. Engineers expanding the park to major league standards found the original structure too unstable for a second deck. The prior construction was scrapped and construction began on a brand-new facility.

The park reopened as Municipal Stadium and the new home for the Athletics in 1955. President Harry Truman threw out the first pitch to christen the stadium. The park then held 30,296. There was one thing lacking, however, the stadium did not have a big-league scoreboard. To fill the gap, the team purchased the redundant scoreboard from Braves Field in Boston.

By 1960, the Athletics would be in the hands of whimsical new owner Charles Oscar "Charlie O" Finley. Finley would be known for scrapping the A's historic elephant mascot and replacing it with a live mule, also named Charlie O, in the 1950s. Charlie O (the mule) spent part of his time carousing in the right field "zoo" which featured goats and sheep fleeing home run balls. Four Minnesota Twins hit consecutive home runs in the park in 1964, something only repeated six other times in the history of baseball.

This park was home to many baseball greats: Monarchs such as Satchel Paige, Bullet Rogan and first base and later, manager, Buck O'Neil: Athletics such as Reggie Jackson, Catfish Hunter and Gene Tenace, who ended up hitting the final home run in

the stadium, and Kansas City Royals such as Lou Piniella, Amos Otis and Steve Busby.

The Beatles set a record at Municipal Stadium in 1964 when Finley offered a then unheard of sum of $150,000 for the band to perform there instead of taking the day off during their first U.S. tour.

The A's moved out in 1967 and headed for Oakland, California, and the Royals played at Municipal Stadium for just three seasons before a new ballpark, Truman Sports Complex, was built to host them.

Municipal Stadium was demolished in 1976. A plaque stands at the corner of Brooklyn Avenue and East 22nd Street to remember this lost ballpark, and single family homes now cover the site.

OPPOSITE *An aerial view of Municipal Stadium in the early 1960s.*

BELOW LEFT *Municipal Stadium was the site of many of Satchel Paige's finest moments before his final game there in 1965, aged 59.*

BELOW *Fans gather for an Athletics game in 1955, the year Blues Stadium got its new name.*

Sick's Stadium, Seattle DEMOLISHED 1979

Seattle baseball fans have enjoyed watching their favorite players at a variety of ballparks that date back to 1890, when Madison Park opened. Madison Park folded in 1892 along with the Pacific Northwest Baseball League whose games were played there. The first sizable ballpark was Dugdale Field which opened on Rainier Avenue South with a double-deck grandstand, electric lights and seating for 15,000. Dugdale was home to the Seattle Indians.

Dugdale Field lasted until the early morning hours of July 5, 1932, when arsonist Robert Driscoll reduced the place to ashes. At first, authorities attributed the blaze to the careless use of fireworks, but in 1935 Driscoll confessed to authorities that he not only set the Dugdale fire, but 114 others as well. Driscoll was an attorney who later told the court that he set a fire every time anyone insulted a client. Judge Robert Jones sentenced Driscoll to serve five to ten years in prison.

In 1938, Emil Sick's Stadium rose up in Dugdale Field's place. Sick bought the Seattle Indians for $100,000 and started construction of a new stadium. He could well afford to buy the team and build it a new home, as he also owned the Rainier Brewing Company. To use modern marketing parlance Sick leveraged the brand by renaming his team "The Rainiers."

The first pitch was thrown at Sick's Stadium on June 15, 1938. Jack Lelivelt, who had won pennants for the Los Angeles Angels, managed the Rainiers. Well-known ballplayers signed on. The player with the most promise was a youngster, an 18-year-old pitcher from Seattle's Franklin High School, Fred Hutchinson. The Rainiers won Pacific Coast League titles in 1939 and 1940. Lelivelt died suddenly at age 55 in January 1941, but the team still went on to take the title that year.

Like Ewing Field in San Francisco and the Polo Grounds below Coogan's Bluff in New York, Sick's Stadium had one flaw that fans quickly exploited. They could watch the Rainiers play for free from a hill outside the left-field fence. The press quickly dubbed the place "Tightwad Hill."

In 1946, the stadium was briefly home to the Seattle Steelheads, members of the short-lived West Coast Baseball Association Negro League. The Steelheads played at the stadium when the Rainiers were on the road.

The Rainiers played at Sick's through the 1964 season. Emil Sick passed away in 1964 but he had already sold his team to the Boston Red Sox in 1960. They in turn sold the team to the Los Angeles Angels and the team became the Seattle Angels from 1965 until 1968, their final season. With the MLB expansion team Seattle Pilots playing at Sick's in 1969 it looked like Seattle baseball would step up a gear. But the Pilots lost money and the franchise left for Milwaukee after just one season. A short-season Class A side took the name Seattle Rainiers from 1972-1976 and played at Sick's while the city wrangled with the baseball administrators and built the Kingdome

With the completion of the Kingdome in 1977, Sick's lay abandoned and forgotten. In 1979, the wrecking ball arrived.

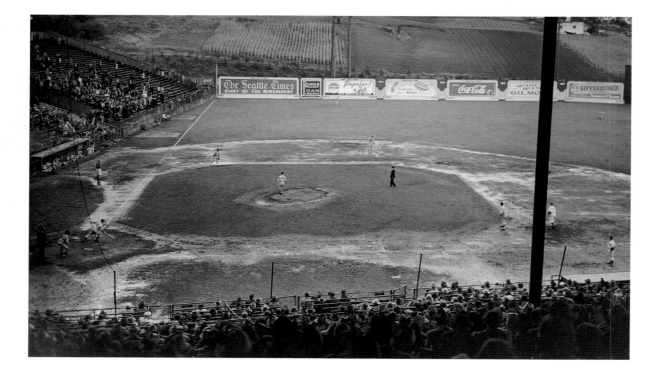

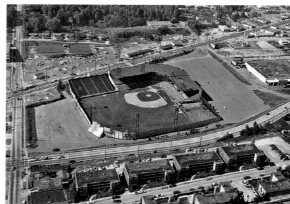

LEFT *Sick's Stadium in the late 1930s surrounded by farmland.*

ABOVE *By 1967 the area beyond the outfield had been developed, but baseball would be played there till 1976.*

OPPOSITE *A crowd of 13,500 fans leave Sick's Stadium after the ballpark's dedication in 1938. The Rainiers lost 3-1 to the Portland Beavers in the opening game.*

DEMOLISHED 1985

The Braves move from Boston to Milwaukee gave the impetus for the Twin Cities to hook a major league team for themselves, but for that they needed a major league stadium. It made perfect sense to locate this new ballpark between them and Gerald Moore, the president of the Minneapolis Chamber of Commerce, found an 160-acre plot of farmland in Bloomington. The stadium would replace Nicollet Park as the home of the Minneapolis Millers.

Ground breaking began in 1955 and on April 24, 1956, the stadium's debut game saw the minor league Millers take on the Wichita Braves. However Millers fans would have to wait till July of that year before their uncomfortably large new ballpark got its official name, Metropolitan Stadium.

Giants owner Horace Stoneham was fulsome with praise for the new facility and declared there were not two better major league stadiums of the time. In 1956, Stoneham was casting his eyes west and the Millers just happened to be one of the Giants' farm teams. Under arcane major league rules, the Giants owned the major league rights to the Minneapolis area, so there was great expectation that the city might welcome the underperforming New York team.

It wasn't to be; local rival Walter O'Malley, owner of the St. Paul Saints as well as the Dodgers, convinced Stoneham to take the Giants to the West Coast. Negotiations continued with the Cincinnati Reds, Cleveland Indians, Philadelphia Athletics and Washington Senators and finally in October 1960, Calvin Griffith announced that the Senators would be moving to Bloomington.

The arrival of Major League Baseball prompted the folding of the Millers and the Saints. It also necessitated an increase in size of "the Met" from 22,000 to a capacity of over 30,000. The newly minted Minnesota Twins played their first home game at Metropolitan Stadium on April 21, 1961, with a loss to the new Washington Senators.

The stadium got expanded once again to accommodate the arrival of the NFL Minnesota Vikings. Temporary wooden bleachers were first used and then replaced in 1965 with a large double-decked grandstand installed in left field. It gave the unusual configuration of a double-deck in left field,

and bleachers behind third base. However it also gave Metropolitan Stadium the feeling of a minor ballpark that had been extended haphazardly, fans in some of the bleachers had to leave the stadium to get to the grandstand, there was no connecting concourse. It was well known as a hitter's ballpark, its short foul lines were exploited to great advantage by pull-hitters like the Twins' Harmon Killebrew.

Given the severity of winters (an advantage for Vikings home games in late season) it was not surprising that maintenance became an issue at the Met. Players complained about the quality of the infield and some suspected that the owners, who had taken over the stadium from the city of Minneapolis, had deliberately let the Met go to seed in order to aid the push for the new indoor arena, the Hubert Humphrey Metrodome. The Twins played their final season here in 1981 and headed indoors for 1982, leaving the stadium to crumble and be replaced by the biggest shopping center in the world on it's opening in 1992, the Mall of America.

ABOVE *A glimpse from the 1960s of what "The Met" would become after it was razed in 1985, the Mall of America.*

RIGHT *An aerial view from 1961.*

BELOW *Tony Oliva of the Twins bats against the Dodgers during the 1965 World Series at Metropolitan Stadium. The Twins won the game 5-1.*

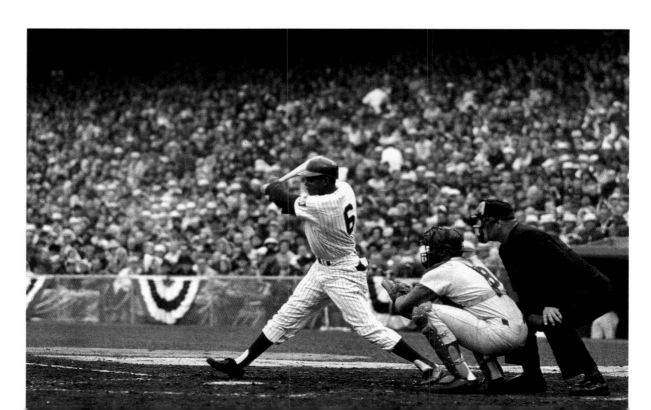

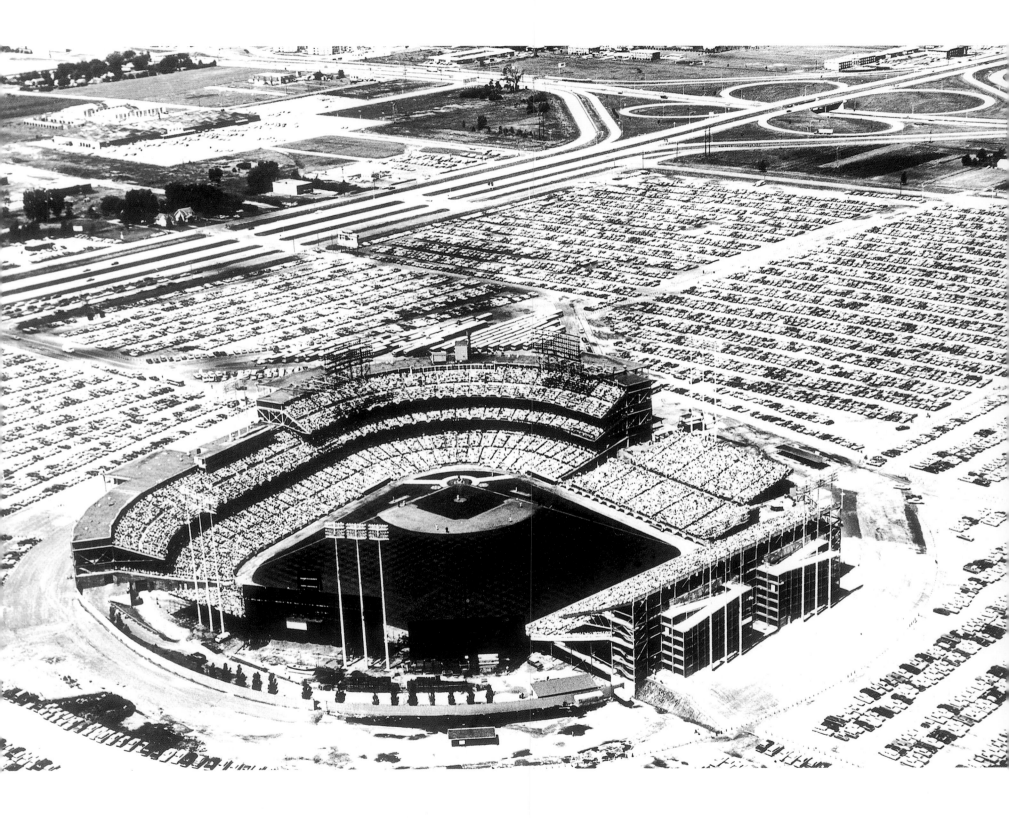

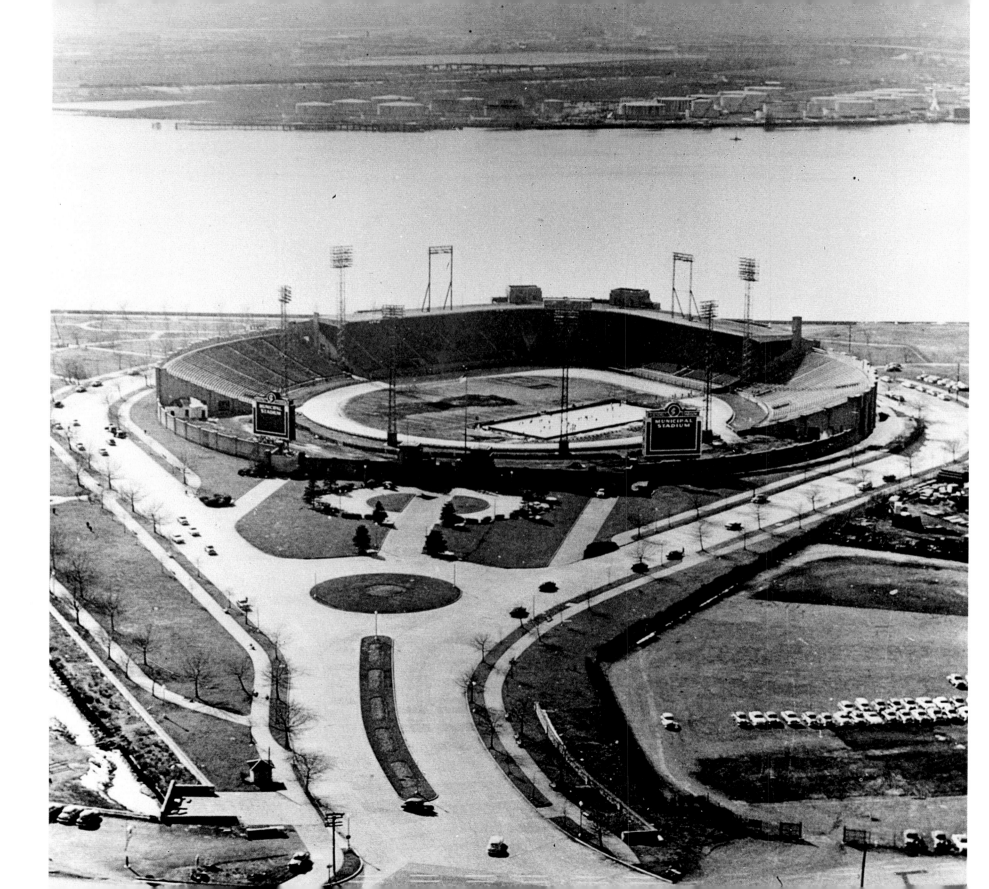

Roosevelt Stadium, Jersey City RAZED 1985

Four hits in five at bats, a three-run homer, four runs scored with three batted in and two stolen bases are good enough stats to make baseball history on any particular day. That exact performance made history that went beyond baseball and America on April 18, 1946, when brand-new Montreal Royal Jackie Robinson stepped into the batter's box at Roosevelt Stadium in Jersey City, New Jersey, for the first time as a professional baseball player on an integrated team.

Ever since Jimmy Claxton had pitched a doubleheader in Oakland way back in 1916, no baseball player of African descent had been permitted to play in the white major leagues. Jackie Robinson changed all that by demonstrating from this very first at bat that black players could compete with ease with white major leaguers. The Royals went on to trounce the Jersey City Giants 14-1.

Roosevelt Stadium had been named for the man who authored the New Deal—President Franklin Delano Roosevelt. The 24,000-seat stadium went up in 1937 using Works Progress Administration funds and labor. The WPA was part of the New Deal initiative to put America's Depression-hit workforce back to work. The stadium rose up on the site of the former Jersey City Airport.

In 1929, Mayor Frank Hague had initiated the effort to build the stadium, which he intended to be used not only for baseball, but for football and track and field as well. The Art Deco steel-and-concrete structure was eventually dedicated to those residents of Jersey City who had lost their lives in World War I and other foreign wars.

The International League Jersey City Giants were affiliated with the big-city New York Giants and played the first game at Roosevelt on April 23, 1937, after rain had canceled the previous day's game—31,234 fans, a number that set an attendance record for the minor leagues, watched as the home team lost to the Rochester Red Wings by a score of 4-3.

Over the years, the park primarily saw use by Jersey City's high schools. However, Roosevelt also hosted 15 home games for the Brooklyn Dodgers in 1956 and 1957 when the team was attempting to leverage the Borough of Brooklyn into constructing a new stadium to replace Ebbets Field. Roosevelt's prime bargaining chips were its 10,000 parking spaces versus the 700 at Ebbets. The ploy failed and the Dodgers ended up in California instead.

Boxing at Roosevelt included Max Baer's defeat of "Two Ton Tony" Galento and Sugar Ray Robinson defending his title against Charley Fusari in 1950. The Jersey City Giants played ball at Roosevelt Stadium until 1951. Like their New Jersey rivals, the Newark Bears, they found themselves competing for baseball fans against three New York major league teams. Jersey City Giants' crowds plunged from 337,000 in 1947 to 63,000 in 1950. The team moved to Ottawa, Ontario, in 1951 and became the Ottawa Giants. When the team moved out of Roosevelt the ballpark had no replacement sports team ready to move in. The city hoped rock concerts would bail the taxpayers out.

The list of musical acts who performed at Roosevelt includes classic rock acts of the 1970s, bands like Yes, The Eagles, Eric Clapton, Pink Floyd, The Beach Boys, the Allman Brothers. The first-ever stadium concert by the glam-rock outfit KISS took place here in 1976. As popular as they were, the concerts failed to pay the stadium's bills. In November 1982, the aging stadium was slated for demolition, which finally took place in 1985, to make way for a condominium complex. Today the site of this lost ballpark is a gated community, Society Hill at Droyer's Point.

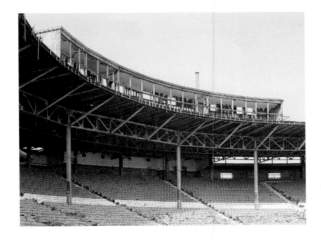

ABOVE AND LEFT *Three images compiled by the Historic American Buildings Survey in 1985 just prior to the demolition of Roosevelt Stadium. The original plan for the site's redevelopment included a marina.*

OPPOSITE *A view of the stadium from the 1950s.*

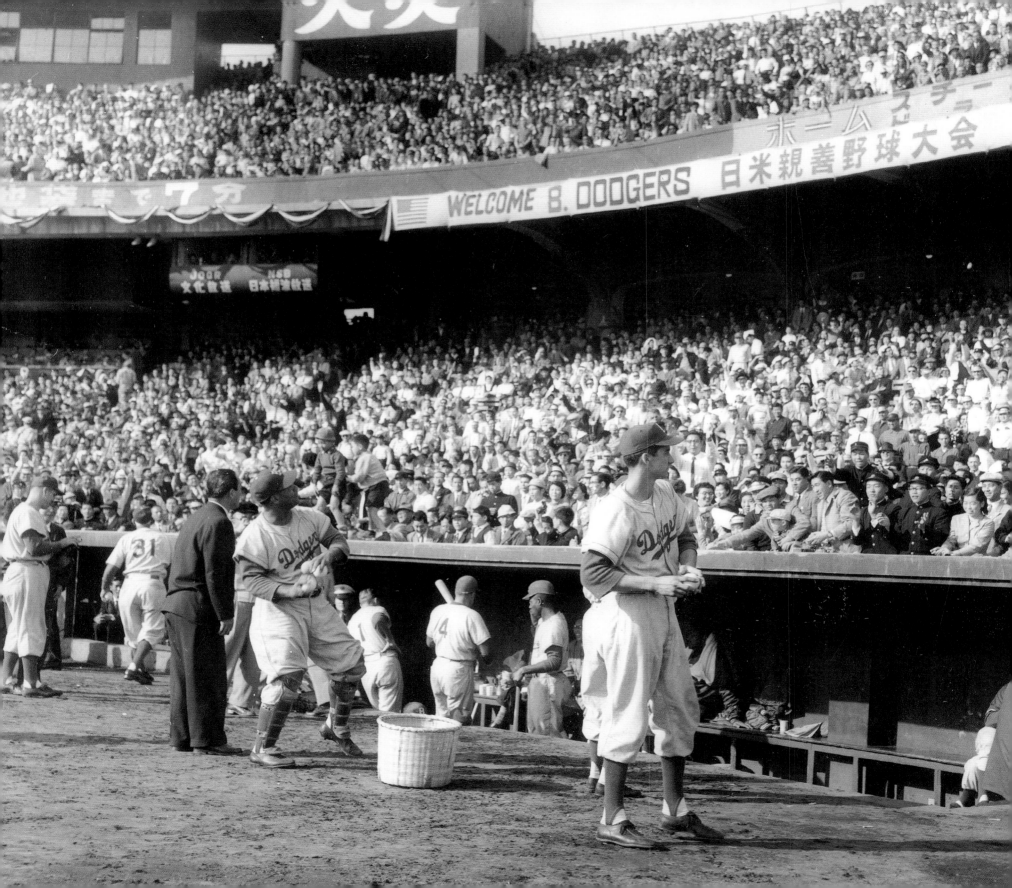

Korakuen Stadium, Tokyo RAZED 1988

Civil War veteran and Maine native Horace Wilson worked in Japan as a professor at Kaisei Gakko—today's Tokyo University—between 1867 and 1873. While teaching there, he decided that his students needed some exercise and began teaching them to play baseball. The game caught on as an amateur sport, especially at the universities. By 1878, Japan's first baseball team appeared under the auspices of the Shimbashi Athletic Club.

Starting in 1910 professional baseball teams from the United States began visiting Japan. In 1934, Babe Ruth and Lou Gehrig headlined the most famous and exciting of the teams that faced Japanese players. Media mogul Matsutaro Shoriki organized the Greater Japan Baseball Club to face the visitors and 18 games between the Americans and Japanese whipped up interest in the sport.

When Babe Ruth and company defeated the Japanese in every game, the home team players decided to take baseball more seriously.

Japanese players visited the United States to sharpen their baseball skills, facing a number of American minor league teams. In 1936, a professional baseball league got underway in Japan. In 1937, they began playing ball in Korakuen Stadium, a venue that seated 50,000 fans. Korakuen is the second part of the name of a popular Tokyo garden "Koishikawa Korakuen," which translates as "the garden for enjoying pleasures later on."

In 1942, Korakuen hosted a record-setting 28-inning, 311-pitch, complete game effort by Michio Nishizawa. That same year fans at Korakuen witnessed the longest-lasting brawl in baseball history. It happened in a game between the hometown Tokyo Giants and the visiting Yakult Swallows. The brouhaha began when the Swallows thought that Giant third baseman Nagashima interfered as Swallow baserunner Tsuchiya was caught in a rundown play between third base and home. When the umpire ruled that Tsuchiya had

reached home and scored safely, a melee erupted that lasted almost two hours. The call at the plate proved to be the winning run, the Swallows beat the hometown team 3-2.

Baseball resumed in full after World War II in 1949. In 1950, two six-team leagues, the Central League and the Pacific League began playing ball. In 1959, Japan's Baseball Hall of Fame opened right next door to Korakuen Stadium.

Fans witnessed the end of an era in Japanese baseball on October 14, 1974, as Yomiuri Giants popular star Shigeo Nagashima tearfully said goodbye to a full house at Korakuen.

An important world record was set at Korakuen on September 3, 1977. Fans cheered as Sadaharu Oh hit his 756th career home, surpassing Hank Aaron's world record.

The stadium closed on November 8, 1987. The Giants moved right next door to the Tokyo Dome. By February 1988, demolition crews had completed their work, and Korakuen Stadium was just a memory. The Tokyo Dome Hotel, an event hall and an outdoor mall now occupy the site.

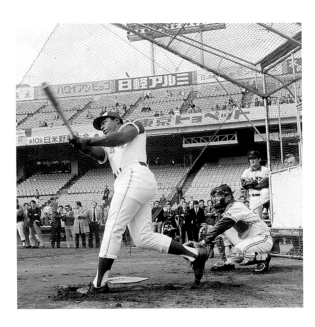

ABOVE *Hank Aaron in action at Korakuen in a Home Run Hitting Contest against the Tokyo Giants' Sadaharu Oh in 1974. It was a close run thing but Aaron won 10-9.*

OPPOSITE *Brooklyn Dodger Ray Campanella and teammates throw baseballs to a packed Korakuen in October 1956.*

RIGHT *An aerial view of the stadium from the 1980s.*

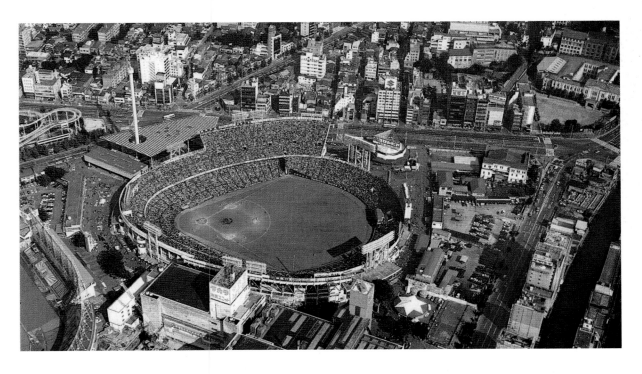

Comiskey Park, Chicago DEMOLISHED 1991

In 1909, Charles Comiskey, the owner of the Chicago White Sox, bought an abandoned city dump at 35th and Shields and built a new stadium, originally called White Sox Park. Three years after the ballpark was built, its name was changed to Comiskey Park. It was considered modern when it was built and was sometimes referred to as "the baseball palace of the world." It was only the third stadium to be made of steel and concrete. The design was influenced by White Sox pitcher of the time, Ed Walsh, and was always considered a "defensive field" with long distances in the outfield to aid pitchers at keeping balls inside the park.

Comiskey was the site of four World Series, including one played, not by the White Sox, but by the Chicago Cubs. In 1918, the Cubs played the Boston Red Sox, and because Comiskey had a larger seating capacity, the Cubs borrowed the field. The Red Sox defeated the Cubs before beginning their 86-year World Series drought. In 1919, the White Sox lost the infamous "Black Sox" series at Comiskey, when players were accused of accepting bribes to lose games. The Sox also played in World Series games at Comiskey in 1917 and in 1959.

From 1922 onwards, the National Football League Chicago Cardinals split their playing time between their original Normal Park, and the more modern Comiskey. By the 1930s, the Cardinals had abandoned Normal Park and played all of their games at Comiskey and Soldier Field.

Comiskey was closely identified with Major League Baseball All-Star Games, and the first All-Star Game was played there in 1933, a promotion associated with the 1933 Century of Progress World's Fair. Comiskey also hosted many of the Negro League's East-West All-Star Games between 1933 and 1960. In some years, the Negro League exhibitions often drew more fans than the MLB All-Star Games held in other ballparks, in part due to Comiskey's high seating capacity.

After 1970, Comiskey was the oldest baseball park still in use in the major league. It came to be characterized by unusual stunts and features, many of them initiated by White Sox owner Bill Veeck, who was known for his promotions. The center-field bleachers were dominated by huge pinwheels that would spin when the White Sox hit a home

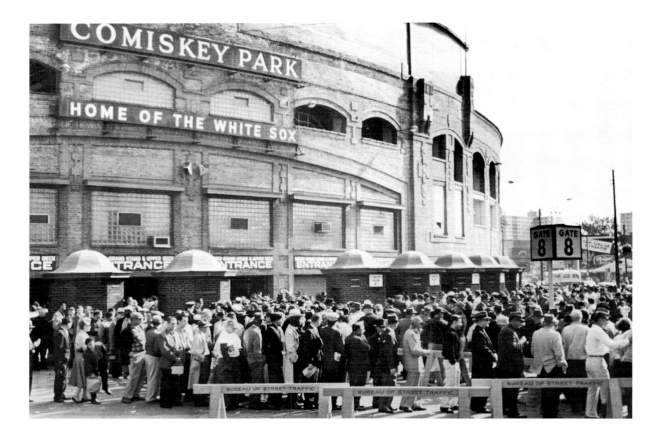

run. Nancy Faust was hired as organist in the early 1970s, and she set a pattern for baseball parks by playing musical snippets that would comment on the game, including "Na-na-na-na...goodbye" that was played when an opposing pitcher left the game.

In 1988, the State of Illinois appropriated money to build a new stadium next to Comiskey in order to stop the team moving to Florida. The destruction of Comiskey took the entire summer of 1991, and the site is now a parking lot for U.S. Cellular Field next door.

ABOVE *Fans lines up for tickets ahead of the World Series games with the Dodgers in October 1959.*
OPPOSITE *An aerial shot of Comiskey Park from 1984, the new stadium would sit on the parking lot next door.*

RIGHT *Long-time owner Bill Veeck surveys development work outside Comiskey Park.*

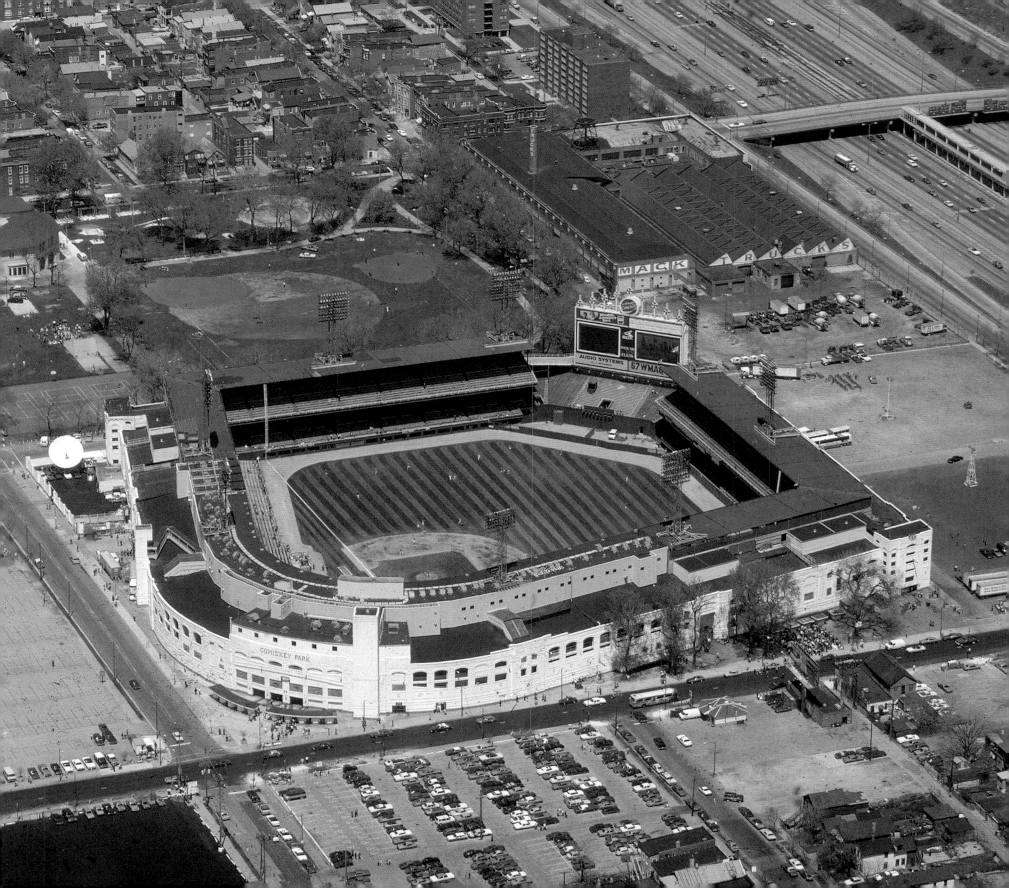

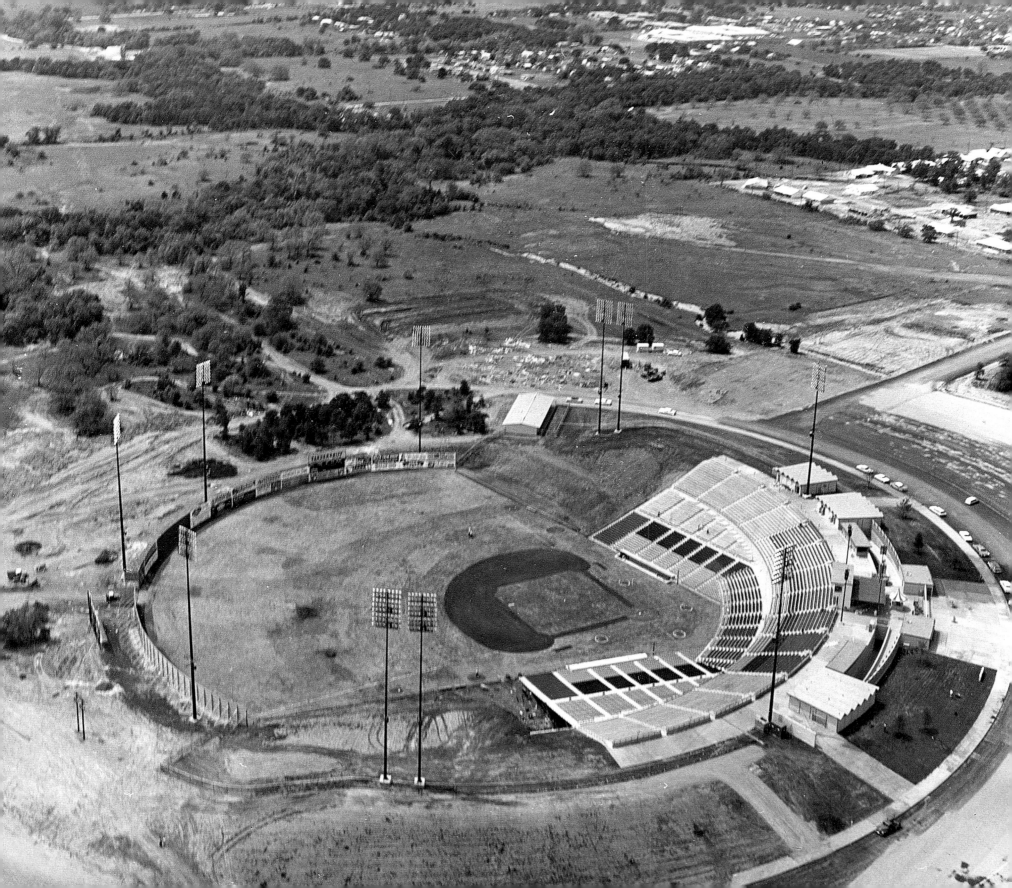

Turnpike/Arlington Stadium, Dallas

DEMOLISHED 1994

Originally Turnpike Stadium took its name from Interstate 30, or the Dallas-Fort Worth Turnpike (today's Tom Landry Highway), the park would also be known as Arlington Stadium after the city where it was located. Suburban Arlington was equidistant between the cities of Dallas and Fort Worth.

When it opened in 1965, Turnpike Stadium was home to a minor league team, the Dallas-Fort Worth Spurs of the Texas League. The Spurs played their ball at Turnpike Stadium from the time it opened until the Washington Senators came to town in 1972. Four years earlier, attorney Robert Short outbid comedian Bob Hope for the majority stake in the Senators. Determined to turn his new acquisition around, Short hired baseball great Ted Williams to manage the team, hopefully to improve the Senators record and with it attendance at RFK Stadium. The plan didn't work and Short began looking for a new home for his cellar-dwelling team.

Dallas had built the stadium in Arlington to suit a man like Robert Short and his Washington Senators. In fact, the stadium was created in such a way that seating could easily be expanded to 50,000 using the area's natural topography. After an expansion in 1970 doubled the capacity at Turnpike Stadium to around 20,000, it was then increased to 35,000 in anticipation of the major league team's arrival. Both the team and the stadium received new names: the Texas Rangers and Arlington Stadium. Following its graduation to the major league Arlington Stadium was expanded four more times, to an ultimate capacity of 43,521 in 1991.

During their 22-year stay in the stadium, the Rangers didn't have much on-field success and the stadium never hosted a playoff game or All-Star Game. The park still saw its share of history, however, when one of the game's greatest pitchers, Nolan Ryan, posted his 5,000th career strikeout and his seventh no-hitter there. The Rangers also ended up on the wrong side of history when they lost the 11th perfect game in major league history to the California Angels' Mike Witt on September 30, 1984, also in Arlington Stadium.

Known as the hottest stadium in baseball, the uncovered field at Arlington let in plenty of Texas heat and daytime temperatures were known to soar above 100 degrees. This, combined with less-than-stellar performances from the Rangers kept attendance low, and to combat the heat, the team held most of its summertime games after dark.

At the end of the 1993 season, the Rangers moved out to their new home, The Ball Park at Arlington (later Ameriquest Field, then Globe Life Park). The last game at Arlington Stadium was played October 3, 1993, and the stadium was demolished the following year. The site of Arlington Stadium ended up with Legends Way (now AT&T Way) passing straight through the site of the removed ballpark on the way to nearby Cowboys (now AT&T) Stadium.

OPPOSITE *Turnpike Stadium soon after its construction in 1965.*

BELOW *Baseball legend Ted Williams moved to Texas with his Senators and adopted the local headgear.*

BOTTOM *An exterior view of Arlington Stadium taken on Nolan Ryan Day in 1993.*

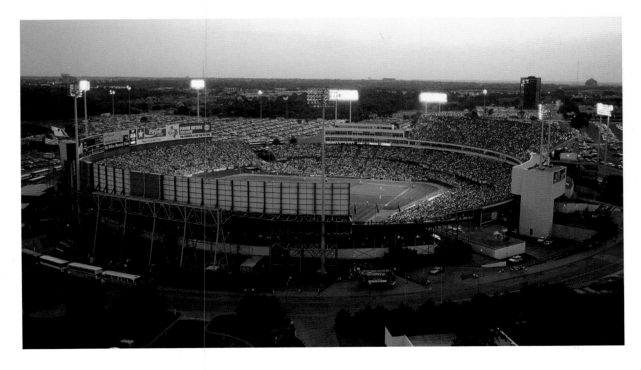

Astrodome, Houston NO LONGER THE EIGHTH WONDER 1996

In the 1960s, nothing demonstrated the "go big or go home" attitude of the biggest city in the state of Texas like the Astrodome.

These days, sports fans don't think twice about access to air-conditioned sports mega-facilities—especially in America. There are over 75 around the world from Tokyo to Germany, including a dozen more under construction and many that have come and gone. But Houston's beloved Astrodome was the first.

The city broke ground on the stadium in 1962 in true Texas fashion: shooting Colt .45 pistols into the dirt. At the time, the 1923 Yankee Stadium in New York was arguably the most notable baseball stadium in the country. But while the 1923 Yankee Stadium was legendary, the Astrodome would be more than just a baseball stadium—it would be dubbed "the Eighth Wonder of the World."

The world's first fully enclosed and climate-controlled domed stadium, Houston had created the world's largest enclosed space. Costing around $35 million, the 66,000-capacity arena (42,217 for baseball in 1965) was a Lucite-paneled dome spanning 642 feet, which could maintain a constant temperature of 73 degrees Fahrenheit at 50 percent humidity. It had its own power plant, and a first-of-its-kind $2 million scoreboard with programmable displays. It was a stadium on a scale never seen before, fitted out with technology that would make it one the nation's most popular domestic tourist destinations behind only the Golden Gate Bridge and Mount Rushmore.

Technically called the Harris County Domed Stadium, voters first approved a bond issue for the stadium in 1958. But the project's true champion

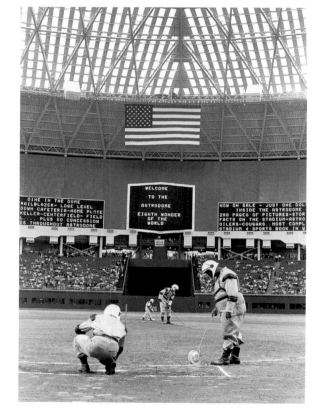

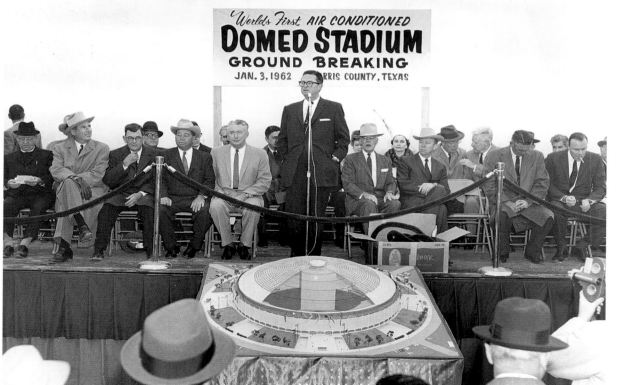

LEFT *Judge Roy Hofheinz at the official Astrodome ground breaking on January 3, 1962. For all of his eccentricity, Hofheinz was ambitious and shrewd. The son of a laundry truck driver, Hofheinz went on to graduate from the Houston Law School at age 19 and would be elected to the Texas House of Representatives in 1934. He was a Harris County judge for eight years and mayor of Houston twice.*

TOP *At the Astrodome, the field was maintained by crew members known as "Earthmen," dressing the part in space suits.*

OPPOSITE *The low light levels within the dome forced a switch from grass to an artificial playing surface, and gave the world AstroTurf.*

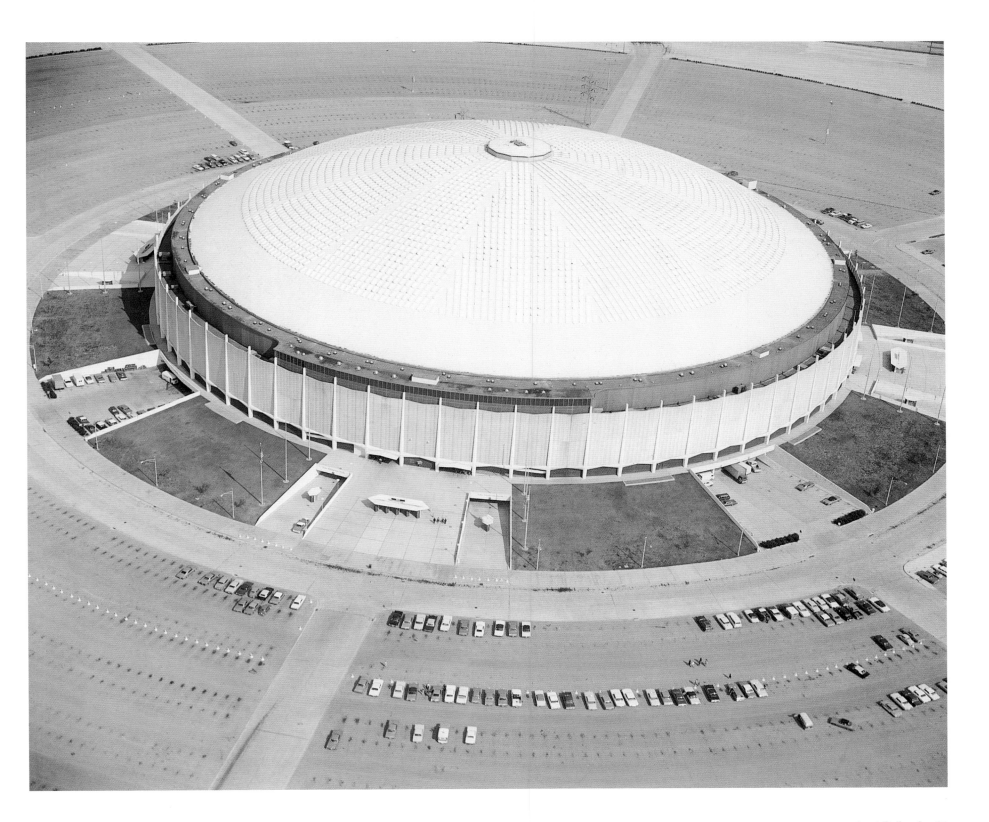

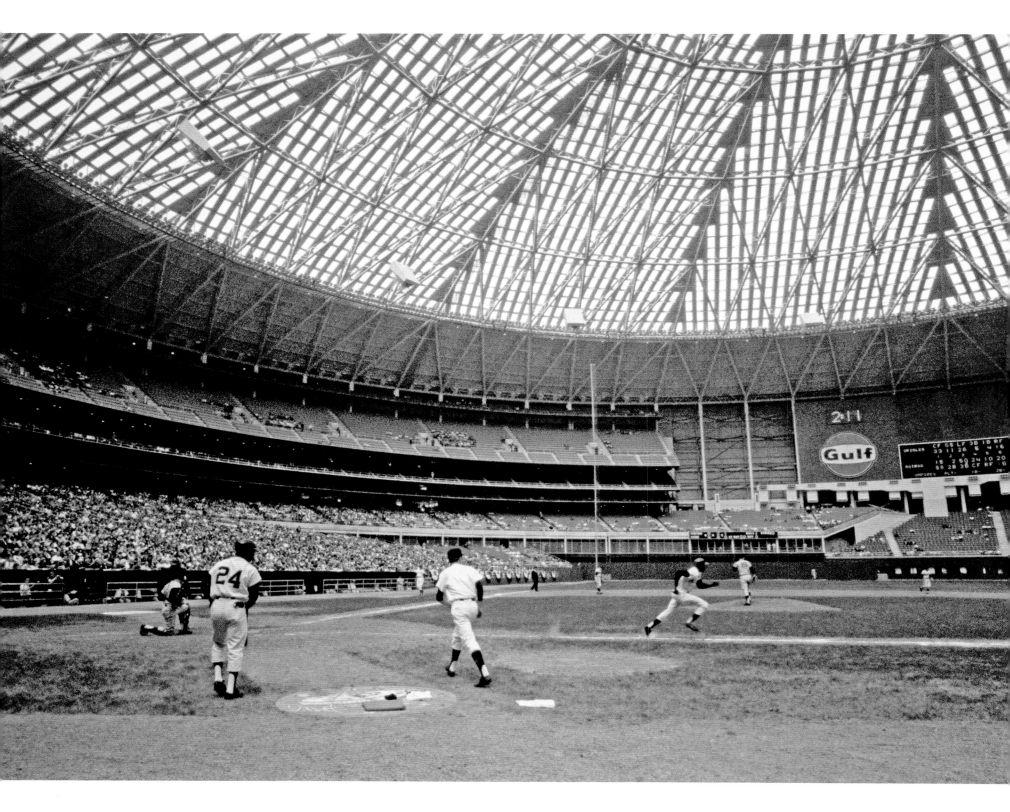

was a driven, self-made Houston politician named Roy "The Judge" Hofheinz. Not only would Hofheinz steward the project to completion, but he would also partner with financier Bob Smith to create the Houston Sports Association—which brought a Major League Baseball team to Houston by promising this elaborate new stadium.

More than 47,000 people—including President Johnson—attended the Dome's opening night on April 9, 1965. The game pitted the newly founded Houston Astros against the Yankees. Yankees legend Mickey Mantle said of the Astrodome, "It reminds me of what I imagine my first ride would be like in a flying saucer."

The crowd, used to bleachers and sunburn, was awestruck with the sheer size; the President called it "massive" and "beautiful." The Astrodome sported five restaurants, a first-of-its-kind "luxury box" and even a penthouse apartment and extravagant office for Hofheinz's private use. Twenty-three of America's 28 astronauts at the time attended the game, which the Astros took 2-1.

The new stadium developed its own trademark playing surface called "AstroTurf" (whose origins lay in an inability to keep the grass alive), which is used around the world today. The turf was originally kept clean by men in spacesuits known as "Earthmen."

Over the years, not only would the Astros use the dome but also the NFL's Houston Oilers, the University of Houston and the United States Football League Houston Gamblers.

Muhammad Ali, Evel Knievel, Elvis, Pink Floyd, The Who, The Rolling Stones, The Jacksons and Bob Dylan all made appearances at the dome.

The facility received a $100 million overhaul in 1987, but by the mid-1990s the thrill was gone. Houston had outgrown the stadium; the Oilers left town in 1996 and the Astros migrated to Enron Field (today Minute Maid Park) in 1999. A flurry of proposals and legislation were batted around town, as the 71,000-seat NRG Stadium next door became the city's premier sporting destination and calls to demolish The Eighth Wonder of the World grew louder.

Parts of the Dome were demolished in 2013, and much of the interior gutted—with bench seats and other memorabilia auctioned off to the public. Harris County Commissioners are looking at proposals to raise the floor level of the dome and create parking space underneath.

OPPOSITE *The Astros played their first regular-season game at the Dome on April 12, 1965, against the Phillies in front of a 42,000 crowd (Phillies took it 2-0). It was the only season that they played on natural grass.*

BELOW LEFT *The Astrodome speakers that towered high above the field were considered to be in play. In 1974, Mike Schmidt hit a mammoth shot that bounced off one of them for a harmless single.*

BELOW *A Hofheinz innovation was the luxury suite and private dining room facilities.*

BOTTOM *A restaurant view of the field from 1968.*

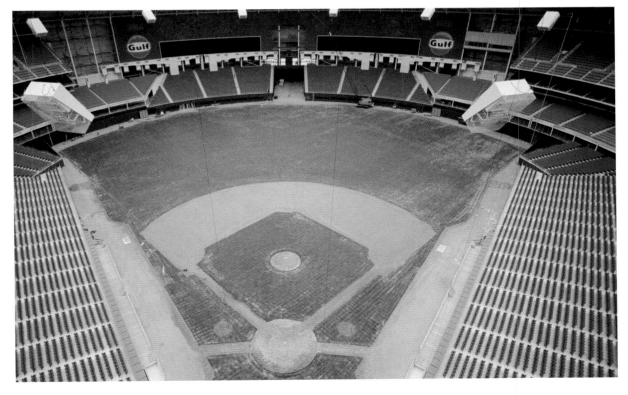

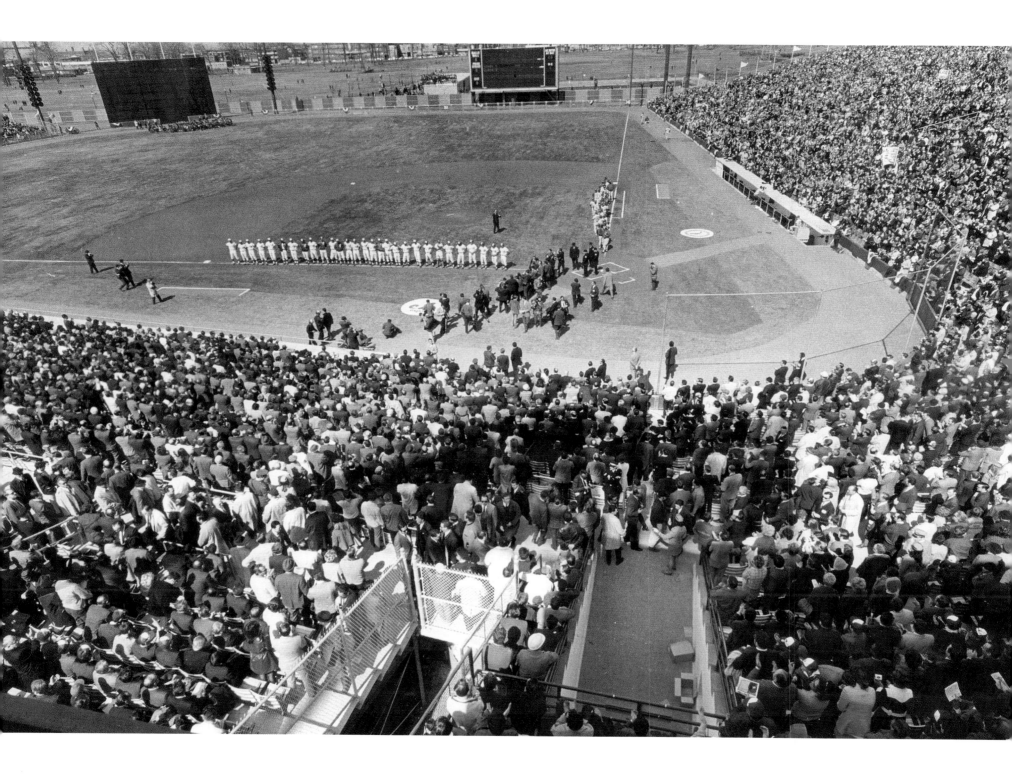

Parc Jarry Stadium, Montreal RECONFIGURED 1996

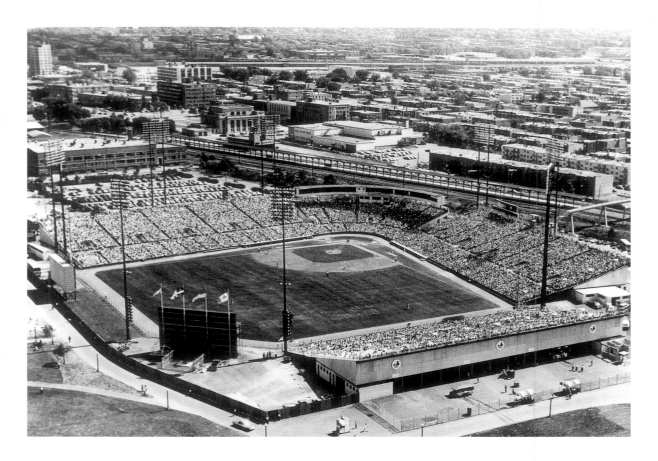

Parc Jarry Stadium (Jarry Park) in Montreal, is birthplace of the National League Montreal Expos. This ballpark began life in 1960 as a humble city park with a baseball diamond and seating for 3000. The city of Montreal owned the ballpark, which was bordered by Rue Faillon, Boulevard St. Laurent, Rue Jarry (thus the name) and the Canadian Pacific Railroad tracks. For years residents had supported the Montreal Royals, a top Brooklyn farm club playing on a field at Delorimier Downs, and who had enjoyed the services of Jackie Robinson in 1946.

Major League Baseball was planning an expansion for the 1969 season. The league targeted four new cities to add to its growing list of venues: San Diego, Seattle, Kansas City and Montreal, that is, if all these cities could have ballparks that met major league standards in time for opening day. Montreal assessed the possibility of expanding the diamond at Parc Jarry to meet the requirement and got right to work. By opening day, April 14, 1969, the upgraded stadium accommodated 28,500. However, some 29,184 people squeezed into the stadium for the first Major League Baseball game ever played in Canada. (The stadium's capacity was the smallest in the major leagues). The Canadian fans went home happy. In a one-run game the newly minted Montreal Expos (named after the inspirational 1967 Montreal Exposition) beat the St. Louis Cardinals 8-7.

The newly remodeled Parc Jarry Stadium featured uncovered, single-deck seating on three sides, with a large scoreboard in right field. Beyond the scoreboard lay a public swimming pool. Power hitter Pittsburgh Pirate Willie Stargell would be the first to make a splash with a 495-foot home run on July 16, 1969. His homer sent swimmers scurrying as it "landed" in the middle of the pool. In the end Stargell would prove to be the most prolific home-run hitter at Jarry with a total of 17.

The city opened Parc Jarry Stadium with the idea that it would soon build a domed facility that would seat more fans. From the onset, Jarry's major league days were numbered. The Expos played there for eight seasons and didn't have much success. A particularly significant moment came on October 2, 1972, when Expo Bill Stoneman pitched the first no-hitter outside the United States against the New York Mets. Interestingly, Hall of Famer Willie Mays had two final at bats in Parc Jarry Stadium: his last as a San Francisco Giant came on May 9, 1972, his last as a member of the Mets (the final at bat of his career) came on September 9, 1973.

The last major league games held in Parc Jarry Stadium took place on September 26, 1976, when the Expos faced the Phillies in a double-header. The Expos lost both games that day, 4-1 and 2-1. In the offseason they prepared a move to Stade Olympique (Olympic Stadium) which hosted the 1976 Olympics. The move came five years after Montreal had expected the team to move, and the new stadium's dome wasn't complete.

For a time, Parc Jarry was renamed Du Maurier Stadium after a brand of Canadian cigarettes. In 1996, it was largely demolished and reconfigured as a tennis stadium seating 11,700. The site is now home to the Canada Masters Tennis Tournament and is named the Uniprix Stadium after a Canadian pharmacy chain. A section of this lost ballpark's grandstand still comprises a part of the Uniprix Stadium.

ABOVE LEFT *Single decked and without cover, the ballpark was never intended to be the Expos longtime home.*

OPPOSITE *The opening game at Parc Jarry (Jarry Park) on April 14, 1969.*

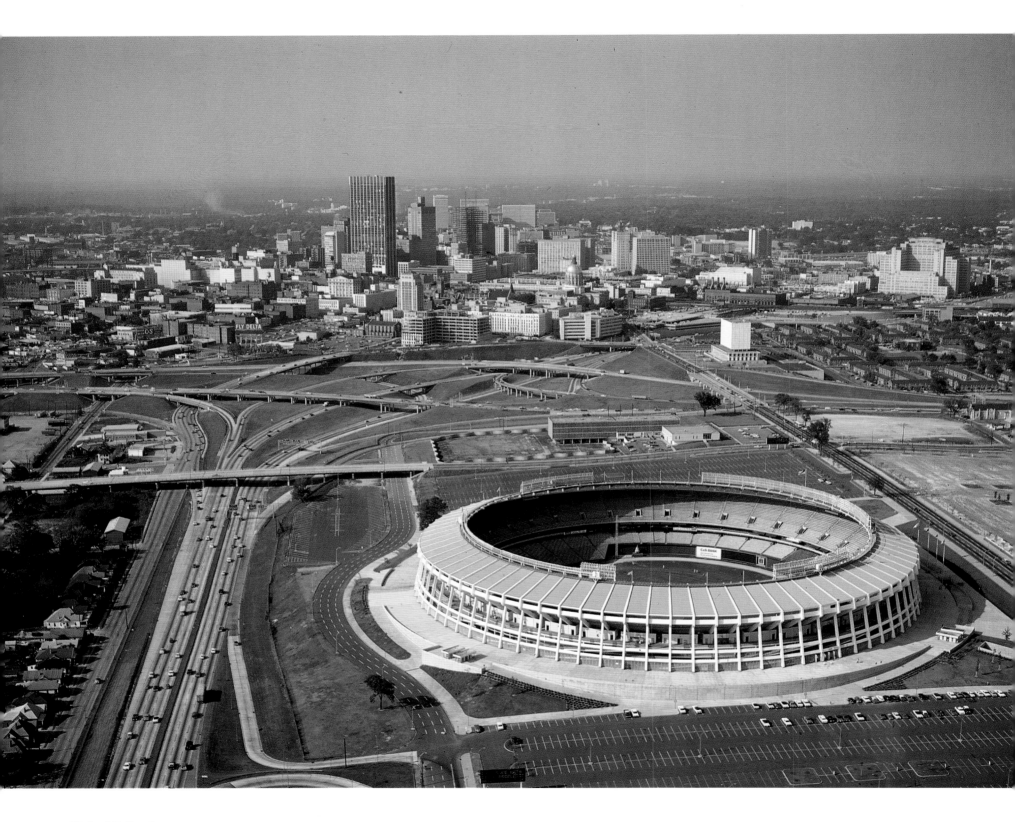

Atlanta Stadium/Atlanta-Fulton County Stadium, Atlanta IMPLODED 1997

Standing in a patch of land featuring the ruins of the once-stately houses of Atlanta's old Washington-Rawson neighborhood, Charlie Finley, the embattled owner of the Kansas City Athletics baseball team proclaimed it the perfect location for a major league ballpark. It was April 1963, and Finley had just heard a smooth sales pitch from Atlanta Mayor Ivan Allen Jr. promoting his city as the next great baseball town—and this spot in particular as the ideal site for a new stadium. Finley, who was under pressure from league owners to keep his team in Kansas City, was sold. "You build a stadium here, and I guarantee you Atlanta will get a major league franchise."

Finley's proclamation set the wheels of Atlanta's power structure in motion, and before long Allen had nearly half a million dollars to finance an architectural and site planning study. The money was fronted by Mills B. Lane, president of the Citizens & Southern National Bank, and the action took place at lightning speed before the Atlanta Board of Aldermen could vote on it. Meanwhile, league owners denied Finley the chance to move his team, but that did not stop Mayor Allen from pursuing other suitors, and the Milwaukee Braves were prime prospects. In 1965, the Milwaukee Braves won approval to make the move to Atlanta.

Later Allen would boast, "We built a stadium on ground we didn't own with money we didn't have for a team we hadn't signed."

Construction began on Atlanta Stadium on April 15, 1964, and was completed almost a year later. Remarking on its closeness to downtown and the expressways, and touting the amount of available parking spaces, the *Atlanta Journal* noted the stadium's convenience to fans. Ironically, critics complained over the stadium's remote location in later years.

The deal to bring the Milwaukee Braves to Atlanta was based on the team moving in 1966, so the Atlanta Crackers, who by this time were the AAA affiliate of the Braves, played in the stadium in 1965, their final year in Atlanta before moving to Richmond. In August of that year, Atlanta Stadium hosted a performance by the Beatles to a crowd of over 30,000.

Atlanta Stadium was a circular, cookie-cutter structure that housed a symmetrical ball field, similar to many stadiums built in that era. Ballparks in earlier times were built in tight spaces in urban areas and had to conform to the contours of surrounding streets and existing structures. Those restrictions resulted in fields of play with uneven outfield measurements.

In addition to Atlanta Braves games and outdoor concerts, the stadium hosted Atlanta Falcon football games, professional soccer matches, and college football's Peach Bowl. Sports fans witnessed a number of exciting events, but none more so than the events of April 8, 1974, when slugger Hank Aaron hit his 715th home run, breaking Babe Ruth's longstanding record. In 1976, Atlanta Stadium was renamed Atlanta-Fulton County Stadium.

In 1996, Atlanta hosted the Centennial Olympic Games and sports venues were constructed throughout the city. The gem of them all was Centennial Olympic Stadium, which after the games was remodeled as a baseball stadium and renamed Turner Field after Braves owner Ted Turner.

The Atlanta Braves were headed there after the 1996 World Series against the New York Yankees was settled. After winning both of the first two games in New York, the Braves headed to Atlanta-Fulton County Stadium with a 2-0 lead and then proceeded to lose all three of their home field games. The Yankees won the series 4-2. On August 2, 1997, the scene of the triple loss was imploded in 30 seconds and became part of the Turner Field parking.

OPPOSITE *When Atlanta Stadium opened in 1965, it was the seventh-largest baseball stadium in the major leagues with a capacity of nearly 52,000. The stadium could expand to a capacity of around 62,000 for Atlanta Falcon football games.*

FAR LEFT *Atlanta Stadium in 1966 shows the ever-present teepee in left field that was the province of the Braves' mascot, Chief Nok-A-Homa. The teepee was removed in 1982 to expand the seating capacity. The Braves discontinued Chief Nok-A-Homa's service in 1986.*

LEFT *Slugger Hank Aaron connects to break Babe Ruth's all-time home run record of 714 in Atlanta Stadium on April 8, 1974. Aaron went on to hit 755 home runs in his career.*

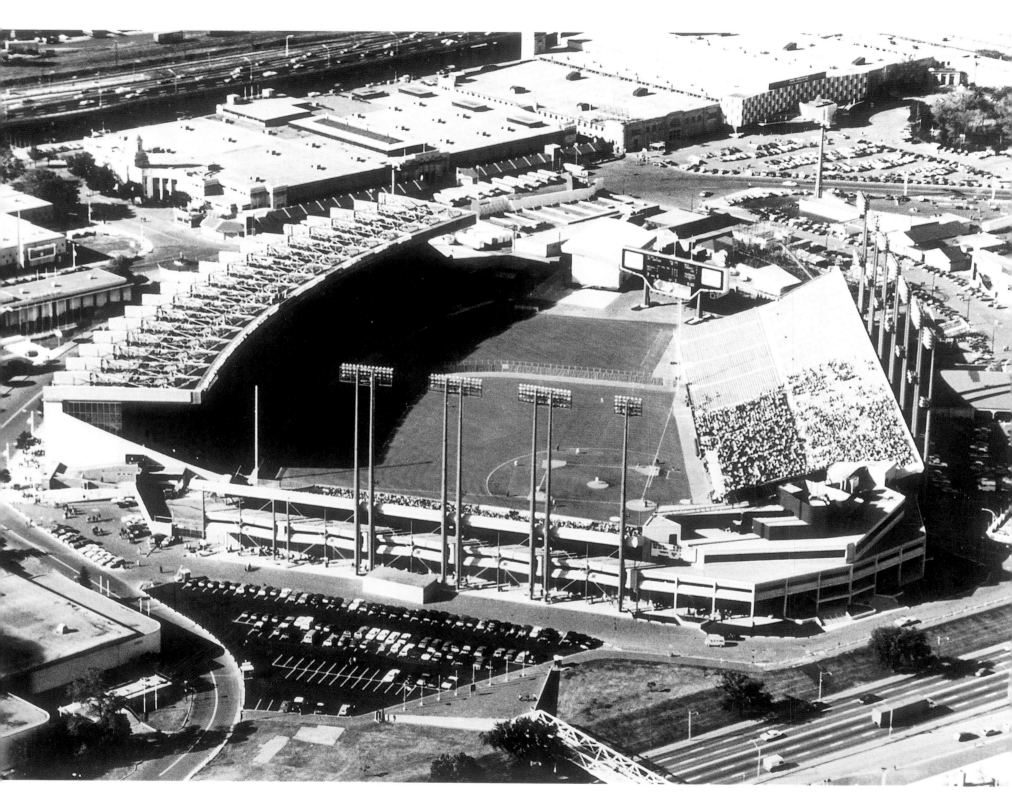

Canadian National Exhibition Stadium, Toronto GIVEN THE 'COUP DE GRACE' 1999

The Canadian National Exhibition Stadium— fondly known to all as "the Ex"—served as the original home of Major League Baseball's Toronto Blue Jays. It had been a multipurpose arena with a grandstand stretching back to exhibitions in the late Victorian period, almost a hundred years before the Blue Jays arrived for their first game.

"The Ex" was remodeled in 1974 in anticipation of attracting a major league team. The 1977 expansion created the Toronto Blue Jays who began playing in what was a highly compromised ballpark. The Ex had many of the weather problems of Candlestick Park (wind and fog) as well as the seating snags of a stadium that was better suited to football.

In fine Canadian form, it snowed the very first day that the Blue Jays played. An icy crowd of 44,649 attended the April 7, 1977, game against the Chicago White Sox, a 9-5 victory for the home team. The Jays posted a 54-107 record that year. Despite the poor record, the team set record attendance levels for a rookie team. Torontonians were ready for professional baseball.

Surely a losing record was to be expected for the newest team in baseball, but for the next three years, Toronto finished last in its division. Tensions built as fans, players and executives realized that their home park wasn't ideal for baseball. Jays owner Paul Beeston said in an interview with the *Toronto Globe and Mail*, that it wasn't just the worst stadium in baseball, it was the worst stadium in sports.

As the aerial photos reveal, the seats down the right-field line and in right center actually faced each and they were a long way from the infield. Some were a colossal 820 feet from home plate—the most remote seating of any major league ballpark. Ironically it was the distant seats that offered the most protection against the elements.

The stadium's proximity to Lake Ontario brought other problems. Like the soon-abandoned Ewing Field in San Francisco there was an issue with fog. The presence of fog once assisted a bizarre inside-the-park home run for the Blue Jay's Kelly Gruber in 1986, when an otherwise routine pop up was lost by the outfielders in the fog.

In 1984, a game against the Texas Rangers was called off when the windspeed hit 60 mph. Doug Rader, the Rangers manager, called on Jim Bibby as his starting pitcher with the memorable quote "he's the heaviest man in the world, and thus will be unaffected by the wind." After only six pitches umpires took the teams off the field.

If the remote seats, fog and wind wasn't enough, there was also the seagull problem.

Due to its position by the lake and encouraged by the food regularly discarded by fans, the stadium became popular with flocks of seagulls. New York Yankees outfielder Dave Winfield threw a ball to the ballboy after his warm-up exercises ahead of the 5th inning in a 1983 game and killed a seagull with his throw. Winfield was arrested for the seabird's intentional slaying. Yankees manager Billy Martin denied that it was intentional: "They wouldn't say that if they'd seen the throws he'd been making all year. It's the first time he's hit the cutoff man." The charges didn't discourage Winfield who later became a Blue Jay and won a World Series with them in 1992, but at the much safer SkyDome.

The last Major League Baseball game at The Canadian National Exhibition Stadium came on May 28, 1989, against the Chicago White Sox. The Jays won 7-5. The new decade found Toronto batting in their new home, the SkyDome, later known as Rogers Centre. They won back-to-back World Series there in 1992 and 1993, marking the first time a world champion baseball team wasn't American.

The unlamented Ex was demolished in 1999 to make way for BMO Field, a new 20,000-seat stadium dedicated to professional soccer.

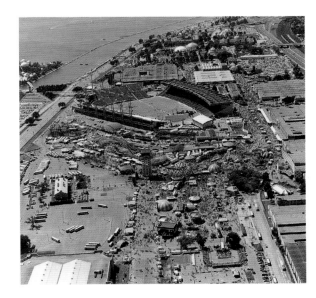

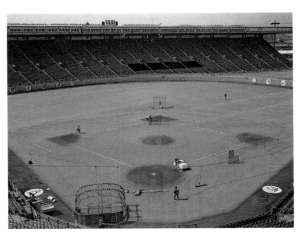

TOP *The stadium was an integral part of the Canadian National Exhibition site.*

ABOVE *The Ex in 1988.*

OPPOSITE *A sparse crowd at Exhibition Stadium in the 1970s, but no sign of the seagulls.*

Kingdome, Seattle IMPLODED 2000

Built on the former site of railyards south of Pioneer Square and downtown, the Kingdome was Seattle's first major league sports stadium.

It took three votes before King County's citizens finally approved the $67 million expense and the location. It had come about after the loss of the Seattle Pilots to Milwaukee, who moved east and became the Brewers. The city of Seattle and the state of Washington sued the American League for breach of contract. Confident that a Major League Baseball side would be coming back to the city, and with the prospect of an NFL expansion team, the city needed to build a suitable venue. Sick's Stadium was not going to be an option.

After first proposing the Seattle Center grounds and then eliminating every other option, planners settled on the more remote area south of downtown. Still, not everyone was a fan of the idea. A group of angry Asian American youth activists from the neighboring International District interrupted the ground breaking ceremony in 1972, hurling insults and mud balls at the politicians and dignitaries.

From its completion in 1976 until implosion in 2000 the Kingdome was home to the NFL Seahawks. The stadium attracted the MLB All-Star Game in 1979 but as time wore on the deficiencies of the stadium began to emerge. It had been built as a football stadium that could be converted to baseball, with a correspondingly large foul territory and seating set back from the playing area. After the 1977 opening day sell-out against the Angels, the Mariners went a decade before they did it again.

As the team's fortunes and attendance picked up in the mid-1990s, so both Seahawks and Mariners felt they would be better off in their own stadium. Ceiling tiles collapsed onto the seating area during one Mariners game and lobbying began for a new venue. Safeco Field, complete with retractable roof, appeared a block away and was ready for play in July 1999. Mariner Ken Griffey Jr. had hit his first home run on his first visit to the plate at the Kingdome in 1989, so it was fitting that on June 27, 1999, he hit the final run in the Kingdome.

It took 16.8 seconds for the 250-foot high concrete shell of the dome to collapse when it was imploded in 2000.

OPPOSITE *The Kingdome nears completion in 1975 with the south parking lot completed and the remaining train tracks on the right.*

BELOW LEFT *The Kingdome is framed by ships from Elliott Bay during Seafair in 1982.*

BELOW *Each explosive creates a puff of dust and smoke as the Kingdome implodes in 2000.*

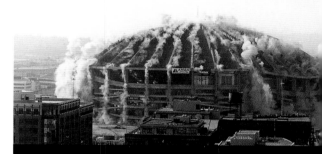

THE 12TH MAN

Seattle teams have a reputation for having loud fans, and the cavernous Kingdome served them perfectly. With 11 men on the football field, the fans became known as the 12th Man and the Kingdome as the loudest stadium in football. The jersey number 12 was retired in the fans' honor during the 1984 season, after the Seahawks' first playoff appearance. In 1989, the NFL instituted its infamous crowd noise rule in response to the 140 decibel echo chamber inside the Kingdome. Visiting teams would be given free yardage when the fans got too loud for the quarterback to make calls. Many fans have priceless memories of Denver's Hall of Fame quarterback John Elway begging officials for help. Amazingly the rule is still on the books but now never put to use.

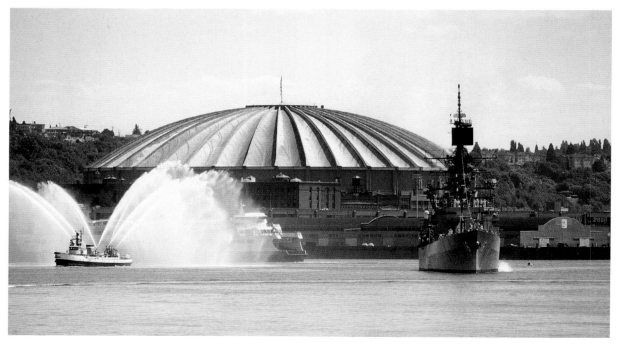

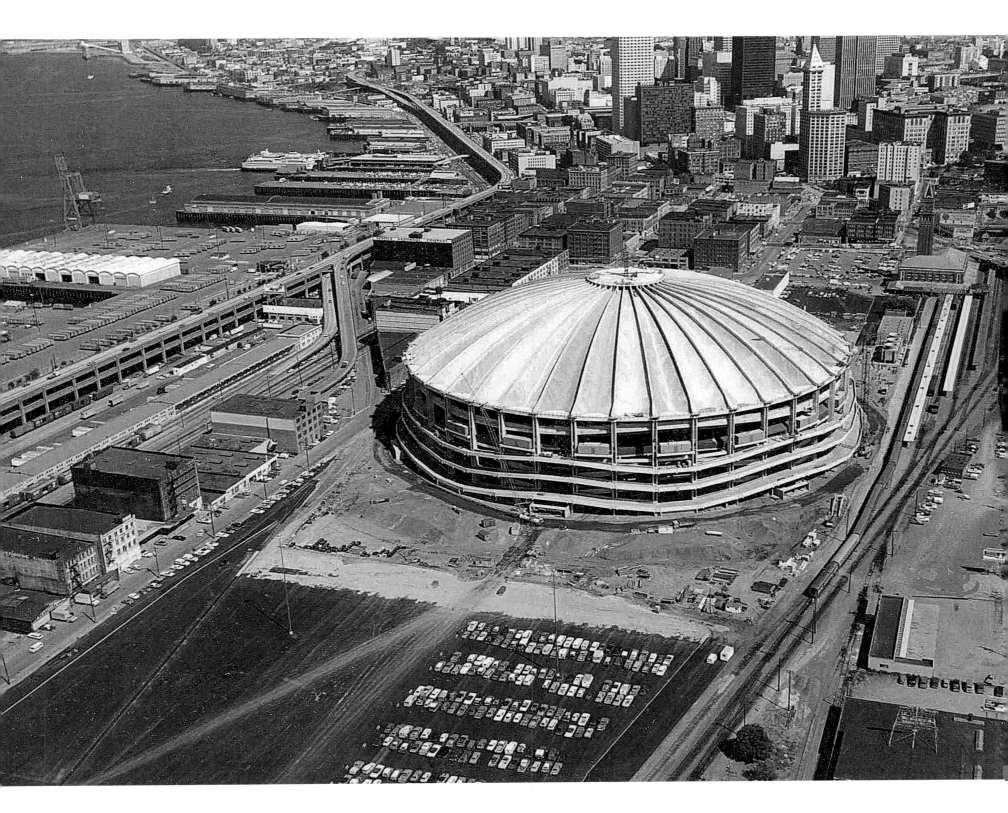

County Stadium, Milwaukee DEMOLISHED 2000

County Stadium in Milwaukee, Wisconsin, has the distinction of being the first large ballpark built in the 1950s. The city of Milwaukee has the added distinction for being the first to attract a team from the East during the series of major league relocations that began in the 1950s. County Stadium was designed to attract just such a team. Construction began October 19, 1950, on the site of a former garbage dump. Both the St. Louis Browns and Boston Braves had expressed interest in Milwaukee, but it would be the Braves who took

the field for the first time on April 14, 1953. The National Football League's Green Bay Packers also began playing at County Stadium that September.

County Stadium could seat 28,111 fans when it opened. The venue featured a double-decked grandstand with wooden bleachers on the second deck. With attendance already on the rise in 1954, seating capacity was expanded to 43,340 with a second deck for seating added down both the left- and right-field foul lines. In 1960, trees were planted just outside the outfield and a picnic area

called "Braves Reservation" was created between the bleachers.

By the early 1960s, flagging attendance at County Stadium led to the Braves pulling up roots and moving from Milwaukee to Atlanta in 1966. This left the Green Bay Packers as the only tenant. The Braves exit did not sit happily with Milwaukee native Bud Selig, a part owner of the Braves who swiftly liquidated his ownership in the franchise. He formed a corporation that year, the Milwaukee Brewers Baseball Club Inc., with the sole purpose

of bringing the team and a name that he knew from his childhood—the minor league Milwaukee Brewers—back to the city he loved as a brand new major league team.

As a test, Selig engaged the Chicago White Sox to play a few games at County Stadium in 1968 and 1969. Selig's move resulted in some of the best home game attendances the White Sox achieved in the late 1960s. It proved to Milwaukeeans that they had a fan base for a professional-caliber home team. This sent Selig out to secure a major league team to play at County Stadium. He settled on the struggling Seattle Pilots, who opened the 1970 season with the name that Selig loved: the Milwaukee Brewers. Selig later played a notable role in Major League Baseball. He served as the

league's commissioner and its chief operating officer from 1992 to 2015.

During the 1970s, County Stadium was home to Bernie the Brewer, the team's mascot, whose chalet sat between the bleachers in center field. By that time, the park had been expanded to seat 52,000 in the new upper deck. In 1990, the Brewers decided they were through with County Stadium. Plans were drawn up for the new Miller Park and, starting in 1996, Milwaukee fans could watch their new cathedral to baseball rising up beyond County Stadium's center-field fence.

A crane accident on July 14, 1999, halted construction at Miller. The accident killed three workers and delayed opening day at the new ballpark for a year. Many found the tragic accident

ironic, pointing out that the rush to complete the stadium had caused the accident, which ended up delaying the completion.

The Brewers played their last game at County Stadium on September 28, 2000. They said goodbye with 56,364 fans looking on as they lost to the Cincinnati Reds. Later that year, the stadium was demolished and has since become Helfaer Field, a ballpark for Little Leaguers named for Evan Helfaer, an original investor in Major League Baseball's return to Milwaukee. As a nod to the past, the kids' park retains the foul poles from the old County Stadium.

ABOVE *Miller Park arises beyond center field and hosted the Brewers from 2001.*

LEFT *A Braves fan shows his team colors during game three of the 1957 World Series.*

Miami Stadium, Miami DEMOLISHED 2001

Miami Stadium opened on August 31, 1949, as the home park for the Miami Sun Sox, a Brooklyn Dodgers farm team. The ballfield stood on real estate bounded on the north and south by Northwest 23rd and 27th streets respectively, and could seat some 13,500 fans.

Over the years, Miami Stadium played host to a variety of minor league clubs other than the Sun Sox. These included the Marlins, the Orioles, the Amigos and the Gold Coast Suns. The Los Angeles Dodgers held their spring training here. In fact, Miami Stadium hosted the first game ever played by the newly minted Dodgers. The Brooklyn evacuees didn't debut at Dodger Stadium in Los Angeles with their new L.A. insignias. The team's first game took place in Miami as part of its spring training ritual on March 8, 1958, before almost 6,000 fans. The Baltimore Orioles followed in the Dodgers' footsteps, holding spring training at Miami Stadium from 1959 to 1990.

Red neon lights, Art Deco styling and murals depicting historic baseball players greeted Miami Stadium's visitors. A specially designed cantilever roof, rare among ballparks, provided shade without any pylons supporting the roof and blocking the view of the field.

Today's major league Marlins never played baseball at Miami Stadium, but they continue a legacy of the Marlins in Miami going back to 1956. The Class AAA Marlins played here between 1956 and 1960 in the International League.

The Marlin name came about, like so many baseball teams, through a fan contest. Earl Purpus, a Miami native, suggested marlin because it was "the most sportingest game fish I know of." For his winning suggestion Purpus received box seats for the entire 1956 season.

In 1987, Miami's city commission voted unanimously to rename the stadium after baseball entrepreneur Bobby Maduro. A native of Cuba, Maduro poured his energies into the expansion of baseball "without borders and without prejudices" over his 50-year career. The player, club owner, stadium builder, scout and diplomat founded leagues both in Cuba and internationally. He also served as the baseball commissioner's "Coordinator of Inter-American Baseball" from 1965 through 1978 after emigrating to the U.S.

In 1989, the stadium found itself housing Nicaraguan refugees seeking political asylum after rebels were encouraged to overthrow the Marxist regime in the Central American country. Some 256 displaced people called the Bobby Maduro Miami Stadium home for a few weeks before the Orioles arrived for spring training.

Once the major league expanded, inviting the creation of the Florida Marlins in 1993, Bobby Maduro Miami Stadium was left behind. The Marlins opted for the much larger Joe Robbie Stadium, home to the Miami Dolphins. Not long after, Miami officials eyed the ballpark property for redevelopment.

The city rezoned the location of Miami Stadium as "residential" and sold it to St. Martin Affordable Housing Inc. for $2.1 million. The organization announced its intention to build an apartment complex on the site. Two years later, the city took the next step in the process and razed Miami Stadium. Today the Miami Stadium Apartments stand on the site of this lost ballpark.

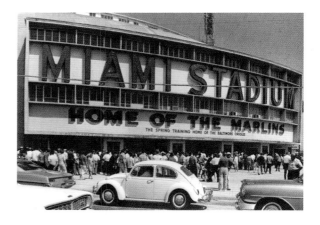

ABOVE *The entrance to Marlin Stadium in the mid 1960s before the Bobby Maduro name was added.*

RIGHT *Miami Stadium around the time that Satchel Paige arrived to pitch for the Marlins after his major league career had ended. In his first game in 1956, he pitched a four-hit shutout.*

BELOW *Yogi Berra of the Yankees is shown driving a home run during an exhibition game against the Baltimore Orioles in 1959.*

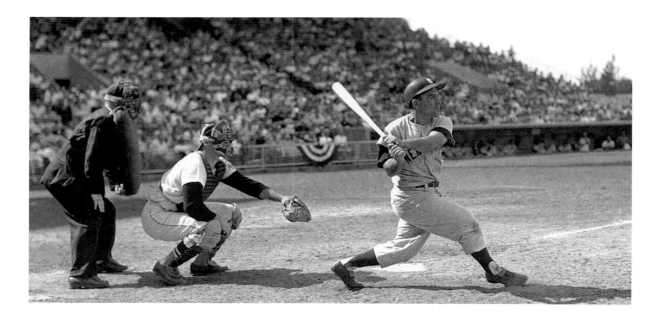

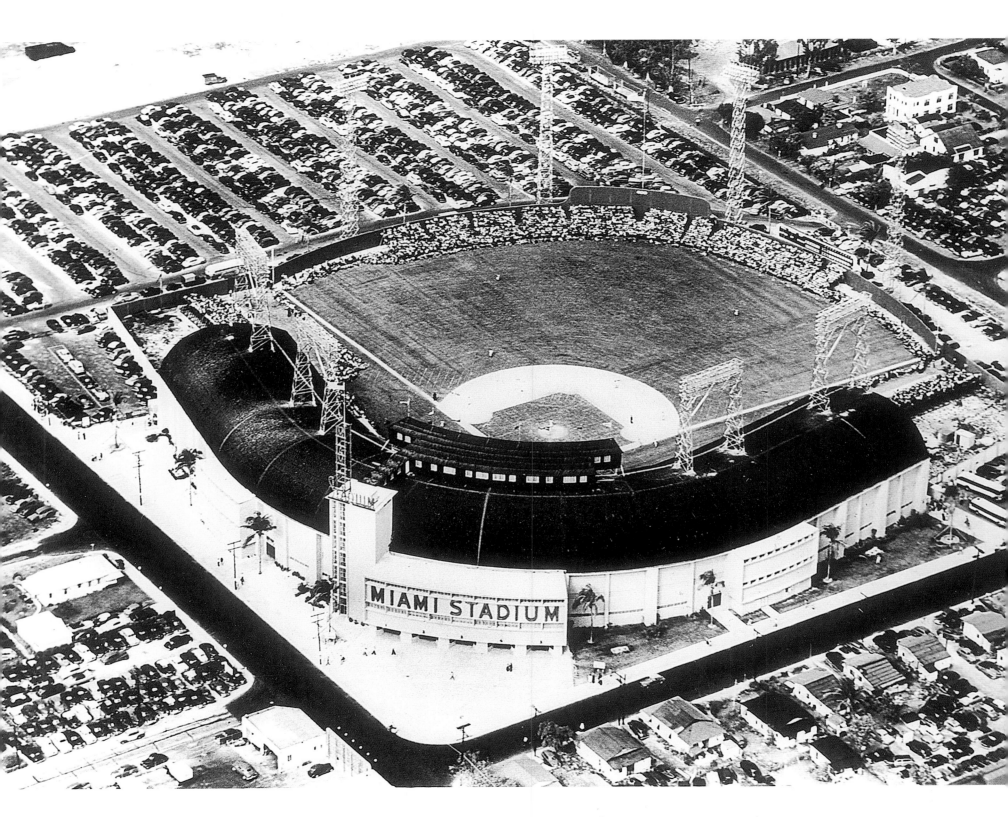

Three Rivers Stadium, Pittsburgh IMPLODED 2001

The Pittsburgh Pirates broke ground for Three Rivers Stadium while they were still playing ball at 60-year-old Forbes Field. The team planned to open the 1970 season in its new home, but plans ran behind schedule. Problems included thieves helping themselves to building materials at the site. The city had already nixed a plan to build Three Rivers on a "bridge" over the Monongahela River.

Ironically, the site chosen was Exposition Park, where the Pirates had played ball before moving to Forbes Field. The new stadium's name recalls the confluence of the Allegheny and Monongahela rivers that form the Ohio River in the heart of the city. Three Rivers finally opened after the mid-season All-Star break on July 16, 1970. The Pirates finished play at Forbes Field on June 28, 1970, with a doubleheader sweep of the Chicago Cubs. Historians (and baseball trivia buffs) love to point out that the first game at Forbes Field on June 30, 1909, was also played against the Cubs. The Pirates lost that one, though, the Cubbies won 3-2.

The Pirates shared the stadium with the Pittsburgh Steelers of the National Football League. Three Rivers Stadium's design echoed that of RFK Stadium in Washington, D.C. and Riverfront Stadium in Cincinnati, Ohio, multi-purpose facilities in a cookie-cutter design or "concrete doughnuts."

A lot of Pirates fans felt that the design of Three Rivers favored the Steelers, because, as it turned out, placing seats that suited football meant that nearly three-quarters of the baseball fans sat in fair-ball rather than foul-ball territory, as was the norm with pure baseball stadiums. In fact, the city considered making the stadium a venue solely for the game of football, but the Steelers did not go along with the idea. Problems arose each time the groundskeepers converted the field from baseball to football. They had to move two banks of 4,000 seats along the first and third base lines and the transition wasn't easy.

In the fall of 1991, a solution seemed at hand when talks began in earnest to build separate stadiums for the Pirates and Steelers. On July 9, 1998, after seven years of political wrangling, the Allegheny Regional Asset District Board approved an $809 million package to fund the Pirates' PNC Park (named for PNC Financial Service) and the Steelers' Heinz Field.

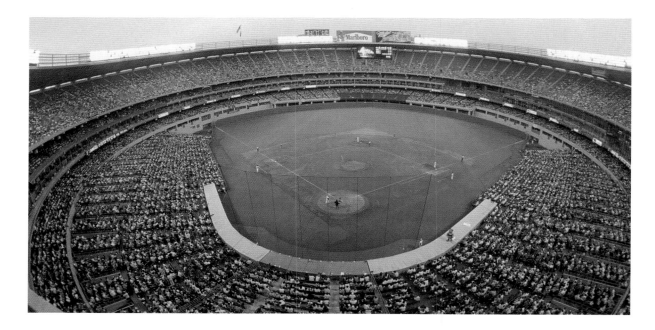

The Pirates opened their 2001 season at PNC Park next to the Sixth Street/Roberto Clemente Bridge. Thousands gathered on hilltops and rooftops on February 11, 2001, to watch explosive experts implode the stadium in 19 seconds. The city paid $5.1 million for Controlled Demolition Inc.'s expertise.

OPPOSITE *It may not have been the ideal ballpark, but Three Rivers Stadium was set in a beautiful location. Heinz Field was erected next door and is visible in the demolition shot below.*

ABOVE *Three Rivers Stadium circa 1985.*

BELOW *Three Rivers Stadium is imploded in 2001 but $30 million of debt remained. The debt wasn't retired until 2010.*

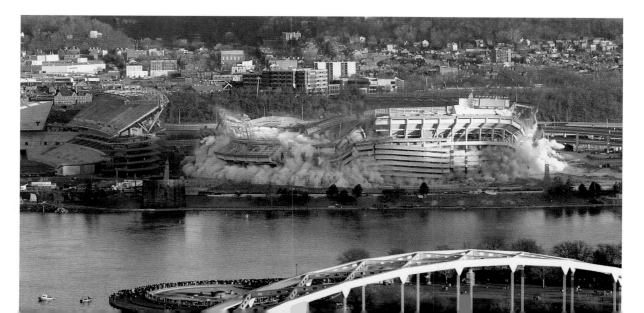

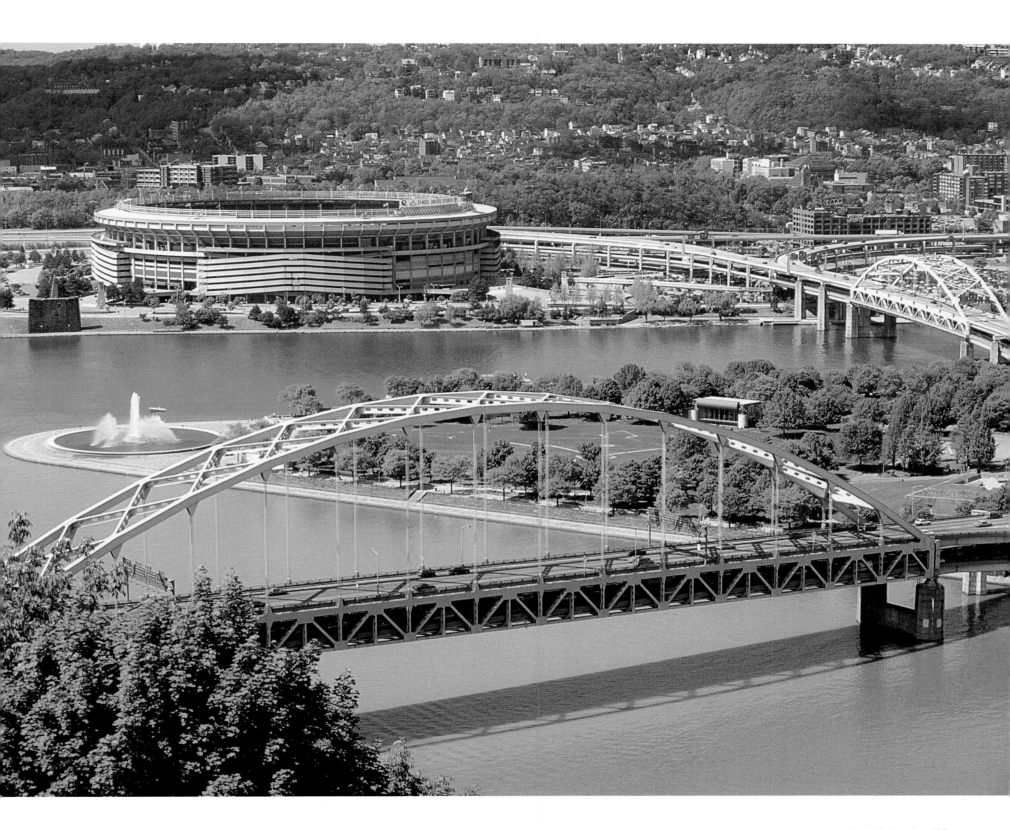

Memorial Stadium, Baltimore RAZED 2002

Known as "The Old Gray Lady of 33rd Street" and as "The World's Largest Outdoor Insane Asylum" for its rabid fans, especially during Baltimore Colts games, Memorial Stadium was the former home of Baltimore's baseball team, the Baltimore Orioles, and its NFL team, the Baltimore Colts. In addition, the stadium played host to college football games and even Canadian Football League games.

Situated in northeast Baltimore, Memorial Stadium was built in 1950 at a cost of $6.5 million and included seating for 31,000 spectators. It stood on the grounds of the former Baltimore Stadium built in 1922. Baltimore Stadium played host to college football games and the Baltimore Orioles of the International League beginning in 1944 after the Orioles' Charles Village stadium burned (see sidebar).

Memorial Stadium continued to be the home of the Baltimore Orioles of the International League, and the team enjoyed much success. Then, in 1954, Bill Veeck decided to move his hapless St. Louis Browns to Baltimore, giving the city a Major League Baseball team. They became the fourth major league franchise to be named the Baltimore Orioles. On April 15, 1954, a parade up Charles Street all the way to Memorial Stadium welcomed the team, and Vice President Richard Nixon was on hand for the celebration. Memorial Stadium was also the home to the Baltimore Colts until the team moved to Indianapolis in 1984.

Memorial Stadium was more than just a place to watch baseball and football. Many of the professional athletes lived in the surrounding neighborhoods, creating an intimacy with the team that fans in most cities today don't experience.

One of the most bizarre incidents occurred on December 19, 1976, when a small private plane crashed into the upper deck of Memorial Stadium on the same day the Colts were hosting the Pittsburgh Steelers in an NFL playoff game. Luckily, there were no serious injuries, as the stadium was rather empty at the time. Unfortunately for Colts fans, the reason there were few fans on hand was because the Steelers were crushing the hometown team, 40–14.

After the Colts' departure from Baltimore, the Orioles continued to play at Memorial Stadium through 1991, when the team moved downtown to the new Oriole Park at Camden Yards. Following the Orioles move downtown, Memorial Stadium was home to the Canadian Football League's Baltimore Stallions, and then in 1996 and 1997 to the Baltimore Ravens, the city's new NFL team. The Ravens played two seasons at Memorial Stadium before moving to a new stadium adjacent to Camden Yards.

After the Ravens left, Memorial Stadium remained empty. The City of Baltimore received

RIGHT *Memorial Stadium was originally built in 1922 as Baltimore Stadium, but it was transformed in 1950 with a $6.5 million investment.*

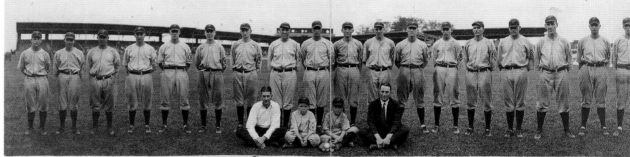

ORIOLE 1921 Base Ball Team.

THE ORIOLES' MANY NESTS

In addition to Memorial Stadium, the Orioles played in several other stadiums during their various incarnations, most of which were in the neighborhood adjacent to Memorial Stadium, around Charles Village. Baltimore had two brief flings with the major leagues in the early twentieth century. In 1903, the Baltimore Orioles of the American League moved to New York, where they eventually became the Yankees. In 1914, a new major league, the Federal League, debuted with the Baltimore Terrapins as members.

The team built a 15,000-seat park named Terrapin Park just across the street from the fourth different Oriole Park, where nineteen-year-old pitcher Babe Ruth was the star attraction for the minor league Baltimore Orioles. The Orioles and Terrapins competed for fans until the Federal League folded after the 1915 season. Terrapin Park was later renamed, becoming the fifth and best-known Oriole Park and the longtime home of both the minor league Orioles and the Negro League's Baltimore Elite Giants.

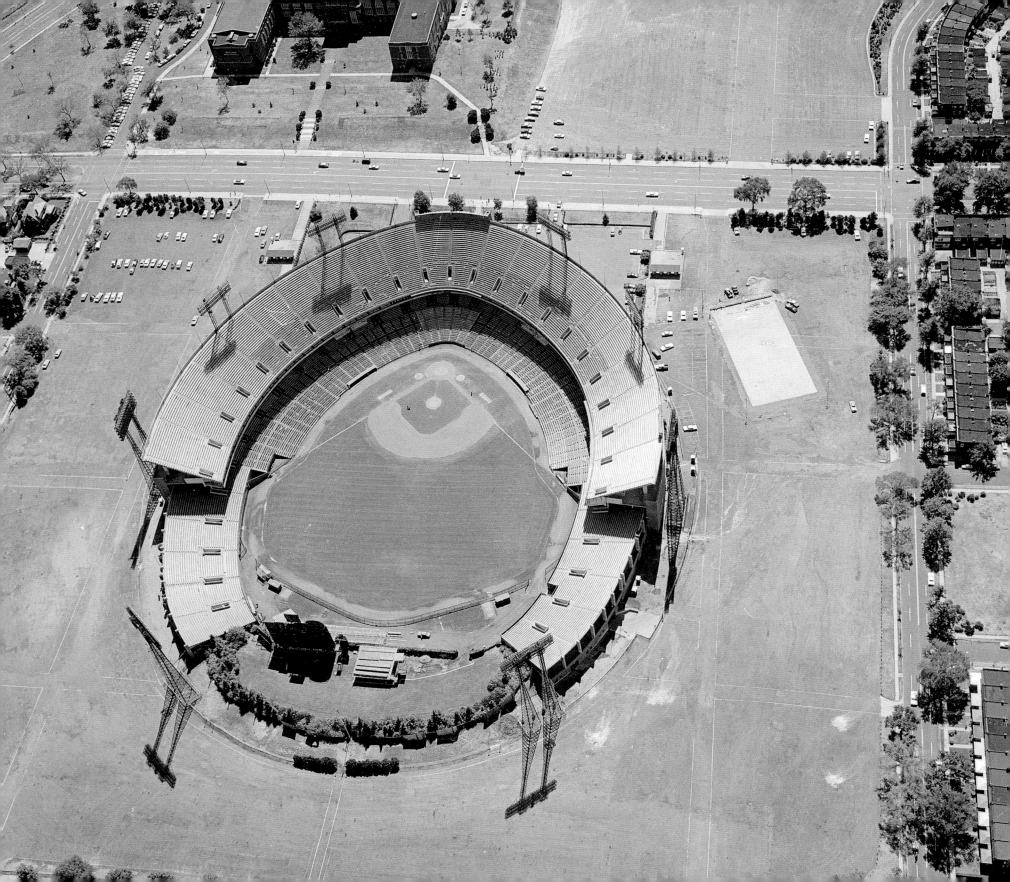

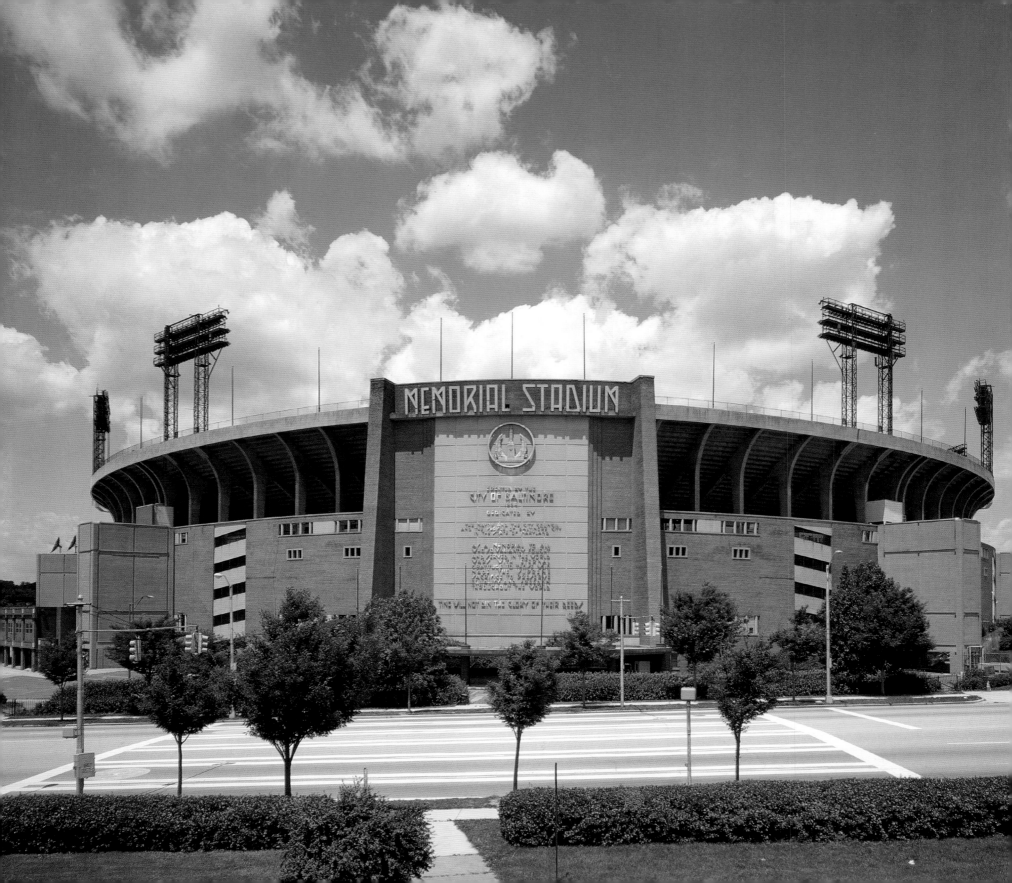

many proposals for reuse of the facility; however, it chose to raze the stadium beginning in 2001 through early 2002. Remnants of the stadium were used to help form an artificial reef in the Chesapeake Bay.

Memorial Stadium's most recognizable architectural element was the enormous plaque that graced the stadium honoring war veterans. On Memorial Day, 2003, an 11-foot-tall, curving black granite wall featuring the well-known phrase from the Memorial Stadium facade ("Time Will Not Dim the Glory of Their Deeds"), spelled out in the original stainless steel lettering, was dedicated at Camden Yards. In another tribute to Memorial Stadium at Camden Yards, an urn containing soil from all foreign American military cemeteries is displayed under glass, and a plaque explains the significance of Memorial Stadium in Baltimore history.

The former site of Memorial Stadium remained vacant until the construction of "Stadium Place," a mixed income housing community for seniors, and the Harry & Jeanette Weinberg Family Center. Also, a new recreational sports field was constructed on the site.

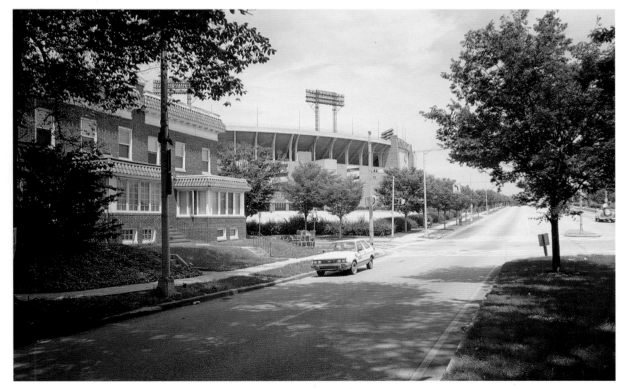

ABOVE *The large plaque honoring veterans was an iconic element of the stadium.*

ABOVE LEFT *After the departure of the Ravens, Memorial Stadium stood empty for many years.*

OPPOSITE AND LEFT *Located in the Waverly neighborhood, fans would often walk to Orioles and Colts games.*

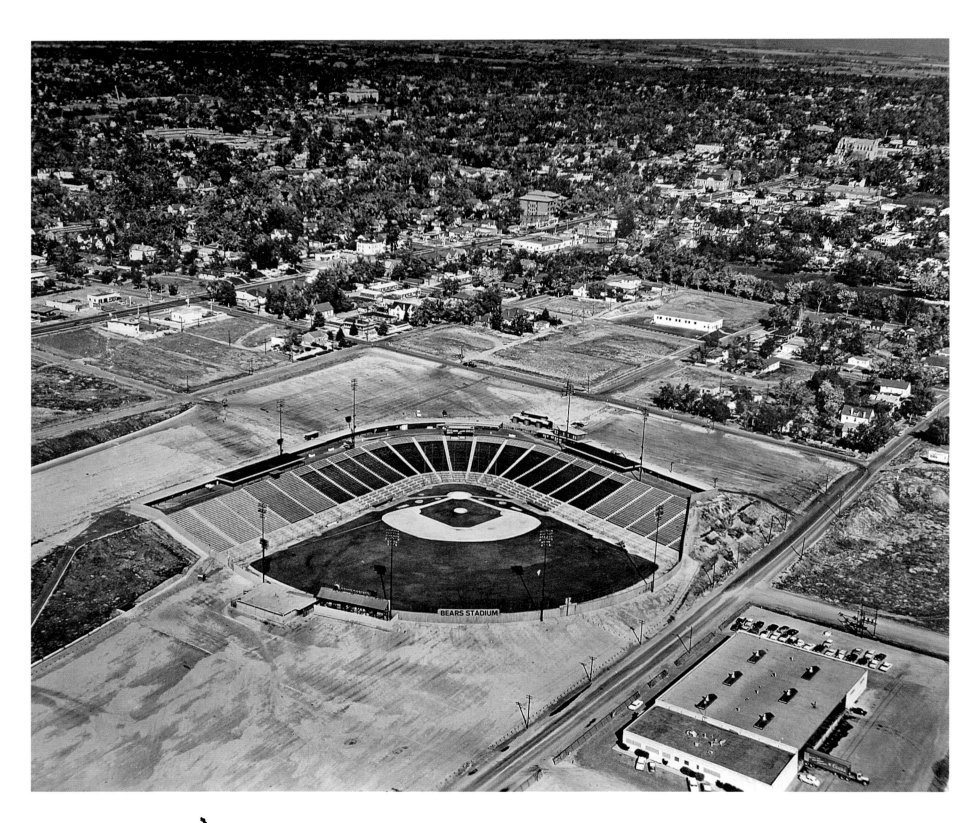

Bears/Mile High Stadium, Denver RAZED 2002

With six professional sports teams, there is no doubt that Denver is a sports town. Since 1948, Bob Howsam, the Denver Broncos' original owner, had owned the city's minor league baseball franchise, the Denver Bears, who played in the Western League. He also owned the 18,000-capacity Bears Stadium, the future Mile High Stadium. As competing forms of entertainment, such as television, caused the number of baseball fans to dwindle, Howsam realized he needed to do something to make more money. Bears Stadium was sitting empty half the year. In 1959, Howsam bought the AFL franchise for the Denver Broncos and Bears Stadium, built in 1948, would be their home from 1960 onwards. Despite many losing seasons the team improved (and dumped the yellow striped socks for the iconic orange and blue), the fan base grew and additions were made to the stadium to increase the seating capacity.

A bond issue to build a new stadium failed in 1967, but a nonprofit group calling themselves the DOERS raised $1.8 million to purchase the stadium from the Bears' owners and give the deed to the city. The following year, a new upper deck increased the capacity to 50,000, and the stadium got a new name—Mile High.

A $25 million bond issue in 1971 allowed for further expansion, and the stadium grew to accommodate 75,000. Luxury skyboxes added in 1986 brought the final capacity to 76,273.

Mile High Stadium returned to its baseball roots in 1993, when the Colorado Rockies expansion team brought major league baseball to Denver. The old Denver Bears became the Denver Zephyrs in 1985 and moved off to New Orleans. The Rockies played their first two seasons in Mile High, which offered movable stands to adjust between a football field and a baseball diamond. The stands, moved via hydraulics, inched along at about two feet per minute. A full move took about six hours to complete.

The Rockies' first game at Mile High drew 80,227 fans—well beyond capacity—setting the record for all-time attendance at a single baseball game, and they would go on to set MLB's largest single season attendance record at 4,483,450.

Meanwhile, the Broncos sold out 237 consecutive regular season games at Mile High Stadium. When the team arrived in 1960, it was the only professional sports team between California, Kansas, Canada and Texas, and the team still draws fans from Wyoming, New Mexico and Utah. Broncos and Rockies fans alike were known for the tremendous din that would arise with thousands of stamping feet.

In 1995, the Rockies moved to their new home at Coors Field and back-to-back Super Bowl wins helped fuel the enthusiasm for a new Broncos stadium. The Broncos played their last season at Mile High in 2000–2001. Then, in the fall of 2001, the Broncos started the season in their new home, sitting side by side with the old stadium before its demolition. A few things were saved and incorporated into the new stadium, such as the 27-foot-high white stallion, known as Bucky, who stood above the scoreboard. The seats were auctioned off, and markers installed in the new stadium's parking lot to show the locations of home plate and the original 50-yard line.

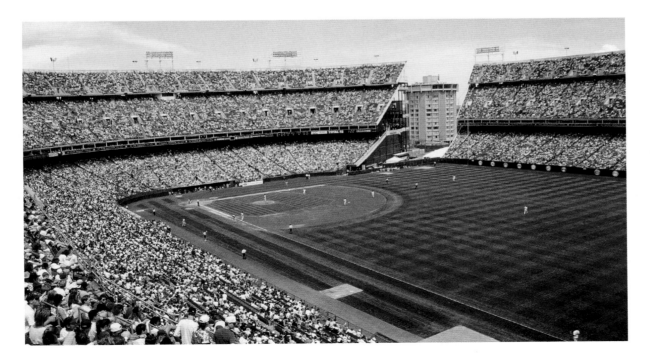

OPPOSITE *The Denver Bears' stadium in the early 1950s.*

ABOVE *A 1978 view of Mile High Stadium showing the scoreboard with its tall white bronco which moved to the new football stadium.*

LEFT *Mile High Stadium, configured for baseball, drew more fans in one season than any stadium in baseball history.*

Clearwater Athletic Field, Florida

ABANDONED 2003

For more than 30 years Clearwater Athletic Field in Clearwater, Florida, served as a spring training venue for Major League Baseball. The city built the park at the intersection of Pennsylvania Avenue and Seminole Street in 1923 to coax the Brooklyn Dodgers to train there each spring. Clearwater City Council sank $25,000 of the public's money into the effort. As a result, Clearwater became one of the premier spring training destinations, and remains so to this day.

To start things off, the Brooklyn Dodgers agreed to come to town to get ready for the 1923 regular season. On March 15, 1923, the Dodgers faced the Boston Braves in the first game here. The festivities included a parade that fans followed into the new ballpark. Baseball's first commissioner Kenesaw Mountain Landis tossed the first pitch to the waiting glove of Clearwater Mayor Frank Booth. The Dodgers delighted the 4,000 fans in attendance that day by beating the Braves 12-7.

The team then trained in Clearwater each spring from 1923 to 1932 and again from 1936 to 1941. Once the Dodgers established themselves at Clearwater Athletic Field, the ballpark took on the nickname "Brooklyn Field."

Other teams practiced for the regular season here. These included the minor league Newark Bears, a New York Yankees franchise. The Cleveland Indians followed the Dodgers. They began spring training here in 1942. The Philadelphia Phillies came to Clearwater five years later. The team still trains in town. As it happened, Cleveland stepped away from Clearwater after just a single season to test out Hi Corbett Field in Tucson, Arizona, as a spring training location. That one-year hiatus gave the Phillies the window they needed to take over Clearwater Athletic Field from the Indians.

In 1940, the city renamed the ballpark Ray Green Field to honor Ray E. Green. Green had served as the city's mayor from 1935 to 1938 and did much to improve the ballpark.

Jack Russell Stadium, just two blocks away, became the Phillies' new spring training facility in 1955. Just after moving to Jack Russell, strong winds helped fuel a fire that destroyed the grandstand at Ray Green Field. The fire started in an area south of the clubhouse on April 12, 1956, but, thanks to prevailing winds, did not reach the building. The ballpark still saw action after the fire, as the Phillies continued to use it as a practice field.

The Phillies finally moved their spring training to another new park, Bright House Field, in 2003. The city of Clearwater decided to redevelop Ray Green Field that same year. The former ballfield of the Dodgers and Phillies has became the North Greenwood Recreation and Aquatic Complex, but Ray E. Green has not been forgotten, the aquatic complex bears his name.

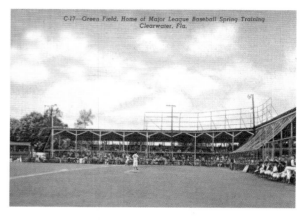

BELOW *Dodgers players Babe Phelps and Leo Durocher play a game of 'pepper' at Ray Green Field in 1937.*

OPPOSITE *A view from the Clearwater grandstand as the Brooklyn Dodgers work out in the batting cage in 1924.*

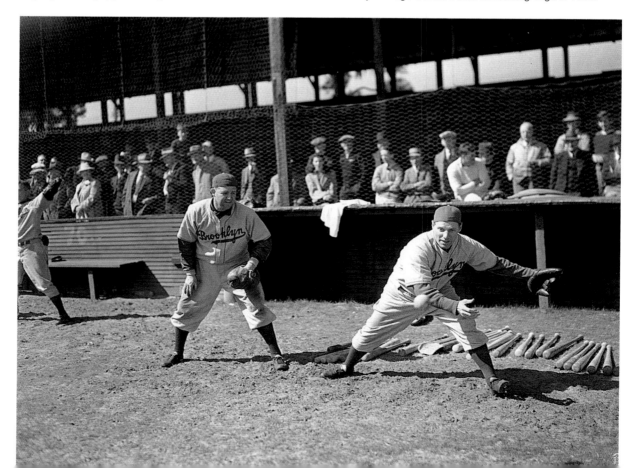

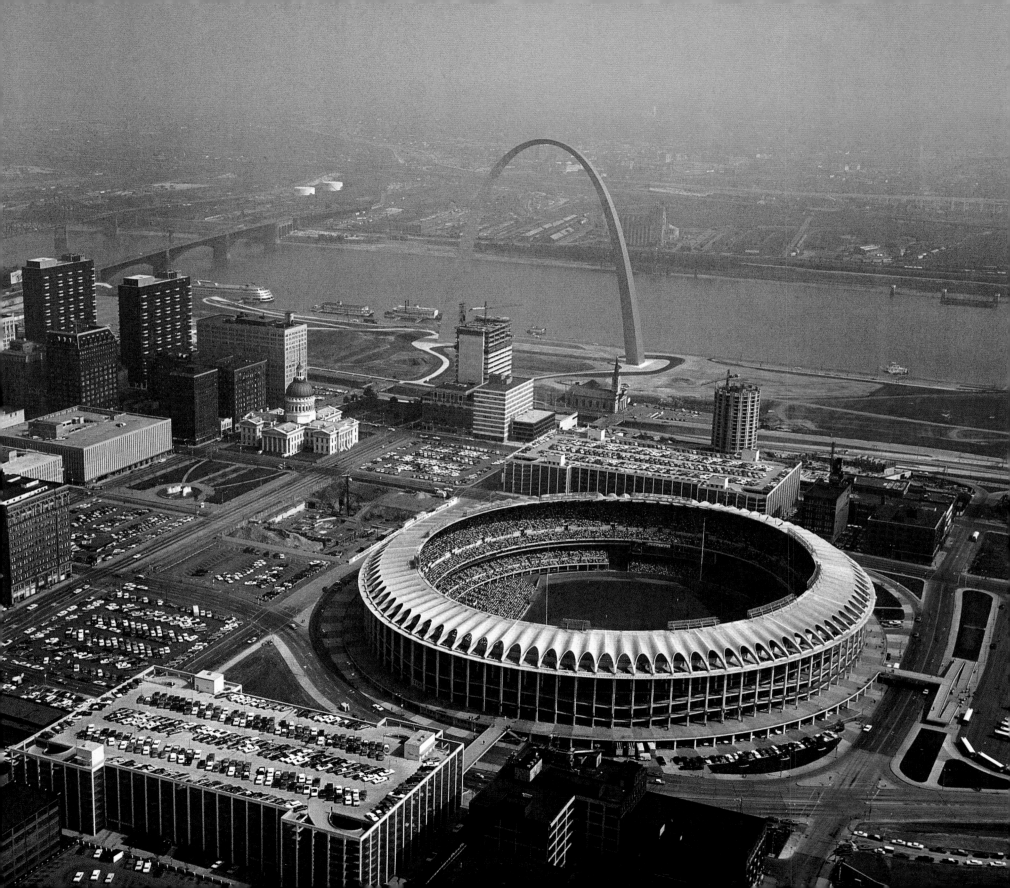

Busch Memorial Stadium, St. Louis

DEMOLISHED 2005

In 1958, the city of St. Louis wanted to revive a 31-block area of downtown and proposed a new baseball stadium as part of the plan. The former Sportsman's Park, now renamed Busch Stadium, was beginning to show its age.

Down came the city's small Chinatown, the Grand Theatre and various redundant fur warehouses to make way for a new kind of multi-use stadium. The original plan had been for a baseball-only ballpark, but when the football Cardinals arrived from Chicago after the 1959 season, the design was amended.

Both Cardinals teams shared Sportsmans Park/Busch Stadium until it was built. Apart from having the confusion of naming over the duplicate St. Louis Cardinals, there was also the multiple identities of the ballparks in town. Over the years there were three versions of Sportsman's Park, and in its latter years, Sportsman's Park was renamed Busch Stadium after team owner Gussie Busch.

The new cookie-cutter stadium both Cardinals would move into (Busch II) was the Busch Memorial Stadium, named for the Anheuser-Busch corporation, and Busch III would be the baseball-only stadium they erected in 2006, by which time the NFL Cardinals had long since left town.

Busch Memorial Stadium was designed by architects Sverdrup and Parcel with a 96-arch "Crown of Arches" at the stadium's rim, echoing the magnificent Jefferson National Expansion Memorial, the "Gateway Arch," that dominated the city after its erection in 1965.

Ground breaking commenced in May 1964, and construction took just under two years. The park was ready for the first pitch on May 12, 1966, one month into the baseball season. It's official name was the overlong Civic Center Busch Memorial Stadium, but that was too much of a mouthful for sportscasters and the "Civic Center" part was soon dropped.

Busch II hosted the Cardinals for 40 seasons until the end of 2005, when a bespoke baseball stadium (Busch III) was erected next door. The successor was designed by stadium specialist Populous (then known as HOK Sport) whose previous ballpark had been Petco Park in San Diego and whose next project would be Nationals Park in Washington, D.C.

Fearing damage to the Metro transit system, the city required that the old stadium was razed by wrecking ball and not imploded. The work was completed in time for Busch III to debut as planned in 2006 and the new season at the dedicated ballpark was a sell-out with a total attendance of 3,407,104 for the season, (at the time) the second-largest in team history.

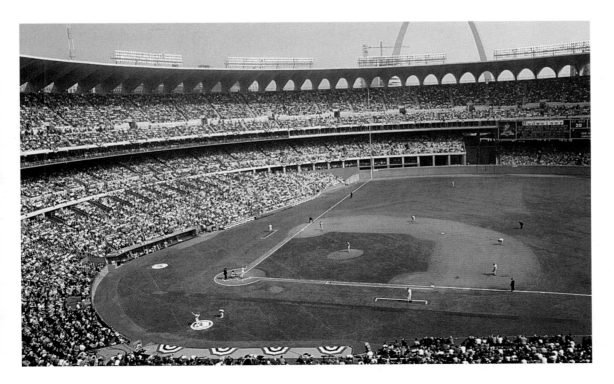

OPPOSITE *A magnificent aerial view of the Gateway Arch overlooking the 96 arches of Busch Memorial Stadium, aka Busch II.*

ABOVE *Busch III goes up in the tight confines of downtown St. Louis, next to Busch II.*

LEFT *The Cardinals play the Boston Red Sox in the 1967 World Series.*

Brookside Stadium, Cleveland REPURPOSED 2007

In 1908, City Clerk Peter Witt pitched an idea to the Cleveland Athletic Club. Witt had a vision. He dreamed of creating a 100,000-seat stadium in Brookside Park. Witt was looking four years into the future and wanted to bring the 1912 Olympic Games to his city. Baseball had been played for the first time at the 1904 St. Louis Olympics.

Witt saw the natural amphitheater in the city-owned Brookside Park as a perfect place to watch sport and recommended that the Athletic Club build the stadium in stages, 25,000 seats at a time. Those seats would overlook a playing field that

measured 500 by 750 feet. Only a portion of Witt's bold plan was ever executed, and the Olympics never came to Cleveland. Stockholm in Sweden hosted the 1912 games.

The stadium witnessed its first baseball game on May 2, 1909, hosting a double-header for the opening day of the Cleveland League between amateur teams. The city officially dedicated the park on May 29, 1909, organizing a 15-mile "City Marathon" starting in Gordon Park and crossing the finish line in Brookside Stadium. The park played host to track-and-field games that day, and Minnie

the Brookside Elephant entertained the crowd.

Witt knew that at least 100,000 fans could easily use the natural hillsides to expand attendance, and they did. An October 10, 1915, game between amateur teams drew a record crowd of some 115,000 to the hills around Brookside Stadium to witness an amateur baseball game between Cleveland's White Autos and the Omaha Lexus. "Over 10 percent of the population of the sixth city of the United States turned out on a chilly afternoon," the *Cleveland Plain Dealer* told its readers the following day.

AMATEUR CHAMPIONSHIP GAME
TELLING'S STROLLERS vs. HANNA'S CLEANERS
BROOKSIDE STADIUM — SEPT. 20, 1914.
ATTENDANCE 100,000

COPYRIGHT 1914
BY
The Miller Studio
2005 CLARK Ave
CLEVELAND O.

The record-breaking number of 115,000 found its place on a panoramic photograph taken that day. Some consider this game, which the White Autos won 11-6, to have drawn the largest attendance in baseball history, certainly in amateur baseball history. Other games recorded in 1914 (pictured above) and 1915 had a reported attendance of around 100,000, but overall the games played here were between amateur teams like Hanna's Cleaners (as pictured above) comprised of street cleaners who worked on Hanna Street for whom few records were kept. These events were free to the public which likely helped boost attendance.

Events other than amateur and youth baseball included concerts and a 1917 performance by the John Phillip Sousa Band.

After its initial popularity, Brookside slowly withered. Baseball moved elsewhere in the city, to League Park and later Municipal Stadium instead. Brookside Stadium became a parking lot for the Cleveland Metroparks Zoo. During the early 1980s, a movement by locals who remembered the park's significance attempted to convince the city to improve the place, but the reverse happened. The city pulled all maintenance funding for the park, and suspended any kind of organized play.

By 2007, Brookside Stadium served as Kokosing Construction Company's staging area while the company worked on the nearby Fulton Road Bridge. This caused major damage to the ballfield. Afterward, the field was regraded and left open and unimproved. The Brookside Stadium Preservation Society was formed in 2012 in an attempt to preserve the memory of this hidden gem of baseball history.

Yankee Stadium, New York DEMOLISHED 2008

When the Yankees began their tenancy of the New York Giants' Polo Grounds in 1913, their landlords did not perceive the struggling team as a threat—but the ambitious Yankees soon developed into a force to be reckoned with. The acquisition of Babe Ruth early in 1920 saw them pulling in bigger crowds than the Giants who asked them to leave, hoping they would relocate to a distant corner of New York.

This occasioned a city-wide search for a suitable piece of land to house a new stadium. Sites in Queens and Upper Manhattan were considered before the owners eventually decided on a 10-acre former lumberyard in the Bronx, owned by William Waldorf Astor. Ironically it was within sight of the Polo Grounds and built in just 284 days.

The fact that the original Yankee Stadium was conceived as something more than an ordinary baseball venue was evident in the architectural feature known as the Frieze. This gently curving latticework ran around the roof of the grandstand and was commissioned by owners Ruppert and Huston to give the stadium an air of dignity.

Opening day of the original Yankees Stadium was April 18, 1923, when the inaugural fixture saw the Yankees face the team who would become their fiercest rivals, Boston Red Sox. The venue was packed to the rafters with a capacity crowd and thousands of disappointed fans were left milling around outside when the Fire Department finally closed the gates. More than 25,000 people were eventually turned away.

Baseball aficionado John Philip Sousa and the Seventh Regiment Band led the teams to the flagpole in center field where the American flag and the Yankees' 1922 American League Pennant were hoisted. The Yankees won 4-1 with Babe Ruth christening the "House That Ruth Built" with a three-run homer into the right-field bleachers.

From the 1920s through the 1960s, Yankee Stadium was also home to other players worthy of the legendary tag; Lou Gehrig, Joe DiMaggio, Mickey Mantle, and Yogi Berra, "the Bronx Bombers" all had numbers eventually retired from use as those "Damn Yankees" continued to dominate Major League Baseball.

Yankee Stadium was the sport's most magnificent and largest venue but by the mid-

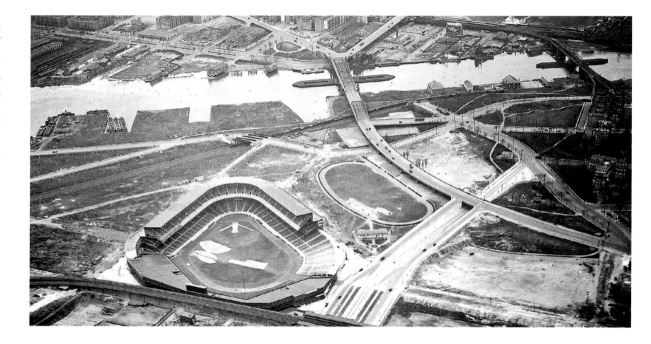

1960s, the imposing triple-decked structure had been allowed to deteriorate and by the early 1970s it was urgently in need of renovation. The surrounding Bronx neighborhood was in decline and the Yankees' form was failing too; the team

ABOVE *The finishing touches are being applied to Yankee Stadium in April 1923.*

OPPOSITE *The completed Yankee Stadium in the 1950s.*

BELOW *Osborn Engineering's illustration of the game-changing new ballpark, released in 1921.*

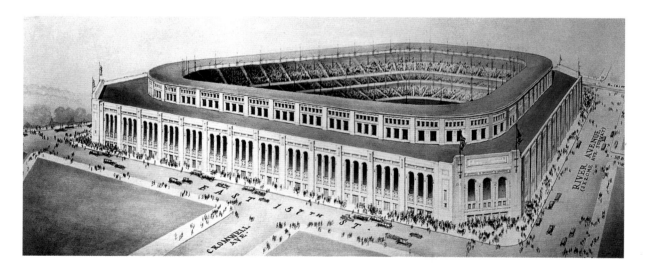

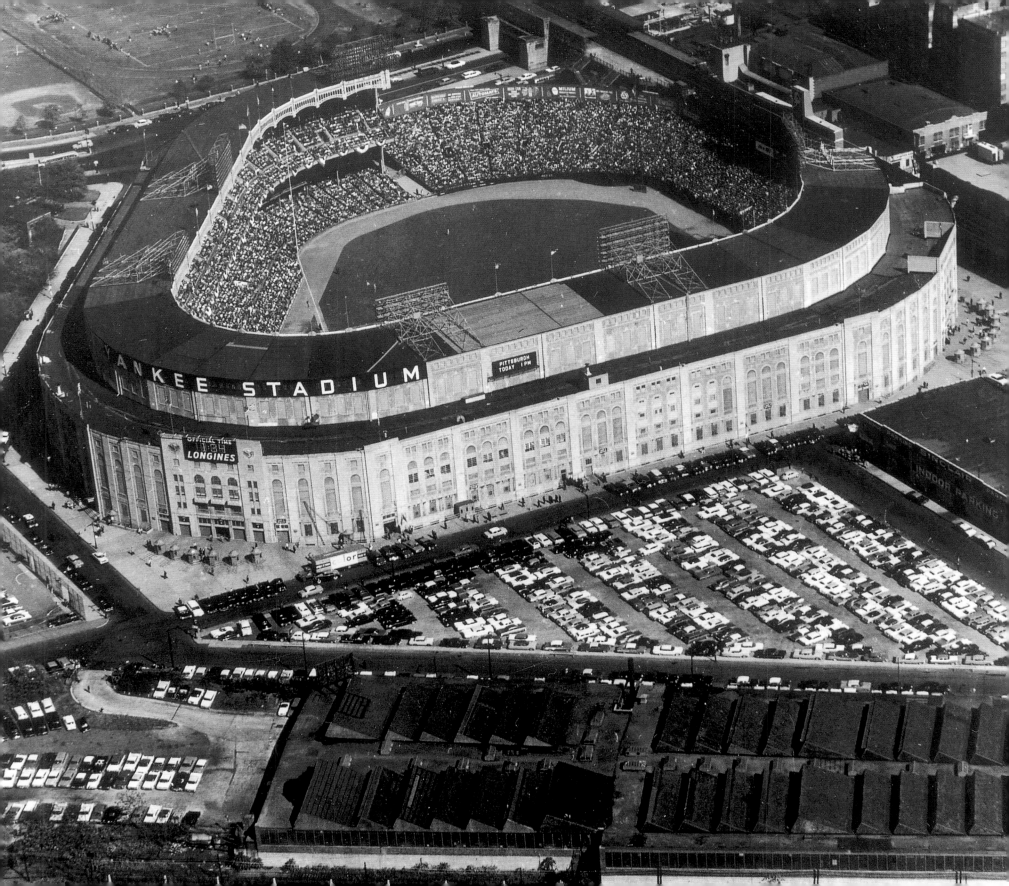

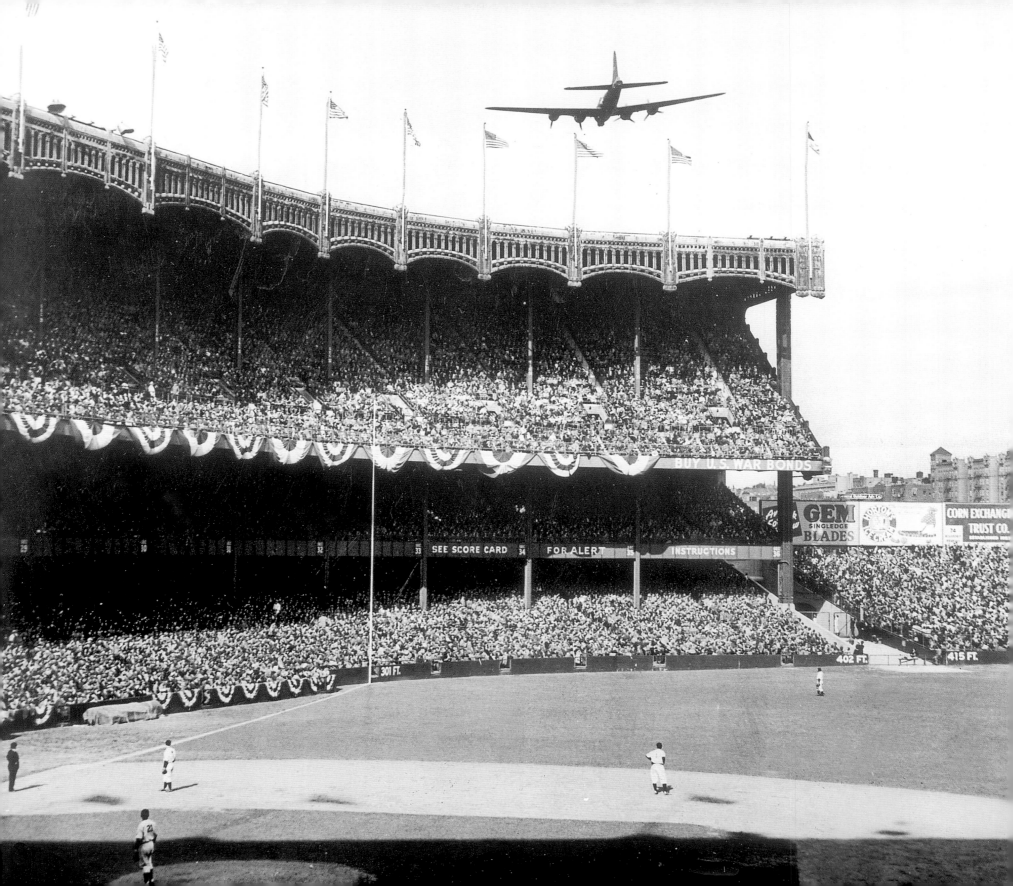

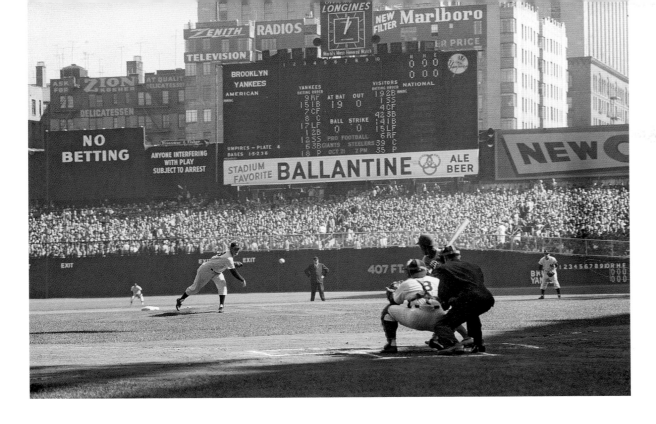

suffered a World Series drought which would last from 1962 to 1976. Yankee Stadium closed for renovation on September 30, 1973, and after the game, fans prised seats from the concrete to take home as souvenirs.

After a two-year sojourn at Shea Stadium, the Yankees returned home for the start of the 1976 season. Before the opening fixture at the refurbished Yankee Stadium on April 15, an opening ceremony took place with Yankees legends Joe DiMaggio, Mickey Mantle, Whitey Ford, Yogi Berra, Billy Martin, Elston Howard and Don Larsen all in attendance. The widows of Babe Ruth and Lou Gehrig also appeared. The first pitch in the renovated ballpark was thrown by 85-year-old Bob Shawkey, the starting pitcher in the first game played in the original stadium. It was a triumphant homecoming as the Yankees beat Minnesota Twins 11-4 in front of 52,613 fans.

Despite the extensive remodeling of the old Yankee Stadium in 1976, owner George Steinbrenner was already talking about the need for a new ballpark in the 1980s. He threatened to move the Yankees across the river to New Jersey because of the decaying conditions in the surrounding Bronx neighborhood.

Negotiations began with the City of New York

and in the late 1990s, Mayor Rudolph Giuliani agreed to a deal which would have committed large amounts of public money to constructing a new stadium. This provoked controversy leading Giuliani's successor, Michael Bloomberg, to revise the scheme. The city would pay for transport and infrastructure improvement and the franchise would fund the construction of the ballpark. The announcement of the building of a new stadium was made in June 2005.

Ironically, the site chosen was just across the street from the existing stadium, Macombs Dam Park, formerly a public open space. The ground breaking ceremony took place on August 19, 2006. The Bronx Bombers continued to play in the original stadium while the new one was being constructed.

The new stadium was closely modelled on the original retaining many of the iconic features and the dimensions of the field of play replicate those of the old in its final days. Because of the larger seats, the capacity was reduced by some 6,000 to 50,287. The Indiana limestone exterior closely resembles that of the old.

The site of the old Yankee Stadium is now a public park complete with baseball diamond overlooked by a giant Louisville Slugger baseball bat.

Shea Stadium, New York DEMOLISHED 2008

The old Yankee Stadium, built in 1923, was regarded as one of the best baseball parks of its era. Shea Stadium, built in 1964 as the home of the New York Mets, was considered one of the worst. Both were demolished in 2008 for modern replacements and both were mourned for lost memories of some of the best moments in New York baseball history.

The New York Mets entered the National League as an expansion franchise in 1962, and although they could do little to assuage the city's loss of the Dodgers and Giants, the team quickly developed a following of its own. After playing their first two years at the Polo Grounds, the Mets moved into brand-new Shea Stadium. It was built in Flushing Meadows on the same site that Walter O'Malley had indignantly refused for a proposed Dodgers ballpark in the 1950s.

Lack of character was the defining architectural feature of many stadiums built in the 1960s and 1970s, and Shea was no different. Built for football as well as baseball, its configuration never satisfied fans of either sport. But despite its remote location in Queens and the Mets disappointing performances, it opened with a bang in its first two years of operation, drawing patrons from the

adjacent World's Fair in 1964 and a full-house of screaming Beatles fans for the group's famous concert in 1965. Its namesake, William Shea, was honored for his role in creating the Mets in 1962, a new team designed to replace the Brooklyn Dodgers.

While Shea Stadium never garnered the same affection as the Dodgers' beloved Ebbets Field, the Mets embodied the Dodgers' underdog spirit and worked their way into the hearts of thousands of fans, winning the 1969 World Series. They would win only one more championship at Shea, a dramatic victory over the Boston Red Sox in 1986, and finally made it to a "subway series" with the Yankees in 2000, a loss for the Mets but a riveting battle for fans throughout the city. Shea's most distinctive features were its huge scoreboard and the gigantic top hat in front of it, from which a lighted "big apple" emerged after every Mets home run. Shea was one of the noisiest ballparks in the major leagues, thanks both to its raucous fans and the airplanes taking off from nearby La Guardia Airport. The architecture was patterned after Dodger Stadium, but New Yorkers soon gave Shea Stadium a character of its own. Shea was where baseball fans first started bringing

homemade banners and signs to ball games, giving the stadium a homey feel that had been lacking in New York baseball since the Dodgers left Ebbets Field.

Shea Stadium served as a relief center after the terrorist attacks of September 11, 2001. Most of the gate areas were filled with food supplies and makeshift lodging for the massive rescue effort. Ten days later, on September 21, the Mets returned to play the Atlanta Braves; 41,235 fans attended the symbolic comeback for New York and its citizens.

Like the Yankees, the Mets had long planned a new ballpark for opening day 2009. One of the last acts of Mayor Rudy Giuliani's administration in December 2001 was to reach tentative agreements with both the New York Mets and New York Yankees for new stadiums, mostly paid for by taxpayers.

The Mets' new 41,922-seat stadium, Citi Field, in the borough of Queens, opened on April 13, 2009. The stadium mixes in elements of other famous New York stadiums—the main entry facade bears a great resemblance to Ebbets Field, and inside, the large rotunda is called the Jackie Robinson even though Robinson never played for the Mets.

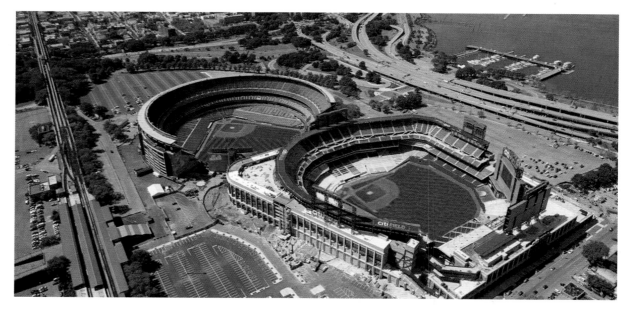

ABOVE *A 1964 view of Shea Stadium from the walkway alongside the elevated train tracks.*

RIGHT *After much political wrangling Citi Field was built in the Mets old car park.*

OPPOSITE *Shea Stadium is packed for the fourth game of the 1969 World Series, won by the "Miracle Mets."*

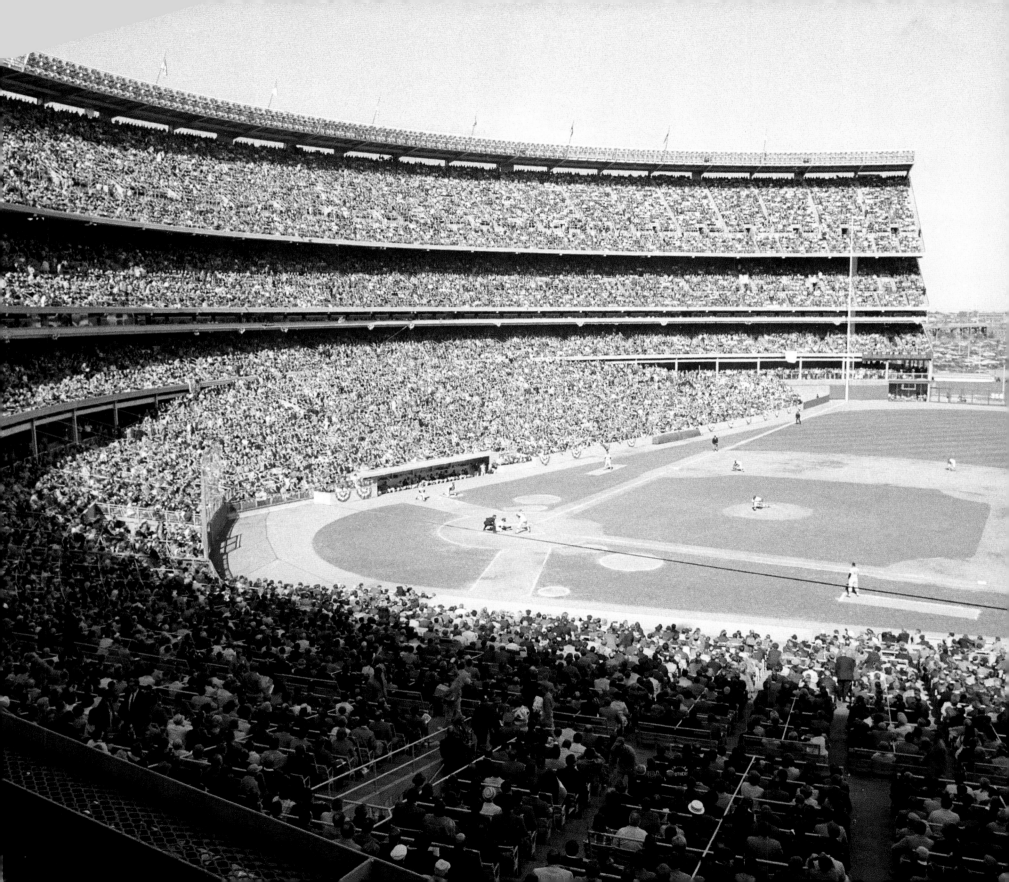

Al Lang Field, St. Petersburg RECONFIGURED 2008

Pittsburgh native Al Lang loved his home team, the Pirates. Even as a kid he couldn't get his fill. His health required that he seek a sunnier clime. In 1910, Lang sold his laundry business and moved to St. Petersburg, Florida. When he arrived he learned that two years earlier the St. Paul Saints had come to town and played the Cincinnati Red Stockings in an exhibition game. The news of professional baseball already played in town whetted Lang's appetite for giving the game he loved a more permanent place in his new home town.

When his boyhood friend Barney Dreyfuss purchased the Pirates, Lang talked to him about bringing his team to St. Petersburg for spring training. When Dreyfuss turned him down, Lang did not give up. He approached the St. Louis Browns and they agreed to come. At first the Browns trained at Sunshine Park (or Coffee Pot Park, as the locals dubbed it for its location on Coffee Pot Bayou). The Browns only trained at Sunshine for the 1914 season, but the Philadelphia Phillies came to town the following year and stayed until 1918.

In 1922, the city built a new ballpark along Tampa Bay's shoreline at First Avenue S.E. and First Street S.E. on a patch of land that was part of the city's mile-long Waterfront Park. It was built in a bid to bring the Boston Braves to town and once constructed, the Boston Braves took St. Petersburg up on its offer and trained there until 1937. The following year the St. Louis Cardinals came to town in what would be a long association with St. Petersburg. In 1925, the New York Yankees had arrived for spring training at nearby Crescent Lake Park.

Waterfront Park has a page of its own in baseball lore. The story goes that on March 25, 1934, Babe Ruth came to the plate at Waterfront in the fifth inning in a game against the Boston Braves. According to *Boston Herald* sports reporter Burt Whitman, "(Babe Ruth) socked a (Huck) Betts pitch 10,000 leagues to right field … far over the canvas and almost into the West Coast Inn (at Third Avenue and First Street)."

Whitman's 10,000 leagues was not intended as an accurate guess of distance, however Ruth's home run set off a debate that has lasted into the twenty-first century. The discussion centers on whether that home-run ball hit short of the hotel

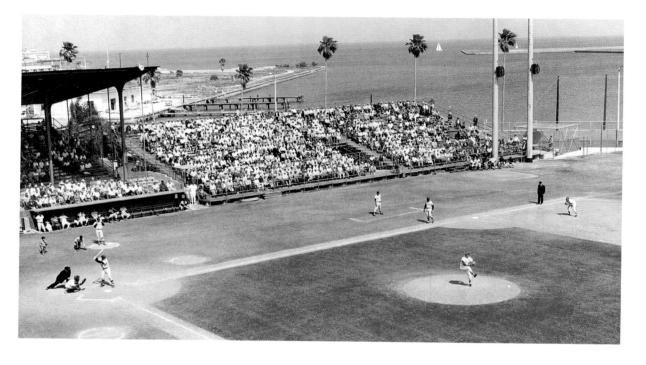

and then rolled to it, or took a bounce in front of the hotel and came to rest on one of the balconies or actually hit one of those balconies directly. Measurements have indeed established that the ball that Babe Ruth hit that day traveled a measured 624 feet plus a few inches. In 2008, the George F. Young Company surveyed and verified that record-smashing distance.

In 1947, Waterfront Park was demolished and replaced with a ballpark named for the man who was instrumental in making baseball a centerpiece in the life of St. Petersburg. Al Lang Field continued to be used for spring training through the 1960s and was reconfigured again in 1976, emerging as Al Lang Stadium. It was improved once more in 1998 for the arrival of the Tampa Bay Devil Rays. They were the final major league club to use the facility, because in 2008 it was turned over to the Tampa Bay Rowdies soccer team of the NASL.

OPPOSITE *St. Louis Cardinals players stretch during Spring training in March 1960. Beyond the outfield is the West Coast Inn.*

ABOVE *The Cardinals training in 1964.*

LEFT *This postcard view of Waterfront Park was most likely taken from the building that Babe Ruth hit in 1934.*

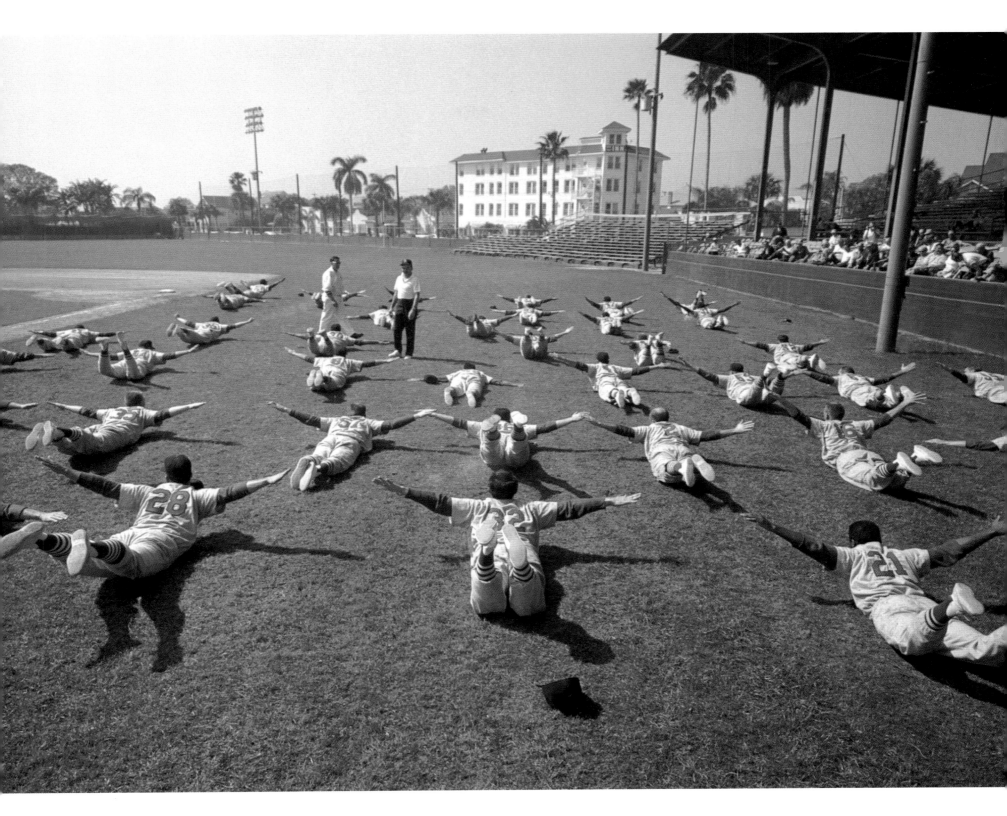

Tiger Stadium, Detroit DEMOLISHED 2009

The original ballpark was named after Charlie Bennett, an 1880s Detroit Tigers' catcher who lost parts of both legs in a train accident in 1894. Bennett Park was located in Woodbridge Grove, a popular spot for picnicking and finding hazelnuts, and in 1875 the site of the city's west side hay market. When Bennett Park opened in 1896 at the corner of Michigan Avenue and Trumbull, the corner would be synonymous with baseball for the next 100 years.

The Detroit Tigers were part of the Western League from 1895 to 1900 when the League changed its name to American. The first American League game at the ballpark was the 1901 season opener against Milwaukee. Charlie Bennett was there to catch the first pitch, something he would continue to do for the next 25 years.

Bennett Park was a wooden, rickety affair whose outfield was compared to a cow pasture early on. Cobblestones left over from the land's market days, and clay soil could make chasing a fly ball a slippery mess. The stands went from holding 5,000 fans to 13,000 by 1910, not including the wildcat stands built outside the left field fence. However, from the beginning, fans outnumbered available seating and standing room. This, combined with the poor state of the clubs' locker room, led the Tigers' owner, Frank Navin, to erect a new stadium that was ready for the 1912 season.

Over the owner's modest protests the new ballpark was named Navin Field. Center field, formerly at National and Cherry streets was moved 90 degrees to Cherry and Trumbull and the new infield stands took care of the wildcat problem.

Another reason for the new stadium was the Tigers' winning seasons, 1907–1909, when they captured the American League pennant three years in a row. Unfortunately, they would not win another pennant until 1934, even with the legendary Ty Cobb. One of the franchise's most famous players, Cobb came on board in 1905, and would stay with the Tigers until 1926, acting as player-manager from 1921 to 1926.

The new stadium was built for 23,000 fans, though 26,000 managed to attend the 1912 opening game. Boston inaugurated its Fenway Park the same day, April 20. By 1936, the stadium had been renovated several times, a second deck added to the left infield stands, with a press box on top, to increase the capacity to 36,000.

Frank Navin died in 1935 and the team was purchased by manufacturing mogul Walter O. Briggs, who had been part-owner since 1919. Double decking was extended along the first base line, into right field and double-decked grandstands were added to left and center field as Cherry Street, on the northern boundary, was closed. Seating capacity rose to nearly 53,000 in the renamed Briggs Stadium. The Detroit Tigers were not the only team to play on the athletic field. From 1938 to 1974 the Detroit Lions hosted their National Football League games in the bowl-shaped arena. No night games were held until 1948, however, when the stadium was the last in the American League to install lights.

When Walter Briggs, Sr. died in 1952, the team was passed on to his son, Walter O. Briggs, Jr. until it was purchased by a syndicate headed by John Fetzer, Kenyon Brown and Fred Knorr. John Fetzer took sole possession in 1960, and in 1961 the ballpark got a new name, Tiger Stadium.

The stadium and team had many highlights over the years: the team announcer was Broadcast Hall of Famer Ernie Harwell; six American League pennants were won there; it was the only one of the original eight charter franchises to retain the same name and city since the team's origin; and Al Kaline, the youngest player in the league to win the batting title.

When subsequent owner Mike Ilitch announced that the team would build a new stadium, fan uproar could not change the decision. Debate arose over the cost of a new stadium, and the history the team and fans would lose. There was a ceremonial close at the Tigers' last game on September 27, 1999, with a procession to move the home plate to the new location.

Ideas were plentiful for the property's reuse, but none proved feasible, or found backing. Stadium "hugs" were held to publicize the plight of the old park by preservationists trying to save it. All was in vain as demolition began in 2008 and was completed in 2009. "The corner" was no more.

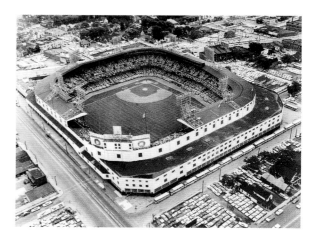

ABOVE *Briggs Stadium was the ballpark's name from 1938 until 1961.*

TOP *An aerial view of the ballpark taken from the bleacher side of the stadium, which also hosted the Detroit Lions.*

OPPOSITE *Tiger Stadium remained shuttered after the last game, September 27, 1999, and was demolished in stages beginning in 2008.*

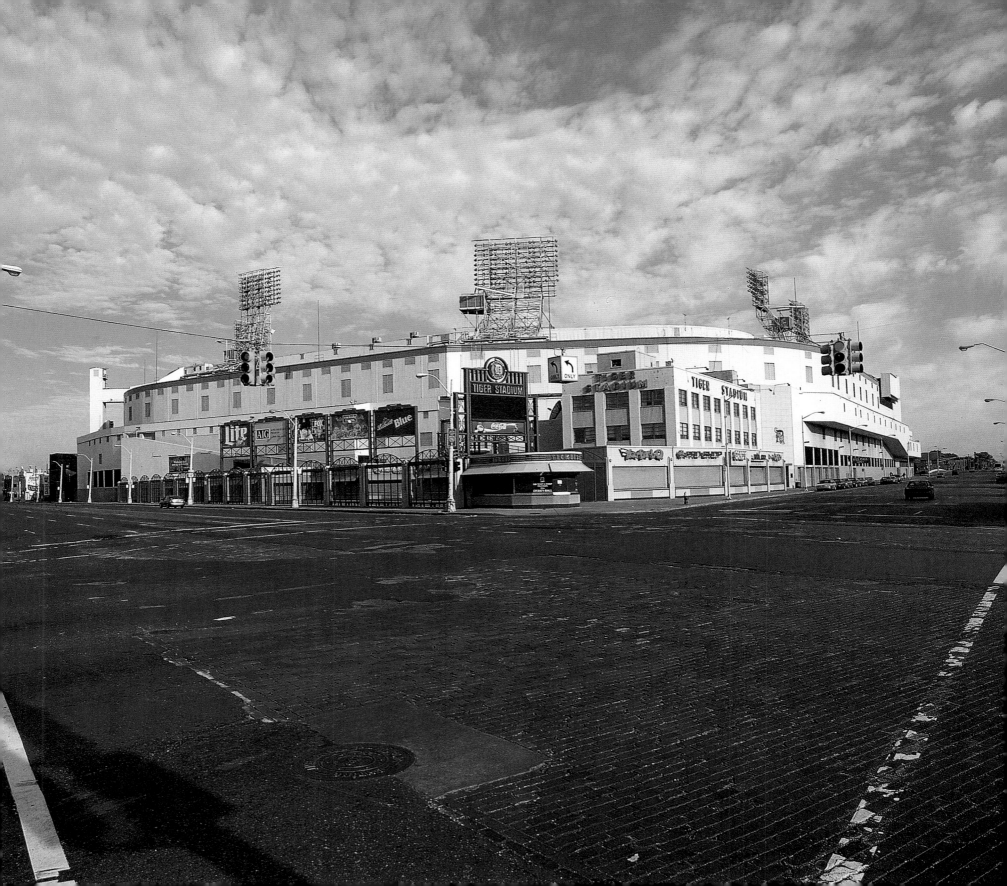

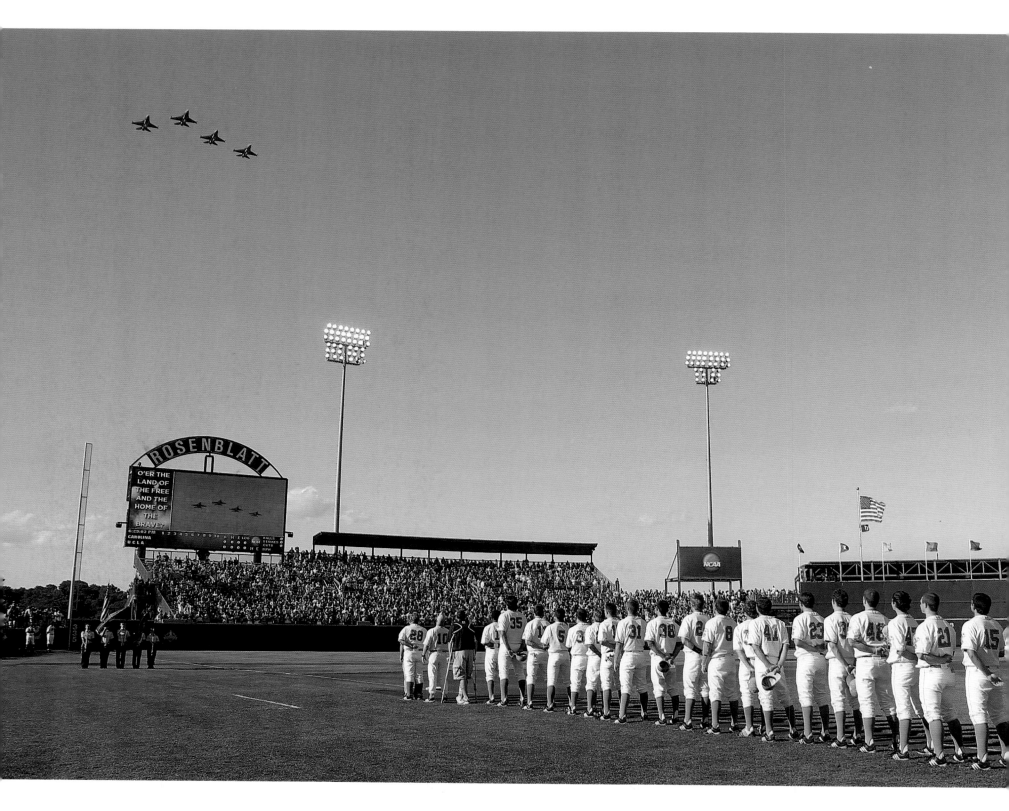

Johnny Rosenblatt Stadium, Omaha

CONVERTED TO A ZOO IN 2012

Johnny Rosenblatt helped create the largest minor league baseball stadium in the United States. He loved the game of baseball, both as a fan and a player. He played outfielder in amateur and semipro leagues for nearly 20 years, taking the field many times at Rourke Park, the predecessor to Municipal/ Rosenblatt Stadium. He played semipro ball under the name Johnny Ross. He once faced Satchel Paige and said of Paige's arm that he never saw a pitch travel so fast in all his life. In 1927, Rosenblatt played in an exhibition game with the likes of Babe Ruth and Lou Gehrig.

With baseball in his blood, Rosenblatt became a prime mover in helping build the stadium that would bear his name from 1964. In the early 1940s, he joined several Omaha businessmen in an effort to bring an AAA baseball franchise to their hometown.

They learned that the American Association ruled Nebraska's capital city out because the city did not have a suitable ballpark (Omaha's only baseball venue, Rourke Park, had burned in 1936.)

The business community appointed Rosenblatt chairman of the Municipal Stadium Sports Committee. Rosenblatt convinced the city's voters to approve a pair of bond issues totaling $760,000 to build the stadium. Municipal Stadium opened in October 1948 with 15,000 fans watching major league ballplayers and Nebraska natives Rex Barney, Richie Ashburn and Johnny Hoop play against hometown sandlot and minor league players.

The College World Series decides the NCAA Division 1 baseball champion in June each year. Previously the series had been played in Kalamazoo,

Michigan (1947-1948) and Wichita, Kansas (1949). Ed Pettis and Morris Jacobs then persuaded the organizers to bring its men's championship baseball series to Omaha's Municipal Stadium. The course was set. Omaha hosted the College World Series until 2010.

With a suitable stadium built in 1948, Rosenblatt was able to attract the St. Louis Cardinals' AAA team in 1955, who became the Omaha Cardinals. They played ball here for four years. Rosenblatt then convinced the Los Angeles Dodgers to bring their AAA club Omaha Dodgers to come to town. They stayed for two years. Then after a gap of seven years the stadium hosted the Kansas City Royals- affiliated Omaha Royals from 1969 to 2010.

But there was a problem with Rosenblatt Stadium. Although it could sell out the ground for

ABOVE: *Municipal Stadium opened in 1948 and was renamed Rosenblatt in 1964.*

LEFT *The stadium viewed in 2010. The Media Tower, which once held TV cameras and media personnel, has been retained by the new Wildlife Safari Park as the Crane Viewing Tower.*

OPPOSITE *The UCLA Bruins stand for the national anthem as F-16s fly overhead before the first game of the men's 2010 NCAA College Baseball World Series against the South Carolina Gamecocks, June 28, 2010.*

the College World Series, it was too big a stadium to host minor league games. In 2001, it had increased its capacity by 10,000 to hold 23,145. The city expressed its desire to build a new stadium to better accommodate local teams.

In May 2007, a grassroots organization called "Save Rosenblatt" rose up. The organization aired a television commercial with no less a personality than actor Kevin Costner, star of *Bull Durham* and *Field of Dreams*. They hoped to renovate, rather than demolish the ballpark, and offered alternative plans. They failed.

The new downtown stadium, TD Ameritrade Park, opened in 2011 with a capacity of 24,505 expandable to 35,000. The College World Series has moved there with a contract that lasts through to 2035. The Omaha Royals changed names to become the Omaha Storm Chasers from 2011 playing their games at the 9,000-capacity Werner Park in Papillion, a southwest suburb of the city.

The Henry Doorly Zoo, Rosenblatt's next-door neighbor, was keen to expand and purchased the land where the stadium sat for $12 million. The zoo waited until Omaha's new downtown stadium, TD Ameritrade Park opened in July 2011. They then proceeded to demolish Rosenblatt. In the summer of 2015, zoo officials created a tribute to Johnny

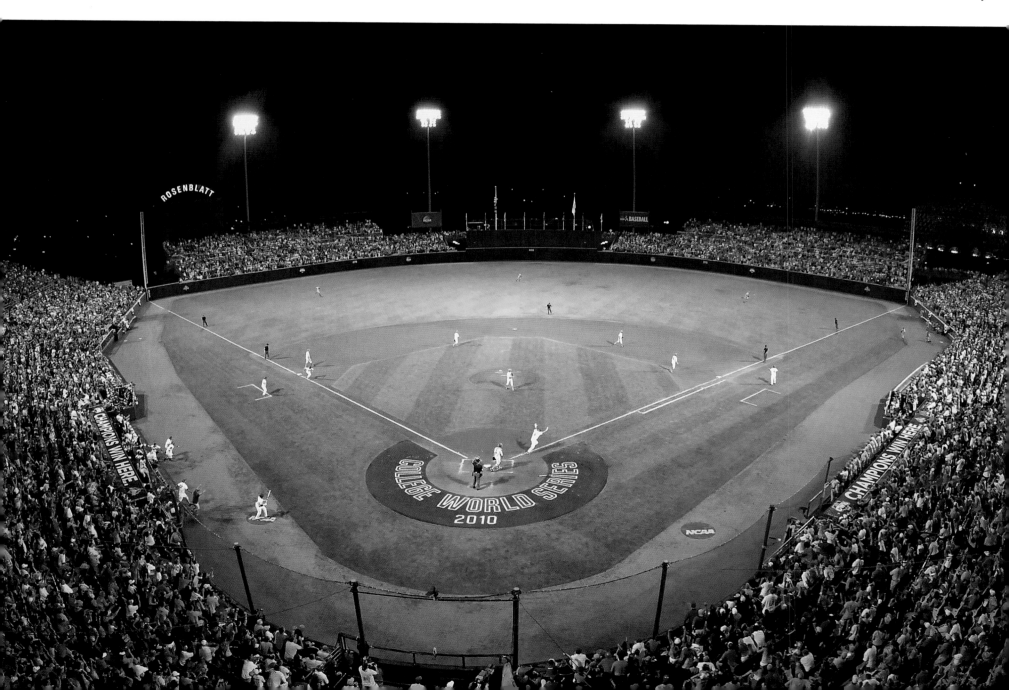

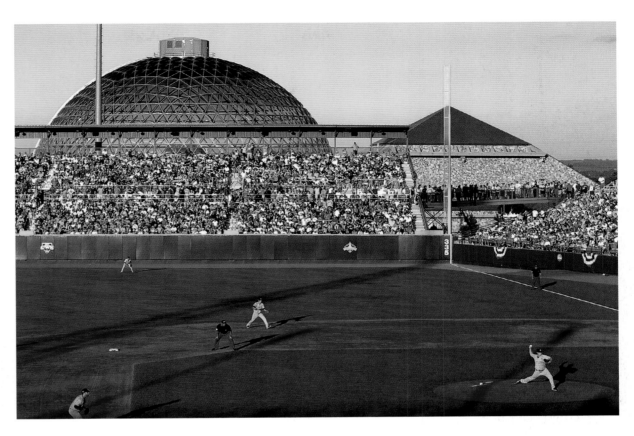

Rosenblatt, the "Infield at the Zoo"—complete with seats from the ballpark they demolished. They have also preserved the old media tower and put it to good use as a crane viewing platform in their Wildlife Safari Park.

ABOVE *"The Oracle of Omaha" Warren Buffett was a familiar face at Rosenblatt Stadium.*

OPPOSITE: *Whit Merrifield of the South Carolina Gamecocks celebrates after hitting the game winning RBI off pitcher Dan Klein of the UCLA Bruins to win game two of the 2010 NCAA College Baseball World Series. The Gamecocks defeated the Bruins 2-1 in eleven innings to win the National Championship.*

TOP RIGHT *The Desert Dome of the Henry Doorly Zoo is clearly visible beyond center field. It is one of the largest indoor desert environments in the world.*

RIGHT *In 1999, the organizers placed the John Lajba sculpture* Road to Omaha *in front of the main entrance.*

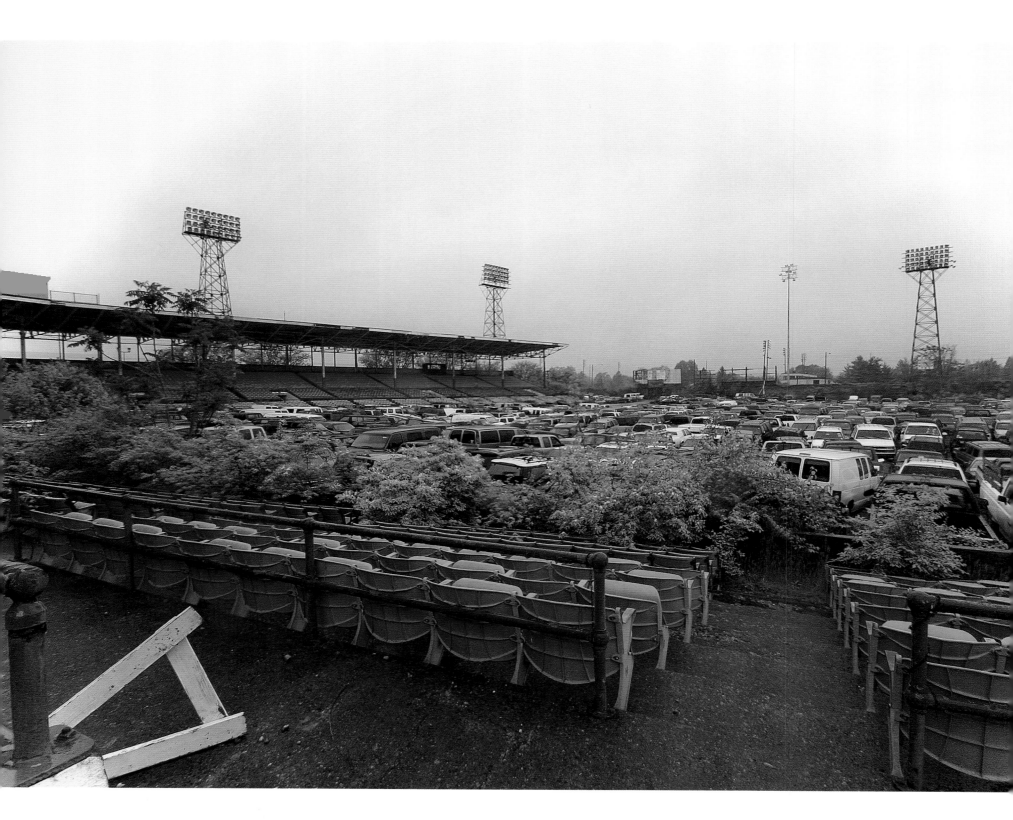

Perry/Bush Stadium, Indianapolis

CONVERTED TO LOFTS 2012

The AAA minor league Indianapolis Indians opened Perry Stadium on September 5, 1931. The stadium on Sixteenth Street in Indianapolis, Indiana, was named for team owner Jim Perry, who had purchased the Indians in 1927 and died in a plane crash in 1929. Jim's brother Norman Perry had the stadium built and dedicated to his brother.

The Indians' new home seated 15,000 fans, some 5,000 fewer than their old stadium, Washington Park. The Negro League's Indianapolis ABCs also played their games at Washington Park. The Perry family ran the Indianapolis Power & Light Company (IPL), which had installed lights at Washington Park. Norm hired Osborn Engineering, the same firm that built Boston's Fenway Park, to build Perry Stadium in Art Deco style and had

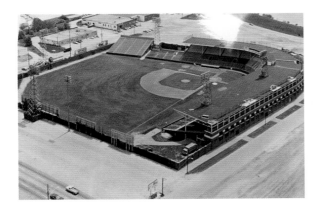

the park's lighting towers hauled over to his new ballpark.

Perry Stadium welcomed Negro League teams. These included the American Giants, the Athletics and the Crawfords. One particularly notable Negro League team, the Indianapolis Clowns, began its unique blend of baseball and comedy at Perry Stadium in 1944. The Clowns barnstormed their way through the integration of Major League Baseball until 1962. In 1952, the major leagues had drafted the team's star player, Hank Aaron. That same year Aaron led the Clowns to a Negro American League championship. Two years later he was playing for the Milwaukee Braves on his way to a career 3,771 hits, 755 of them home runs. Aaron's spot on the Clowns' roster was filled by Toni Stone, the first female player in the Negro League.

Norm Perry sold the Indians to Frank McKinney and Owen "Donie" Bush right around America's entrance to World War II, in December 1941. McKinney was politically connected to President Harry Truman and owned several teams, while Bush had played, managed and scouted teams. The deal did not include the stadium, which Perry

LEFT *An aerial shot of Bush Stadium in the 1970s.*

BELOW LEFT *Perry Stadium became Victory Field during WWII.*

BELOW AND BELOW RIGHT *Two different views of the Stadium Lofts and Stadium Flats development.*

leased to the duo, who refurbished and renamed the place Victory Field in support of the war effort.

In 1967, the city of Indianapolis took over ownership of the stadium. The city honored Donie Bush by renaming Perry Field for him. At that late date, Bush was still serving as the Indians' president.

In 1987, Bush Stadium played the parts of both Chicago's Comiskey Park and Cincinnati's Crosley Field in the Hollywood film *Eight Men Out* about the 1919 Black Sox scandal. In 1996, the Indianapolis Indians found a new home at the new Victory Field, the downtown ballpark built near where an old Federal League ballpark once stood.

For a time Bush Stadium hosted midget auto races as the Sixteenth Street Speedway. In 2008 the city established "Cash for Clunkers," a program that allowed resident to sell the city their gas-guzzling cars (also known as "clunkers"). The city demoted Bush Stadium, using it as a storage lot for those old automobiles (pictured opposite).

Three years later, the site was ripe for a new idea. A plan was proposed to create apartments on the site of the former baseball stadium. Part of the Bush Stadium was demolished in 2012 and just one year later the first phase of the city's Stadium Renaissance program opened as Stadium Lofts. In 2014, phase two of the development project opened as Stadium Flats, a unique and remarkable conversion of a cherished old baseball stadium.

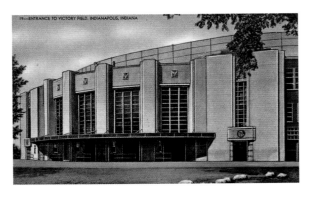

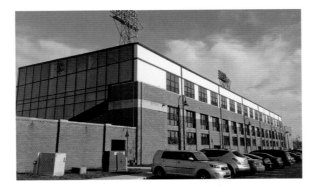

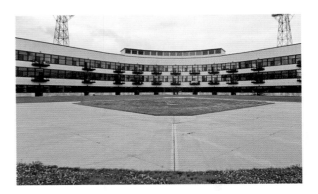

Knights Stadium, Fort Mill BATTERED DOWN 2015

Located in the quiet suburb of Fort Mill Township, South Carolina, Knights Stadium served as the home field for another state's team. Built across the state line from downtown Charlotte, North Carolina, Knights Stadium was designed to eventually host a major league team for the Queen City. (Charlotte bears the named of Queen Charlotte, wife of King George III).

Constructed in 1990, the build left room to expand the initial seating of 10,002 to 40,000 if Charlotte could attract more fans than the Double A Southern League Charlotte Knights. While the stadium was under construction the Knights used a temporary facility that locals referred to as Knights Castle. The Charlotte Knights served the Chicago Cubs as farm team until 1992. The team then played ball for three other major league clubs: the Cleveland Indians through 1994, the Florida Marlins until 1998 and the Chicago White Sox to 2003.

Knights Stadium featured both a miniature golf course and merry-go-round for younger fans. For the older set, free programs titled "Joust" were available at some games. The seats featured an unusual color scheme created by Charlotte fashion designer Alexander Julian, who aimed to create a design resembling textile patterns in reference to Charlotte's history in the clothing industry.

To watch a Charlotte Knights game, their Charlotte-based fans had to drive along notoriously congested Interstate 77, crossing the border into their southern sister state, to a town of 12,000 people still considered inside Charlotte's sphere of influence. The Knights drew strong attendance until 1993 when they joined the newly expanded Triple A International League.

Suddenly the Knights were drawing the smallest crowds of any team in their new league. Attendance doubled for a few games in 2002 as long-ball hitter Jose Canseco wrapped up his career with Charlotte. Canseco played 18 games with the Knights batting just .172 with five home runs before announcing his retirement.

Changing tastes and the desire for a more intimate baseball stadium threw the wide-open Knights Stadium a curve ball. The stadium hosted its last Knights' game on September 2, 2013. Some 6,900 fans attended the game. They watched as the home team said farewell both to the 2013 season and to Knights Stadium by beating the Gwinnett Braves 4-0. Fans rose to their feet in unison with two outs in the top of the ninth inning as Knights pitcher Duente Heath got Braves Phil Gosselin to pop out to first baseman Andy Wilkins for the final out of the final game at Knights Stadium

The Knights had invited their former teammates to the game and held a ceremony afterward to thank them. All in attendance looked on as the head groundskeeper and his son, removed home plate. A pair of long-time employees escorted home plate to a helicopter waiting in center field. The team's mascot, Homer the Dragon, boarded the helicopter as he waved goodbye to Knights Stadium.

Crews began demolishing Knights Stadium in March 2015. Since moving back to the big city, the Knights have broken all prior attendance records. Charlotte-based fashion retailer Cato now owns the 33-acre property and the company announced that it has plans to build a distribution center for its women's apparel and accessories on the site.

BELOW *Traveling across the state line to watch their team proved too much for a lot of Knights fans.*

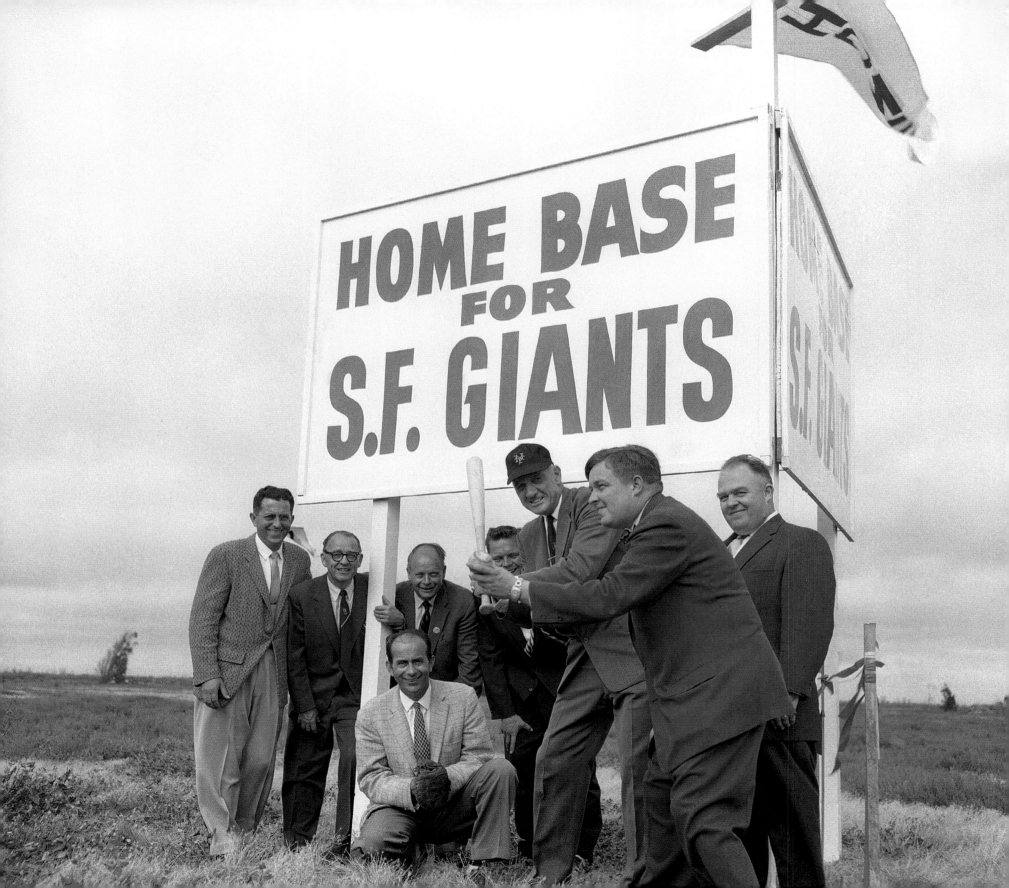

Candlestick Park, San Francisco ERASED 2015

Although the Giants played two seasons in Seals Stadium it was never intended to be their home field. The arrival of this status symbol to the City and County of San Francisco had come with expensive strings attached. In exchange for the team's move from the Big Apple, its adopted West Coast city was going to have to build the Giants a new ballpark.

The idea of bringing Major League Baseball to the City by the Bay dates to 1953 during Mayor Elmer Robinson's administration, when the Board of Supervisors approved a $5 million bond issue for a new stadium.

That same year contractor Charles Harney purchased 65 acres of land at Candlestick Point from the city for $2,100 an acre. In 1954, voters approved the bond measure and work could get underway. The city ended up buying the land back from Harney at an inflated price, a move many

considered a swindle. They settled on the name Candlestick Park on March 3, 1959, following a name-the-park contest. The name reflected the ballpark's location at Candlestick Point.

San Francisco turned to architect John Bolles who designed the park like a horseshoe, open in the outfield. That design turned the stadium into a virtual wind tunnel. The place was so cold and windy that some fans returned their season tickets for refunds, the most famous among them was San Francisco attorney Melvin Belli. The Giants had promised radiant heat from under-seat heating which proved ineffective.

Belli appeared before the judge in the case decked out in an Alaskan parka coat. He explained that the Giants had advertised that Candlestick would be warm, and it wasn't. Belli was suing for the price of his season tickets, about $1,500, and he won.

Despite the wind and the chill, Candlestick Park had a positive side as the first modern baseball stadium built entirely of reinforced concrete. Indeed, the ballpark held its own when the Loma Prieta Earthquake struck on October 17, 1989. Candlestick was full of baseball fans ready to enjoy the third game of the "Bay Bridge" World Series when the temblor struck. Everyone got out safely.

From the beginning, Candlestick Park hosted both professional baseball and football games. Vice President Richard Nixon threw out the ceremonial first pitch on opening day, April 12, 1960, while the Oakland Raiders played the final three games of the 1960 season there through to the end of the 1961 season.

When the San Francisco 49ers moved from their old Kezar Stadium in 1971, they moved into a fully enclosed Candlestick Park. Apart form increasing the capacity, the enclosure was expected to solve

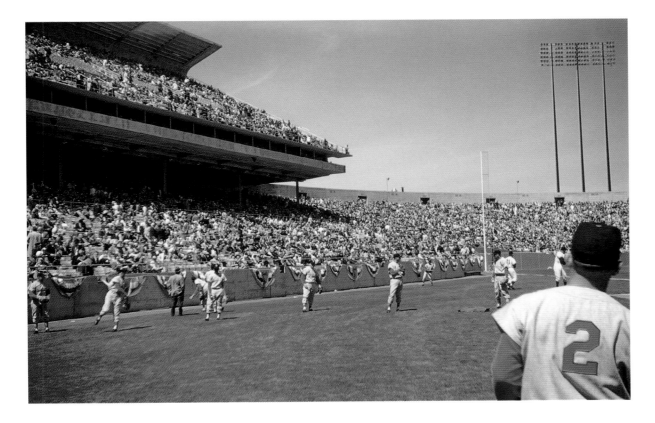

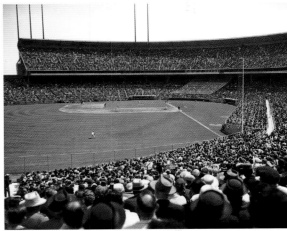

OPPOSITE *The Giants staff were a lot more enthusiastic about the site before they moved in. Owner Horace Stoneham was aware of the wind but concrete baffles designed to subdue it were reduced to save money.*

LEFT *The Cardinals warm up before the opening day game at Candlestick on April 12, 1960.*

ABOVE *Fans grew to call the park "The North Pole" and "Windlestick Park" or "The Dump" based on the site's former use as a garbage site.*

the wind problem. Though it was diminished, it tended to swirl around the stadium's interior. And any view of the bay was gone.

The Giants played their last game at Candlestick Park on September 30, 1999. They moved from one of the worst stadiums to one of the best, along the waterfront in downtown San Francisco at AT&T Park. The 49ers endured much longer and played their last game at Candlestick on December 23, 2013. When the 49ers departed for Levi's Stadium in Santa Clara, Candlestick Park no longer had any tenants; it would face the wrecking ball.

The park went out in style, hosting Paul McCartney on August 14, 2014, some 48 years after McCartney had sung there as a member of the Beatles in what had been a historic final concert for the Fab Four. Demolition began three months later, workers started tearing out the seats in November 2014.

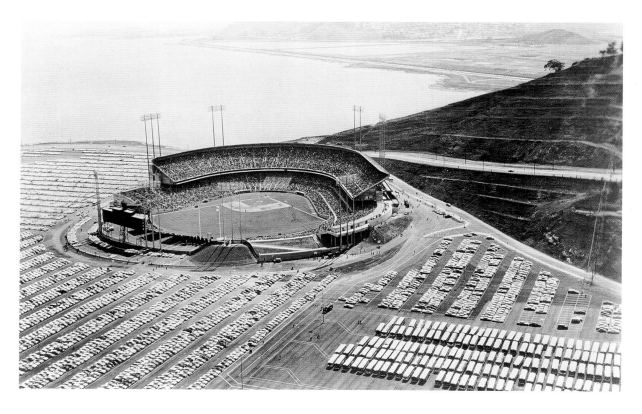

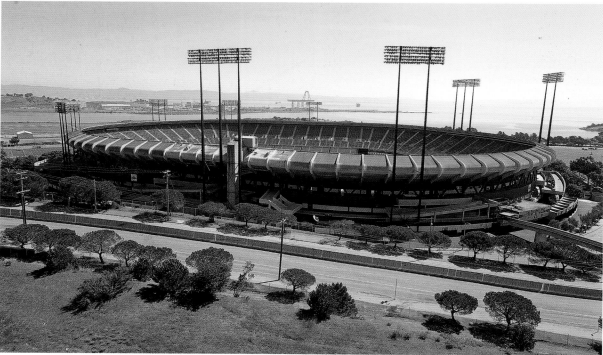

TOP *Candlestick Park in its unenclosed pre-1971 form. The wind was so strong that Giants pitcher Stu Miller was blown off the mound during the 1961 All-Star Game.*

LEFT *The park's 1960 capacity was 43,765; by 1993 that had risen to 58,000.*

ABOVE *A 2016 site photo from exactly the same spot as the picture at left—minus a stadium.*

RIGHT *The 49ers endured much longer at Candlestick Park or, as it was known over the years, 3Com Park and Monster Park.*

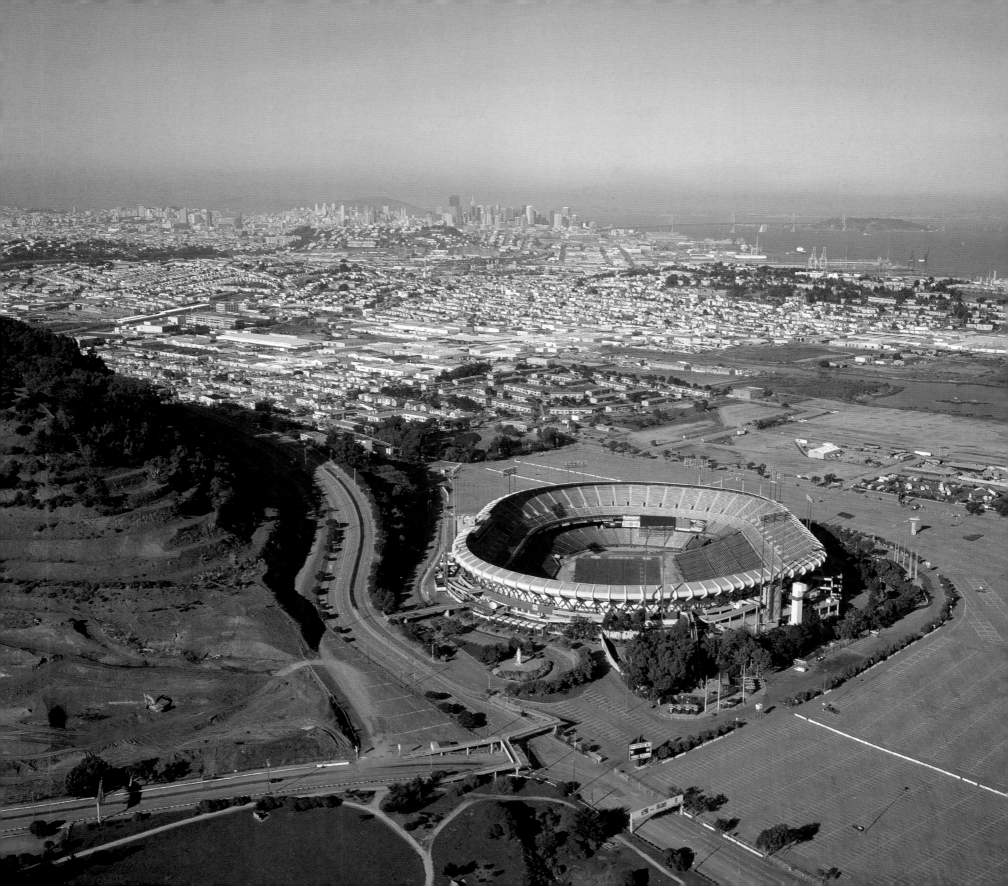

Lost Baseball—a final at bat for...

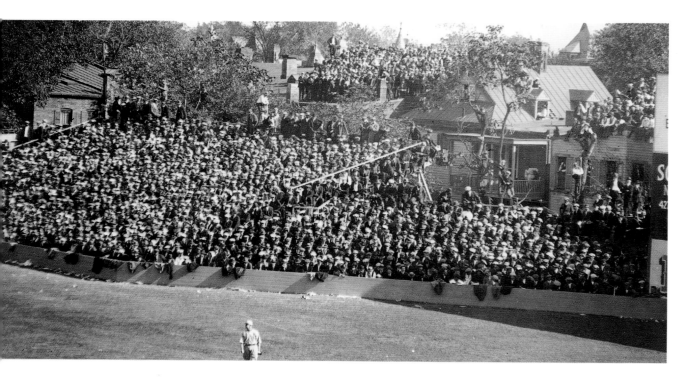

ABOVE *Every available vantage point, no matter how precarious, is used in this view of center field at Griffith Park, Washington, D.C. Free views of major league games have long since disappeared. While some ballparks built fences to block the wildcat bleachers, the Chicago Cubs have pursued a policy of buying up the rooftop views of Wrigley Field and have enfranchised most of the Wrigley Rooftops.*

ABOVE RIGHT *Renowned FSA (Farm Security Administration) photographer Russell Lee took this photo of a crowd listening to a radio broadcast of the 1940 World Series. Spilling out onto the sidewalk in St. George, Utah, they listen as the Cincinnati Reds play out a seven-game thriller with Detroit Tigers. National broadcasting of the games took baseball off the sidewalk and into every American home, but the rise of the sports bar has brought fans back into town.*

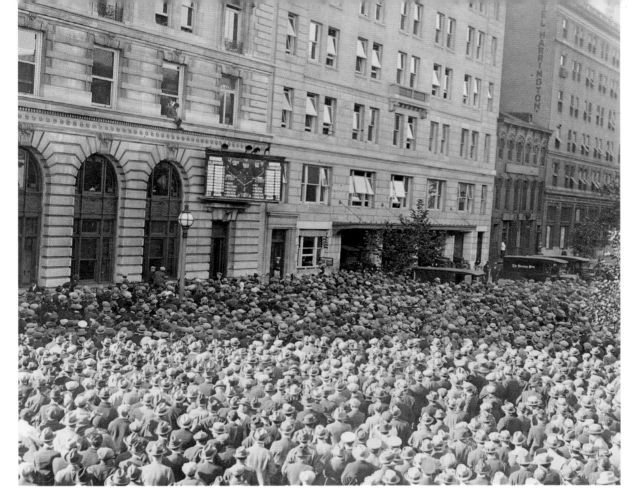

LEFT AND OPPOSITE *Crowds throng the streets of Washington, D.C. in 1925 to watch the play-by-play baseball scoreboard outside the Washington Star newspaper. Scores were relayed from the Pirates versus Senators World Series games. Edward Van Zile had applied for his patent "Bulletin Board" system as early as 1888. He was a reporter on Joseph Pulitzer's newspaper The World and his "Base-Ball Indicator" was displayed outside their office in Manhattan. Many newspapers jumped on the bandwagon and during the 1912 World Series the New York Times drew a crowd that stretched from Times Square to 45th Street. The advent of national radio made electric bulletins such as the Bulletin Board and the Play-O-Graph redundant.*

BELOW LEFT *Comedy romp baseball films involving today's MLB stars are no more. Such was the fame of Babe Ruth in the 1920s that he could star with Harold Lloyd in the 1928 film Speedy and here he is in the short film Curves (1931) getting persuaded to coach a girls team and slip inconspicuously into the batting line-up.*

BELOW *Like the story that Abner Doubleday invented baseball, so goes the tale that Cuba's revolutionary leader Fidel Castro was once scouted as a pitcher for the major leagues. There is evidence to suggest he pitched in college in Havana, but little else. The Communist president was prepared to do more than throw out a ceremonial pitch, though, and stood on the pitcher's mound in a 1959 charity game. The likelihood of a modern world leader trying out their curve ball is slim indeed.*

INDEX

Aaron, Hank 85, 97, 135
Abell, Ferdinand 47
Al Lang Field (St. Petersburg) 126–127
Allen, Ivan 97
Arizona Diamondbacks 44
Arlington Stadium (Dallas) 88–89
AT&T Park (San Francisco) 140
Athletic Park (Milwaukee) 34–35
Atlanta Braves 97, 102
Atlanta Black Crackers 60
Atlanta Crackers 60, 97
Atlanta-Fulton County Stadium (Atlanta) 97
Atlanta Stadium (Atlanta) 60, 96–97
Atlantics 19
Baker, William F. 31
Baker Bowl (Philadelphia) 11, 30–31, 74
Baltimore Colts 108
Baltimore Elite Giants 108
Baltimore Orioles 64, 104, 108
Baltimore Ravens 108
Baltimore Terrapins 108
Bears Stadium (Denver) 112–13
Beeston, Paul 99
Bell, Cool Papa 25
Bennett, Charlie 128
Bennett Park (Detroit) 128
Berra, Yogi 104, 120, 123
Berry brothers 22
Bibby, Jim 99
Binghamton Bingoes 66
Binghampton Triplets 66
Blackburne, Lena 31
Bloomberg, Michael 123
Blues Stadium (Kansas City) 77
Bolles, John 139
Borchert, Otto 35
Borchert Field (Milwaukee) 34–35
Boston Braves 12, 14, 35, 37, 44, 80, 102, 114, 126
Boston Red Sox 12, 31, 37, 78, 86, 117, 120, 124
Braves Field (Boston) 36–37, 77
Bridegrooms 19
Briggs, Walter O. 128
Briggs Stadium (Detroit) 128
Brooklyn Baseball Club 19
Brooklyn Dodgers 37, 40, 44, 47, 55, 60, 74, 83, 104, 114, 124
Brooklyn Grays 47
Brooklyn Nationals 47
Brooklyn Tip-Tops 19, 47
Brookside Stadium (Cleveland) 118–119
Brush, John 11, 53
Buffalo Buffeds 19
Buffett, Warren 133
Busch, "Gussie" 117
Busch Memorial Stadium (St. Louis) 63, 116–117
Bush, Donie 135
Bush Stadium (Indianapolis) 134–135
Byrne, Charles 47
Campanella, Roy 60, 85
Canadian National Exhibition Stadium (Toronto) 98–99
Candlestick Park (San Francisco) 138–40
Carnegie, Andrew 71

Castro, Fidel 143
Chapman, Ray 53
Charleston, Oscar 25
Charlotte Knights 136, 137
Chicago American Giants 27
Chicago Browns 26
Chicago Colts 16
Chicago Cubs 11, 16, 26, 27, 29, 69, 71, 72, 86, 106, 136, 142
Chicago Whales 16
Chicago White Sox 16, 26–27, 51, 86, 99, 103, 136
Cincinnati Reds 16, 29, 103, 126, 142
Citi Field (New York) 124
Claxton, Jimmy 38, 39, 83
Clearwater Athletic Field (Florida) 114–115
Cleveland Buckeyes 33
Cleveland Indians 33, 47, 51, 114, 136
Cleveland Lake Shores 33
Cleveland Municipal Stadium 33
Cleveland Spiders 33
Cobb, Ty 128
Colorado Rockies 113
Colt Stadium (Houston) 72–73
Columbia Park (Philadelphia) 74
Comiskey, Charles 16, 26, 27, 86
Comiskey Park (Chicago) 26, 27, 86–87
Connie Mack Stadium (Philadelphia) 74–75
Cooke, Jack Kent 65
County Stadium (Milwaukee) 35, 37, 102–103
Crosley Field (Cincinnati) 11
Dallas-Fort Worth Spurs 89
Denver Bears 113
Denver Broncos 113
Denver Zephyrs 113
Des Moines Boosters 29
Des Moines Demons 29
Detroit Tigers 12, 60, 128, 142
DiMaggio, Joe 33, 44, 120, 123
Doyle, Joseph 47
Dreyfuss, Barney 71, 126
Dugdale Field (Seattle) 78
Dunn, "Sunny Jim" 33
Eastern Park (Brooklyn) 19, 47
Ebbets, Charles 19, 47–8
Ebbets Field (Brooklyn) 46–49, 83, 124
Emery, Joseph 39
Emeryville 38–39
Endicott, Henry B. 66
Ewing, James Calvin 'Cal' 22
Ewing Field (San Francisco) 22–23, 99
Faust, Nancy 86
Fenway Park (Boston) 12, 14, 33, 128
Fetzer, John 128
Finley, Charles Oscar 77, 97
Fitzgerald, John F. 12
Florida Marlins 104, 136
Forbes Field (Pittsburgh) 25, 70–71, 106
Ford, Whitey 123
Foster, Rube 27
Foutz, Dave 47
Franks, Herman 53

Gaffney, James 37
Gardner, Russell E. 51
Gehrig, Lou 69, 85, 120, 131
Gibson, Josh 25, 56
Gilmore, Earl 40
Gilmore Field (Hollywood) 40–41, 69
Giuliani, Rudolph 123
Giusti, Dave 71
Globe Life Park (Dallas) 89
Gosselin, Phil 137
Green, Ray E. 114
Greenlee, Gus 25
Greenlee Field (Pittsburgh) 24–25
Griffey, Ken 100
Griffith, Calvin 80
Griffith, Clark 56, 58
Griffith Stadium (Washington, D.C.) 56–57, 142
Gruber, Kelly 99
Gwinnett Braves 137
Hanlan's Point Stadium (Toronto) 64–65
Harney, Charles 139
Harwell, Ernie 128
Hofheinz, Roy "the Judge" 72, 90, 93
Holcomb Park (Des Moines) 28–29
Hollywood Stars 40, 43, 69
Homestead Grays 25, 56
Horan, Shags 29
Houston Astrodome 72, 90–93
Houston Astros 72, 93
Houston Colt .45s 72
Howard, Elston 123
Howsam, Bob 113
Hubert Humphrey Metrodome (Minneapolis/St.Paul) 80
Hunt, Harriet 20
Hutchinson, Fred 78
Indianapolis ABCs 135
Indianapolis Clowns 135
Indianapolis Indians 135
Jack Russell Stadium (Florida) 114
Jersey City 82–83
Jersey City Giants 83
Johnny Rosenblatt Stadium (Omaha) 130–133
Johnson, Arnold 77
Johnson, George F. 66
Johnson, Lyndon B. 93
Johnson, Walter 56
Johnson Field (Binghamton) 66–67
Kansas City Athletics 44, 66, 77
Kansas City Blues 77
Kansas City Monarchs 77
Kansas City Royals 131
Keeler, "Wee" Willie 47
Kennedy, John F. 58
Ketchikan Harbor Ballpark (Alaska) 20–21
Keyes, Stan 29
Keyser, Lee 29
Killebrew, Harmon 80
Kingdome (Seattle) 78, 100–101
Knights Stadium (Fort Mill) 136–137
Korakuen Stadium (Tokyo) 84–85
Landis, Kenesaw Mountain 29, 114
Lane, Bill "Hardpan" 43
Lane, Mills B. 97
Lane Field (San Diego) 42–43
Larsen, Don 123
Lasker, Albert 16

League Park (Cincinnati) 11
League Park (Cleveland) 32–33
Lelivelt, Jack 78
Leonard, Buck 25
Los Angeles Angels 22, 69, 78, 100
Los Angeles Coliseum 69
Los Angeles Dodgers 44, 48, 104
Mack, Connie 56, 74
Malone, Pat 29
Mantle, Mickey 93, 120, 123
Martin, Alfred "Billy" 39, 99, 123
Mathews, Eddie 60
Mays, Carl 53
Mays, Willie 44, 53, 95
Mazeroski, Bill 71
McCarthy, Joe 37
McGillicuddy, Cornelius 56
McKechnie, Bill 37
McKinney, Frank 135
Memorial Stadium (Baltimore) 108–112
Memphis Chickasaws 51
Memphis Egyptians 51
Merrifield, Whit 137
Metropolitan Stadium (Minneapolis/St.Paul) 80–81
Miami Marlins 104
Miami Stadium (Miami) 104–105
Miami Sun Sox 104
Mile High Stadium (Denver) 112–113
Miller Park (Milwaukee) 103
Milwaukee Bears 35
Milwaukee Braves 35, 37, 44, 80, 97, 102, 135
Milwaukee Brewers 35, 100, 103
Milwaukee Chicks 35
Milwaukee Creams 35
Minneapolis Millers 80
Minnesota Twins 123
Minute Maid Park (Houston) 93
Montreal Expos 95
Montreal Royals 95
Moore, Gerald 80
Muehlebach Field (Kansas City) 77
Municipal Stadium (Cleveland) 119
Municipal Stadium (Kansas City) 76–77
Munson, Thurman 67
Musial, Stan 63
Muskogee Chiefs 29
Nagashima, Shigeo 85
National Park (Washington D.C.) 56
Navin, Frank 128
New York Black Yankees 25
New York Giants 19, 44, 53, 55, 80, 83, 120
New York Mets 48, 55, 95, 124
New York Yankees 29, 38, 53, 66, 71, 93, 97, 120, 123
Newark Bears 114
Nickerson Field (Boston) 37
Nicollet Park (Minneapolis/St.Paul) 80
Nishizawa, Michio 85
Nixon, Richard 108, 139
Oakland Oaks 22, 38, 39, 44
Oaks Park (Emeryville) 38–39
O'Doul, Lefty 43
Oh, Sadaharu 85
Omaha Cardinals 131
Omaha Lexus 118–119

Omaha Royals 131, 132
Omaha Storm Chasers 132
O'Malley, Walter 48, 55, 69, 80, 124
Ott, Mel 38
Ottawa Giants 83
Paige, Satchel 25, 77, 104, 131
Palace of the Fans (Cincinnati) 10–11
Parc Jarry Stadium (Montreal) 94–95
Perini, Lou 37
Perry, Jim 135
Perry, Norman 135
Perry Stadium (Indianapolis) 134–135
Peters Park (Atlanta) 60
Philadelphia Athletics 31, 44, 53, 74
Philadelphia Hilldale Giants 25, 31
Philadelphia Phillies 25, 31, 74, 95, 114
Phoenix Giants 43
Piedmont Park (Atlanta) 60
Pittsburgh Crawfords 25
Pittsburgh Keystones 25
Pittsburgh Pirates 25, 71, 106, 126
PNC Park (Pittsburgh) 106
Polo Grounds (New York) 11, 52–55, 120, 124
Ponce de Leon Park (Atlanta) 60–61
Providence Grays 64
Purpus, Earl 104
Rader, Doug 99
Rickey, Branch 48
Robinson, Elmer 139
Robinson, Jackie 48, 60, 74, 77, 83, 95, 124
Robinson, Wilbert 47
Rochester Red Wings 83
Rogers Centre (Toronto) 99
Roosevelt, Franklin D. 58, 83
Roosevelt Stadium (Jersey City) 82–83
Rosenblatt, Johnny 131
Rourke Park (Omaha) 131
Ruppert Stadium (Kansas City) 77
Russwood Park (Memphis) 50–51
Ruth, Babe 31, 33, 37, 53, 60, 64, 69, 85, 97, 108, 120, 126, 131, 143
Ryan, Nolan 89
St. Louis Braves 102
St. Louis Browns 63, 108, 126
St. Louis Cardinals 63, 117, 126
St. Paul Saints 80, 126
San Diego Padres 38, 43
San Francisco Giants 44, 55, 139, 140
San Francisco Mission Reds 44
San Francisco Seals 22, 69
Schenz, Hank 53
Schorling, John 27
Schorling's Park (Chicago) 27
Seals Stadium (San Francisco) 44–45, 139
Seattle Indians 78
Seattle Mariners 100
Seattle Pilots 100, 103
Seattle Rainiers 78
Seattle Steelheads 78
Selig, Bud 102–103

Shawkey, Bob 123
Shea, William 124
Shea Stadium (New York) 124–125
Shibe, Ben 74
Shibe Park (Philadelphia) 31, 74–75
Shoriki, Matsutaro 85
Short, Robert 89
Sick, Emil 78
Sick's Stadium (Seattle) 78–79, 100
Slaughter, Enos 63
Smith, Bob 93
Smith, Elmer 33
Smith, Willie 71
Sousa, John Philip 120
South Carolina Gamecocks 131, 133
South End Grounds (Boston) 12, 14–15
South Side Park (Chicago) 26–27
Spiller, Rell Jackson 60
Sportsman's Park (St. Louis) 62–63, 117
Steinbrenner, George 123
Stengel, Casey 38, 39
Stone, Toni 135
Stoneham, Horace 80, 139
Taft, William 56, 58
Tampa Bay Devil Rays 126
Taylor, George 47
TD Ameritrade Park (Omaha) 132
Texas Rangers 89, 99
Thomson, Bobby 53, 55
Three Rivers Stadium (Pittsburgh) 106–107
Tiger Stadium (Detroit) 128–129
Tokyo Giants 85
Toronto Blue Jays 99
Toronto Maple Leafs 64
Truman, Harry 77
Tucson Sidewinders 44
Turnpike Stadium (Dallas) 88–89
U.S. Cellular Field (Chicago) 26, 86
UCLA Bruins 131, 133
Van Zile, Edward 143
Vancouver Mounties 39
Veeck, Bill 35, 63, 86, 108
Victory Field (Indianapolis) 135
Wagner, Charles F. 64
Walsh, Ed 44, 86
Wambsganss, Bill "Wamby" 33
Washington Park (Brooklyn) 18–19, 47, 48
Washington Senators 56, 80, 89
Weeghman, Charles 16
West Side Grounds (Chicago) 16–17
Westgate Park (San Diego) 43
White Autos 118–119
Wichita Aviators 29
Wichita Braves 80
Williams, Theodore "Ted" 42, 43, 89
Wilson, Horace 85
Winfield, Dave 99
Witt, Mike 89
Witt, Peter 118
Wrigley, Philip K. 69
Wrigley, William 16, 69
Wrigley Field (Chicago) 16, 29, 142
Wrigley Field (Los Angeles) 68–69
Yakult Swallows 85
Yankee Stadium (New York) 129–123, 124
Young, Cy 12